The Rococo Age

FRENCH MASTERPIECES OF THE EIGHTEENTH CENTURY

Eric M. Zafran

Introductory Essay by Jean-Luc Bordeaux

High Museum of Art
Atlanta, Georgia

Copyright 1983 High Museum of Art
All rights reserved
Published by the High Museum of Art
Atlanta, Georgia

Library of Congress Catalogue No. 83-81104
ISBN 0-939802-19-8

Editing by Kelly Morris.
Design by Jim Zambounis, Atlanta.
Hand lettering by David Dobra.
Typesetting in Garamond Light
by National Graphics, Inc., Decatur, Georgia.
Printing by Balding + Mansell, Wisbech, England.

Cover: Hughes Taraval, *The Triumph of Amphitrite*,
detail (no. 21)

This exhibition and catalogue have been made
possible by a grant from the Forward Arts
Foundation of Atlanta.

*The Rococo Age: French Masterpieces of the Eighteenth
Century* is presented under the patronage of the
Honorable Bernard Vernier-Palliez, Ambassador of
France to the United States.

Contents

Lenders to the Exhibition

Albright-Knox Art Gallery, Buffalo
The Art Museum, Princeton University
Alice and George Benston, Rochester
Channing Blake, New York
Bill Blass Collection, New York
Robert D. Brewster, New York
The Chrysler Museum, Norfolk
The Cleveland Museum of Art
Columbia Museums of Art and Science,
 South Carolina
Columbus Museum of Art, Ohio
The Cooper-Hewitt Museum, The Smithsonian
 Institution's National Museum of Design,
 New York
The Corcoran Gallery of Art, Washington, D.C.
Cummer Gallery of Art, Jacksonville
The Currier Gallery of Art, Manchester, New
 Hampshire
The Detroit Institute of Arts
Elvehjem Museum of Art, Madison, Wisconsin
Mr. and Mrs. Arthur Frankel, New York
Jacqueline and Matt Friedlander, Moultrie,
 Georgia
Mr. and Mrs. Morton B. Harris, New York
High Museum of Art, Atlanta
Hirschl & Adler Galleries, Inc., New York
Indianapolis Museum of Art
The John and Mable Ringling Museum of Art,
 Sarasota, Florida
Kimbell Art Museum, Fort Worth
Krannert Art Museum, University of Illinois,
 Champaign
Mead Art Museum, Amherst College,
 Massachusetts
Memorial Art Gallery of the University of
 Rochester
The Metropolitan Museum of Art, New York
Milwaukee Art Museum
The Minneapolis Institute of Arts
Musée du Louvre, Paris
Musée National du Château de Versailles
Museo de Arte de Ponce, The Luis A. Ferré
 Foundation, Puerto Rico
Museum of Art, Carnegie Institute, Pittsburgh
The Museum of Fine Arts, Houston

National Gallery of Art, Washington, D.C.
The Nelson-Atkins Museum of Art, Kansas City,
 Missouri
New Orleans Museum of Art
The Phillips Family Collection
Phoenix Art Museum
Portland Art Museum, Oregon
Private Collection, Atlanta
Private Collections, New York
Mr. and Mrs. Stewart Resnick, Los Angeles
Collection of Arthur Ross, New York
The St. Louis Art Museum
Maurice Segoura Gallery, New York
Snite Museum of Art, University of Notre Dame,
 Indiana
Mrs. Frederick M. Stafford, New York
Stanford University Museum of Art
Sterling and Francine Clark Art Institute,
 Williamstown, Massachusetts
E. V. Thaw and Co., Inc., New York
The Toledo Museum of Art, Ohio
Utah Museum of Fine Arts, Salt Lake City
Vassar College Art Gallery, Poughkeepsie
Virginia Museum, Richmond
Wadsworth Atheneum, Hartford, Connecticut
Ian Woodner Collection, New York
Worcester Art Museum, Massachusetts
Yale University Art Gallery, The Barker Welfare
 Foundation, New Haven

Preface

Fifteen years ago, at the opening of the Atlanta Memorial Arts Center, I wrote in a catalogue foreword that we needed to celebrate that auspicious event with a distinguished exhibition which would represent the standards with which we hoped to carry out our function in the community. On that occasion we presented a loan exhibition drawn from Parisian museums, *The Taste of Paris*, selected for us by Adeline Cacan of the Petit Palais, and made possible by a grant from the Forward Arts Foundation.

Now in 1983, as we inaugurate the new building of Richard Meier in the complex of the Woodruff Arts Center, it is appropriate that we look to that same noble tradition of creativity and present an outstanding exhibition of eighteenth-century French paintings. This time the works have been culled from collections throughout the United States as well as the Musée du Louvre and Musée du Château de Versailles in France, and to all these lenders we are most grateful. The High Museum's Curator of European Art, Dr. Eric Zafran, has on this occasion been responsible for the organization of this exhibition and for the catalogue entries.

Dr. Zafran has had the effective assistance of the museum staff in his work for this exhibition, and I wish to single out the Registrar, Marjorie Harvey, and Jon Speck, the museum's Chief Art Handler, for their contributions toward the project. Our Editor, Kelly Morris, and the designer, Jim Zambounis, deserve special credit for their tireless efforts in producing this catalogue with accuracy and flair.

Once again, the Forward Arts Foundation of Atlanta, now under the leadership of Mrs. Philip H. Alston, has seen fit to make possible an exhibition which will, we hope, enchant visitors during this exciting moment in the cultural life of Atlanta. The Forward Arts Foundation has supported the High Museum for two decades with extraordinary generosity towards exhibitions and notable acquisitions. We are deeply grateful to the dedicated members of the Foundation for their steadfast support.

7

Gudmund Vigtel
Director

Foreword and Acknowledgements

The idea for this exhibition grew out of the desire to present to the Atlanta public an old master exhibition that would complement the new High Museum designed by Richard Meier. As the plans for the new building took shape, it was evident that here, in contemporary terms, was a statement of great refinement and elegance; we decided to present an exhibition which would highlight the eighteenth century in France, an era so often thought of as the quintessential "age of elegance"! It soon became apparent, however, that such a narrow focus as the "age of elegance" was an outdated concept, derived from the approach taken in the late nineteenth and early twentieth century publications by the Goncourts and Dimier. The ground-breaking exhibitions organized by Denys Sutton for London in 1968 and Pierre Rosenberg for Toledo in 1975, as well as the texts published by Kalnein and Levey (1972) and Conisbee (1981), have shown that this was an age of the greatest variety and contrast in styles. These contrasts are found not only in the art but also in the thought and writing of the period. A frivolous and self-indulgent era, it was also the time of those most serious gentlemen, the *philosophes*.

Nothing can make this contrast as palpable as actually confronting the works of art, and in the present exhibition our usual notions of the history of taste and the catagories of art history are truly confounded. The fact that our cover piece, Taraval's bubbling *Amphitrite* (no. 21) was exhibited at the Salon as late as 1781 and the first version of Vien's *Greek Woman at the Bath* (no. 12) was shown precisely twenty years earlier is astonishing. This exhibition concentrates on the period from 1700 to 1792, when the Revolution toppled the *ancien régime* and the neo-classical style nascent in Vien's work blossomed into the severe style of David, who, as the portrait shown here (no. 37) makes evident, was himself firmly rooted in the rococo tradition.

Another reason for choosing eighteenth-century France as the subject of our inaugural exhibition is the richness of American collections in works of this period. It has been possible for many institutions throughout the country to honor the High Museum's opening with the loan of a significant painting or drawing, and we have thus been able to assemble a representative survey of all the major painters of the period. These works in turn reveal a great deal about the history of collecting and taste. Several of the paintings – genre and mythological subjects as well as portraits – were commissioned by the royal family (nos. 13, 26, 72, 82). Others were in the collection of such extraordinary connoisseurs and patrons of art as the duc de Choiseul (no. 12), Samuel Bernard (no. 71), the duc d'Antin (no. 4), Bergeret de Grancourt (nos. 13, 35), and comte du Barry (nos. 41, 52a, 52b). Additionally, many of the works, nearly a fourth in fact, were exhibited at the Salon, and we thus have the opportunity to note the contemporary critical reaction – not always favorable – to these creations. French eighteenth-century paintings quickly found an audience abroad, and patrons such as Frederick the Great (no. 43), and the Duke of Bridgewater – whose pair of Vernets (nos. 63 and 64) we are pleased to be able to reunite temporarily – were among the earliest collectors.

The American liking for the elegance, refinement, and "taste" that this period symbolizes dates from the eighteenth century itself, when Americans admired Lafayette, and Benjamin Franklin and Thomas Jefferson visited Paris. In the late nineteenth and early twentieth centuries, the paintings and the furnishings of eighteenth-century France became fashionable in America as signs of wealth and good taste. Whole rooms from Paris *hôtels* were transported to mansions in New York City, Newport and Baltimore, eventually finding their way into the country's major museums. This taste continued well into our century, and the names of such notable collectors as Mellon, Hearst, and Kress can be found in the provenances of this catalogue (nos. 3, 28, 43). Most of the works acquired by the early collectors were the decorative compositions of Fragonard, Boucher, Pater, and Lancret, the still lifes of Chardin, and the portraits of Nattier and Drouais. Since we are able to present such famous and widely-published works as Chardin's *Boy Blowing Bubbles* and Fragonard's *L'Inspiration*, we have limited the bibliographic and exhibition listings to only the most recent references where full information may be found.

During the past decade, American museums and private collectors have also discovered the major history and religious painters. Works such as Pierre's *Harmonia* in the Metropolitan, his *Adoration* in Detroit, Jouvenet's *Deposition* in Toledo, and Hallé's *Death of Seneca* in Boston are outstanding examples that reveal the role of scholarship in changing taste. This is reflected also in the works in our sections of history & religion and mythology & allegory, many of which (nos. 4, 6, 13, 16, 18, 19, and 21) have entered their respective museums only within the past ten years. In bringing together these remarkable masterpieces from collections as widely dispersed as Houston, Salt Lake City, Amherst, Stanford, and Richmond, we feel this exhibition serves the valuable purpose of documenting the continuing development of taste. In addition to the resurrection of these history and religious painters, many other significant painters of the period have recently been the subject in both France and America of extensive museum exhibitions accompanied by important monographic catalogues. For instance, notable exhibitions have been devoted to Natoire (1977), Carle van Loo (1977), Largillierre (1981), Vigée Le Brun (1982), and Oudry (1983). It is thus with a sense of accomplishment that we are able to present outstanding works by all these artists (nos. 4, 14, 22, 36, 46, and 59) which have not previously been shown in the context of a special exhibition.

A special mention seems called for in regard to the selection of drawings, which we have included as a separate category. We have chosen highly finished works that will hold their own on the wall with the paintings and which reveal the polish and mastery of their respective masters, who were for the most part passionate practitioners of the draughtman's art. These drawings in fact present a capsule survey of the subjects and fads of the century. There is to be seen the jewel-like fantasy of Lajoue characteristic of the ornamental phase of rococo art (no. 73); the influence of the theater is exemplified in the sheet by Watteau (no. 70). The concern for the nude as an exercise is found in the Lépicié *académie* (no. 74) and as a ravishing preliminary study in the *trois crayon* manner in Boucher's drawing (no. 75). Our representative example of *chinoiserie* (no. 74) is also by Boucher, and in Loutherbourg's work (no. 80) is expressed another taste – that of anglomania. Finally we have a group of remarkable portraits in chalk and in pastel by Rigaud, Nattier, Perroneau, and Vigée Le Brun (nos. 71, 72, 81, 82) which reveal the fascination with character and the appropiate physiognomy that so ruled the age.

To locate and select the works for the exhibition was a task that called for the assistance of many knowledgeable individuals. Professor Jean-Luc Bordeaux of California State University in Northridge, the author of our introduction, provided many helpful suggestions. Joseph Baillio, Director of Research for Wildenstein in New York, was most kind in sharing with me his vast knowledge of the eighteenth century and helping me to establish a coherent framework for the exhibition. Other experts whose suggestions helped to refine the selection of works and whose kindness is deeply appreciated are Edgar Munhall, Victor Carlson, Donald Posner, Martin Eidelberg, Myra Nan Rosenfeld, Dean Walker, David Lomax, Mary Tavener Holmes, Jean-Pierre Cuzin, Marianne Roland Michel, and Jean Cailleux. Suggestions as to the location of works in collections unknown to me were generously made by Christophe Janet, Scott Schaefer, Clyde Newhouse, Gerald Stiebel, Gerard Stora, William Gwynn, and Frederick Schab.

I visited many museums and private collectors and to those who gave of their time, but whose works do not appear in the exhibition, I express my thanks for their patience. To arrange for the loans took the cooperation of many individuals in many institutions. I would particularly like to express my appreciation to our colleagues in France who so generously supported our efforts from the start and made it possible to borrow outstanding treasures from their collections: Pierre Rosenberg, *Conservateur en Chef au Department des Peintures* at the *Musée du Louvre* and Pierre Lemoine, *Conservateur en Chef* and Claire Constant, *Conservateur* of the *Musée National du Château de Versailles*.

We are most indebted to all the lenders both public and private, who for three months have consented to part with their justly treasured possessions, and at the various institutions in this country from which we have borrowed works, the following have been of particular assistance: Albright-Knox Art Gallery, Robert T. Buck, Director, and Sarah Ulen, Registrar; The Art Museum, Princeton University, Allen Rosenbaum, Director, and Betsy Rosasco, Curator; The Chrysler

9

Museum, David W. Steadman, Director, Thomas Sokolowski, Chief Curator, and Catherine Jordan, Registrar; The Cleveland Museum of Art, Sherman E. Lee, Director; Columbia Museums of Art and Science, Nina Parris, Curator; Columbus Museum of Art, Budd H. Bishop, Director, Steven W. Rosen, Curator, and Susan R. Visser, Registrar; Cooper-Hewitt Museum, The Smithsonian Institution's National Museum of Design, Lisa M. Taylor, Director, Elaine Evans Dee, Curator of Drawings and Prints; The Corcoran Gallery of Art, Michael Botwinick, Director, Edward J. Nygren, Curator, Judith Riley, Registrar; Cummer Gallery of Art, Robert W. Schlageter, Director, I. Vance Shrum, Assistant to the Director; The Currier Gallery of Art, Robert M. Doty, Director, Philip D. Zimmerman, Curator; The Detroit Institute of Arts, Frederick J. Cummings, Director, J. Patrice Marandel, Curator; Elvehjem Museum of Art, Carlton Overland, Curator of Collections; Hirschl and Adler Galleries, Inc., Norman Hirshl and Martha Parrish; Indianapolis Museum of Art, Robert A. Yassin, Director, Anthony F. Janson, Curator; The John and Mable Ringling Museum of Art, Richard S. Carroll, Director, the late William Wilson, Curator, Elizabeth S. Telford, Head of Collections Management; Kimbell Art Museum, William B. Jordan, Deputy Director; Krannert Art Museum, Fred Walker, Assistant Director; Mead Art Museum, Frank Trapp, Director, Judith A. Barter, Curator of Collections; Memorial Art Gallery of the University of Rochester, Bret Waller, Director, Donald A. Rosenthal, Chief Curator; The Metropolitan Museum of Art, Philippe de Montebello, Director, Katharine Baetjer, Curator, Frederick Gordon, Loans Department; Milwaukee Art Museum, Gerald Nordland, Director, Russell Bowman, Chief Curator, Thomas Beckman, Registrar; The Minneapolis Institute of Arts, Samuel Sachs II, Director, Michael Conforti, Chairman Curatorial Division; Museo de Arte de Ponce, Rene Taylor, Director Emeritus, Marimar Benitez, Visiting Curator; Museum of Art, Carnegie Institute, John R. Lane, Director, Henry Adams, Curator of Fine Arts; The Museum of Fine Arts, Houston, David B. Warren, Associate Director; National Gallery of Art, J. Carter Brown, Director, David Rust, Curator of French Painting; The Nelson-Atkins Museum of Art, Marc Wilson, Director, Roger Ward, Curator; New Orleans Museum of Art, William A. Fagaly, Assistant Director for Art; Phoenix Art Museum, Susan Gordon, Assistant Curator; Portland Art Museum, Donald Jenkins, Director; The St. Louis Art Museum, James D. Burke, Director; Sterling and Francine Clark Art Institute, David Brooke, Director; Snite Museum of Art, Stephen Spiro, Chief Curator; Stanford University Museum of Art, Carol M. Osborne, Assistant Director; The Toledo Museum of Art, Roger Mandle, Director, William Hutton, Senior Curator; Vassar College Art Gallery, Joan Lukach, Director; Virginia Museum, Pinkney Near, Curator; Utah Museum of Fine Arts, Thomas V. Southam, Curator; Wadsworth Atheneum, Gregory Hedberg, Chief Curator; Worcester Art Museum, Tom Freudenheim, Director, James A. Welu, Curator, Stephen B. Jarecki, Registrar; Yale University Art Gallery, Alan Shestack, Director, David Steinberg, Curatorial Assistant.

Many individuals on the High Museum's staff also contributed greatly to the success of this undertaking. Gudmund Vigtel, the Museum's Director, has lent his wholehearted support to this project. My assistant Theodore Kingsley not only sought out research materials at local libraries, but prepared biographical information on several of the artists as well as writing the entry on Loutherbourg. Paula Hancock provided insight on several iconographic questions: Eugene Abrams assisted with the French translations. The manuscript of the catalogue was prepared for the printer through the dedicated efforts of Rhetta Kilpatrick, Liz Lane, and Paul Brandt. It was edited with great skill by Kelly Morris and Amanda Woods, and the excellent design was prepared in short time by Jim Zambounis. Linda Combs of National Graphics oversaw the typesetting, and Guy Dawson and Michael Wojtowycz of Balding + Mansell helped bring the book into daylight. The patience and professionalism of the Museum's registrar, Marjorie Harvey, assured that the loan process went smoothly, and the installation was carried out most efficiently by Jon Speck and his hardworking crew. For the patronage of the French Ambassador we are grateful not only to the Ambassador Bernard Vernier-Palliez himself but also to Jean-Marie Gueheno, Cultural Counsellor, New York, and Jack Batho, *Attaché Culturel*, New Orleans. For their willingness to support this international project and commemorate it in the present catalogue, the Forward Arts Foundation of Atlanta is to be warmly lauded.

Eric Zafran
Curator of European Art

The Rococo Age
Jean-Luc Bordeaux

With a population of some nineteen million when Louis XIV died in 1715, France was near bankruptcy after the failure of the king's policy in the War of the Spanish Succession (1702-1713) and the outrageous expenditures for the construction of Versailles. There was a new king, Louis XV, great-grandson of Louis XIV, but he was only five years old, a situation that required the Regency of Philippe d'Orléans from 1715 to 1723. During those eight years, France turned away from imperialistic pursuits and became a land of peace, economic recovery, and epicurean life. In art, the creation of a new style mirrored the change in politics and morals. It was the beginning of the Rococo Age.

The changes in the visual arts in France span several decades. Rococo characteristics appeared first in the decorative arts, but it was perhaps in painting that the new age expressed itself with the most clarity and richness. The furniture and the paneling of interiors became lighter and more graceful in design, and the use of the *rocaille* motif, a truly inventive ornament, helped create the fashionable style of the sensuous curve and the arabesque. In painting, the first signs of stylistic change began in the 1680s, when Charles de la Fosse and Antoine Coypel reformed the Académie Royale de Peinture directed by Charles Le Brun. At the same time, controversial theoretical lectures were being given in the Académie, with the partisans of Poussin and Raphael extolling the merits of classicism and drawing, and the Rubenists and Neo-Venetianists led by Roger de Piles advocating the merits of colorism. It was left to the younger generation of artists such as François Desportes, Jean-Baptiste Oudry, Antoine Watteau, Jean-François de Troy, and François Lemoyne, who inherited the Rubenist standards, to secure the outcome of that aesthetic quarrel, a victory for the colorists.

Colorism meant a new style – a style that had been anticipated in the decoration of the Grand Trianon (1688-1714), where idyllic and gallant mythologies had supplanted the traditional (usually heroic) pictorial themes of legend and history. During the Regency, colorism implied no single point of view. For some, it meant either the sensuous quality of Rubens's art, his compositional invention and his rich palette, the tasteful and subtle sensuality of Correggio, or Veronese's elegant and voluptuous women in gorgeous robes. For others, it meant the naturalism and the masterful workmanship admired in the small wood panels of the Netherlandish schools, and/or the bright color scheme and the virtuosity of brushwork displayed by contemporary Venetian masters such as Sebastiano Ricci and Giovanni Antonio Pellegrini, the most widely travelled painters of their generation.

During the Regency, the rococo style of painting took shape and entered its first phase, which lasted two decades. The death of François Lemoyne in 1737, the important Salon of that year, and the decoration by Natoire (fig. 1) in the Hôtel de Soubise (1736-1739) may indicate the end of the early rococo and the beginning of a new era, which saw the rapid rise of François Boucher and the artistic hegemony of Louis XV's legendary mistress, the Marquise de Pompadour. The formation of the rococo style in painting corresponds to a much more profound change in

Fig. 1. The Oval Salon of the Princess de Rohan, Hôtel de Soubise, Paris, with painted decorations by Charles-Joseph Natoire, 1736-39.

the taste, manners, and morals of French society than is generally acknowledged.

Philippe d'Orléans himself symbolized the transition to the rococo spirit. He moved the government from Versailles to Paris, where his Palais Royal became the scene of frivolous parties and masquerades. His appetite for beauty and pleasure – the grace and the vivaciousness of the Regency women, *danseuses* and actresses, and the elegant picnics in the Bois de Boulogne – were reflected in his own art collection, rich in works from the Northern schools and by Cinquecento Venetian masters. But even before the Regency, the duc d'Orléans had set the tone in the first decade of the century when he commissioned Antoine Coypel to decorate his Palais with scenes from the story of Aeneas. The project was an overnight success; the Correggesque quality of the paintings aroused general admiration and Coypel was appointed director of the Académie in 1714, marking the beginning of his influential role as a theorist.

In his lectures to the Académie of 1720 and 1721, Coypel recommended the study of nature, the colors of Veronese, and the graceful elegance of Correggio's female nudes, as well as the expressive form and the drawing of the great Bolognese masters of the preceding century, Annibale Carracci, Guido Reni, and Domenichino. These lessons were not forgotten by painters who worked in the so-called "*grande manière*" (history painting) throughout the eighteenth century: Lemoyne to Natoire and Boucher, and from de Troy, Noël-Nicolas Coypel and his half-brother, Charles-Antoine, to Carle van Loo, Jean-Baptiste-Marie Pierre, Jean-Simon Berthélemy, Louis and Jean-Jacques Lagrenée, Nicolas-Guy Brenet, Hughes Taraval, and Fragonard, to mention only a few.

Most of these artists expressed themselves in a variety of genres, but they shared a common interest or obsession – the female nude. At no other time in the history of art can we find so many canvases interpreting the seductive quality of the female body. The popularity of the female nude in artistic circles of the eighteenth century remains both a social and an artistic phenomenon which needs to be seriously investigated. Although it was perhaps Jean-François de Troy who first understood the financial reward of exploiting this taste, it was left to Watteau and Lemoyne to produce the first truly seductive nudes in French art. Lemoyne might even be credited with

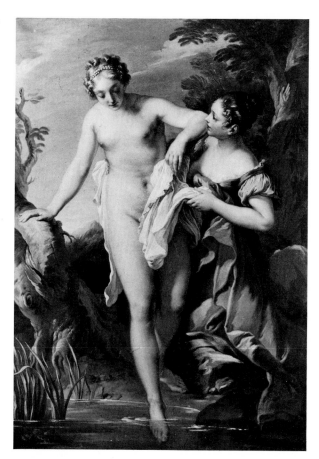

Fig. 2. François Lemoyne, *The Bather*, 1725, Musée des Beaux-Arts, Tours.

the invention of "*La Baigneuse*" (*The Bather*, fig. 2), which was to become in the second half of the nineteenth century one of the most important pictorial themes explored by French artists. Boucher, influenced by both Watteau and Lemoyne, created a smaller female type – decorative, charmingly sensual, and often shameless (see no. 75) – which he and his studio commercialized into a world fashion. Despite Diderot's attacks and the moralistic reaction, the woman seen as a tasteful sex object remained an aesthetic priority until the French Revolution.

In order to foster a more rapid economic recovery, the Regent enlisted the services of a financial wizard, the Scot John Law, who organized the first national bank and credit system in France. The so-called Law System not only became an immediate success but it also led to the creation of the *Compagnie des Indes*, which monopolized all foreign commerce, including the exploitation of the Mississippi basin, then under French control.

12

Stocks issued in the *Compagnie* were rapidly exchanged at an ever-increasing rate, a wave of speculation fed by the news of fantastic mineral riches in Louisiana. But the Law System turned into a financial debacle and collapsed by 1721. According to Saint-Simon's *Memoires*, huge fortunes were made, some in a few days. The wisest managed to cash their shares before the bad news from Louisiana reached Paris. They bought land, houses, diamonds, jewelry, and art. Some of the richest became richer; the duc de Bourbon and the Prince de Conti were seen carting away their new treasure when they disposed of their stocks for millions of pounds in gold.

The Regent himself was a major shareholder of the *Compagnie*. Advised by his friend, Pierre Crozat (1665-1740), a banker and the most astute art connoisseur in Europe, the Regent exchanged his shares for great quantities of diamonds, which enabled him to acquire the famous art collection of Queen Christina of Sweden. After several years of negotiations with Baldassare Odescalchi, Christina's heir in Rome, the entire collection arrived in Paris in 1721. Apart from its richness in masterpieces from all schools, above all Cinquecento Venetian masters, and its direct impact on the young French artists, the collection stimulated other rich men to buy art, to form collections and commission artists to decorate their newly built townhouses.

In a Parisian hôtel he began to build in 1704, Crozat gathered a splendid collection of paintings and drawings; and promoted a new style of painting (led by Charles de la Fosse and Antoine Watteau). His home became one of the major cultural salons of Europe. In such surroundings, art criticism was born, the favorite Rubenist issues were discussed, and contemporary Venetian masters or critics such as the influential Rosalba Carriera and A. Maria Zanetti could be met. When one examines Crozat's collection (now for the most part in the Hermitage, Leningrad), the collector's preference for relatively small canvases and the technical side of painting is well illustrated by the number of works by Titian, Veronese, Bassano, Fetti, Barocci, Rubens, van Dyck, Rembrandt, and Wouwermans. In his eclectic collection, there were 19,000 drawings. Crozat had a passion for this medium, long neglected by French collectors except the banker Jabach, the theorist Roger de Piles, and the abbé de Marolles in the preceding century. Crozat's enthusiastic collecting stimulated many young artists and future dealers, connoisseurs, critics, and collectors – such as Jean de Julienne (responsible for popularizing Watteau's works), the antiquarian-critic comte de Caylus (whose biographies of eighteenth-century French artists remain important), Pierre-Jean Mariette (the compiler of the fascinating *Cabinet Crozat* and author of the indispensable *Abécédario*), and the dealer Edmé-François Gersaint (who pioneered the first systematic sale catalogue in 1744, documenting Watteau's life and describing each item from the famous Quentin de Lorangere collection).

The consequences of the enlightened artistic patronage of both the Regent and Crozat and the large sums of gold earned from the Law System were felt throughout the eighteenth century. Powerful aristocrats like the Prince de Conti, the comte de Vandreuit, and, much later, the duc de Choiseul, and wealthy financiers and tax collectors (*fermiers généraux*) were thus incited to compete among themselves and manifest their individuality in the construction of beautiful Parisian hôtels, which they had decorated by the most admired modern painters. This is how Christophe La Live de Jully and Samuel Bernard (no. 71) commissioned Jean-François de Troy to execute more than fifty works – ranging from decorative *dessus-de-porte* and allegories illustrating the Seasons and the Hours of the Day to religious and mythological scenes. These decorations are dispersed today, but a few of the mythological scenes from the Samuel Bernard hôtel are conserved in the Museum of Neuchâtel in Switzerland. In 1729, a former wigmaker, Abraham Peyrenc de Moras, who had just acquired an estate with a title, offered the decoration of his hôtel (a remarkable Parisian townhouse built by Gabriel and today housing the Musée Rodin) to Lemoyne, who executed eighteen paintings, the majority of which are today lost. A few years later, in 1732, it was the turn of the duc d'Antin, Superintendant of the Royal Buildings, to seek a suitable artist to decorate his house. It was not the duke's protégé Lemoyne who executed the commission, but Natoire, who had just returned from Italy and who was probably recommended by his former teacher (whose influence in *Jacob and Rachel Leaving the House of Laban* (no. 4), one of three works commissioned by the Superintendent, is very striking). In 1731 Natoire had helped

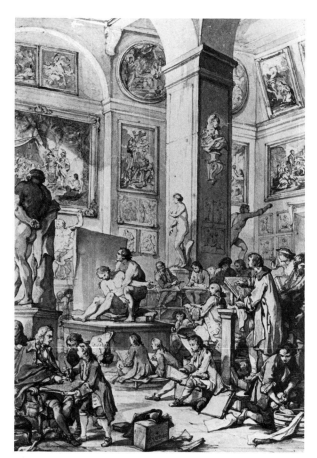

14

Fig. 3. Charles-Joseph Natoire, *Drawing Class at the Académie Royale*, 1746, Courtauld Institute of Art, Witt Collection.

Lemoyne put the final touches to his ceiling of the cupola of the Chapel of the Virgin Mary in Saint-Sulpice. Unlike Boucher, Natoire never denied his artistic debt to his former master and, in a well-known drawing (fig. 3), he places Lemoyne's *Annunciation* near other famous works by Le Brun and Jouvenet.

From the beginning of the eighteenth century, an art collection was regarded as a sign of wealth and taste. Not always of noble origin, those who made rapid fortunes on various financial markets became the chief patrons of modern artists. This, to a certain extent, explains the success of painters working in the category of genre like Antoine Watteau and Jean-Siméon Chardin.

Watteau, a provincial artist from Valenciennes and creator of the poetic *fête galante*, had fragile health, was shy and restless, and often failed to meet the requirements of the Royal Academy. However, he managed to attract the support of a few devoted and influential friends and patrons such as Antoine de la Roque (no. 23, editor of the

Mercure de France), Crozat, Jean de Julienne, and the dealer Gersaint. Watteau's early career, from 1702 to about 1709, remains vaguely documented. It was difficult to succeed in Paris without knowledge of old masters, proper introductions, and proper patronage. Following the contemporary taste for small Dutch pictures by Teniers, Wouvermans, or Dou depicting scenes from domestic life and a broad range of countryside activities, Watteau began to paint peasant and military subjects for purely commercial reasons. When he became a pupil of Claude Gillot before 1710, he was introduced to the world of the theatre, the *commedia dell'arte*, which stimulated his imagination and allowed him to explore human nature from a different perspective. He quickly dispensed with stage scenery and the actual characters of the Italian comedy dear to Gillot (no. 42), retaining only the character's slender proportions and costumes to portray the longing of the French upper classes for idyllic love (no. 70).

Watteau was received into the Académie in 1717 as a painter of *fêtes galantes,* for *The Departure from the Island of Cythera* (Louvre), which depicts a bittersweet scene of pairs of lovers awakening to reality as they leave the island of love. For the rest of his life, a feeling of nostalgia pervaded Watteau's most successful canvases, which are often autobiographical in their search for happiness. Watteau's legacy was more complex and long-lasting than is generally acknowledged, and should not be connected with any single category of picture. Among those others who painted *fêtes galantes,* one must distinguish between the direct followers of Watteau – like the excellent colorist Nicolas Lancret (no. 43) and the less robust Jean-Baptiste Pater (no. 44) – and countless imitators who vulgarized Watteau's poetic genius.

It was Watteau's profound humanity and the seriousness of his works which touched the Goncourt brothers more than a century later, leading them (in the remarkable *Art du dix-huitième Siècle,* 1856-76) to take a deeper look at the century which produced Chardin, Boucher, Quentin de La Tour, and Fragonard. Curiously, it is Chardin's serene genre scenes and still lifes that reveal the greatest affinities with Watteau's fanciful and nostalgic reveries. Boucher's and Fragonard's works are generally more sparkling, provocative, and amusing to the eye, and a work such as Carle van

Loo's brilliant oil sketch (no. 46) is a striking example of technical virtuosity, but it does not go much beyond portraying the French aristocracy at play. Chardin, however, was able to give life to inanimate objects, to create the actual presence of things, and to express the inner emotions of his figures. Just as the protagonists of Watteau's *fêtes galantes* act in a restrained manner, often with their backs to the viewer, so Chardin's subjects are understated. For Chardin, a silver goblet, a piece of fruit, or a glass of water and three small white onions (no. 57) could suffice. By comparison, Anne Vallayer-Coster, the most famous woman painter after Mmes. Vigée Le Brun and Labille-Guiard, is more anecdotal and more detailed, her color scheme attractive but less inspired in its general harmony (no. 61).

Turning to figure composition at the urging of his friend, the portaitist Joseph Aved, Chardin produced a substantial number of figure paintings in the late 1730s. As a result, his popularity rose rapidly and these new works were reproduced in great quantity by commercial engravers. The theme of a boy blowing bubbles – one of the best versions of *Soap Bubbles* is exhibited here (no. 47) – is typical of the artist's exploration of adolescence, a subject dear to the philosopher J.-J. Rousseau and later exploited for its moralistic implications by Greuze. In most cases, Chardin portrays the young boys or girls at a critical moment, when simply breathing may disturb a castle made of cards, when a soap bubble has reached its maximum fullness, or when a top is just about to fall (no. 25). Chardin's figures are caught in moments of serenity and silence, as if, for a moment, time was suspended.

Four years after Watteau's death, the newly-appointed director of the Académie, Louis de Boullogne, decided to rekindle a spirit of competition among academicians and reassure the public about the progress of modern artists and the quality of their works. The Salon of 1725 was the first one since 1704, when the exhibitions had been suspended for financial reasons. It was then not held again until 1737. Thereafter, this most important public event, attended by up to one thousand visitors per day, took place every year or every other year on August 25th in the Salon Carré of the Louvre. A *livret* or brief catalogue was sold at the door. The show's run varied from ten days in 1725 to about four weeks in the second half of the century, an extension which gave adequate time to critics to review the works. In

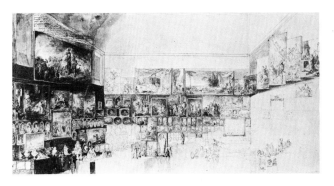

Fig. 4. Gabriel Jacques de Saint-Aubin, *The Salon of 1765*, Musée du Louvre, Paris.

the *livrets* of the middle decades, paintings, sculptures, and engravings were listed in hierarchical order, starting with the full members of the Académie, followed by the *agréés*. These were young artists who had satisfied the first academic requirements and were then requested to prepare a *morceau de reception* in order to be *reçu* or received as full members of the Académie in one of the standard categories of painting. The subject of the reception piece was generally specified and the work usually had to be completed within one year. Exceptions were made; Watteau, for example took five years to complete his *fête galante* (in 1717), for which he had chosen his own subject. Salon *livrets* became more and more systematic; dimensions were given, and works were numbered and described. The most celebrated *livrets* are those annotated with tiny sketches by Gabriel-Jacques de Saint-Aubin, who also occasionally recorded panoramic views of the crowded Salon galleries (fig. 4).

The opening of the Salon of 1725 was met with great expectation by the entire art community and the 103 members of the Académie Royale. It is difficult to measure the significance of this Salon, which remained open for less than two weeks. History painters in particular needed public exposure and official recognition, for royal patronage and church commissions were at their lowest level since Louis XIV's death. History painting was regarded as the most elevated field, requiring study of ancient and Renaissance literature, perspective, geometry, and, above all, the intensive study of the human figure either from life (fig. 5) or from plaster casts of antique statuary. Generally these studies lasted several years, preparing the young candidate for the highest academic degree, the coveted Prix de Rome or

15

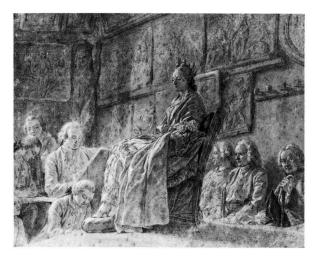

Fig. 5. Charles-Nicolas Cochin, *The Competition for the Prize in Drawing Heads and Expression*, 1763, Musée Carnavalet, Paris.

Grand Prix, which meant a trip to Rome, where the winners were received at the Académie de France as *pensionnaires* of the king. This three-year fellowship in Italy had not been awarded since 1711 for lack of funds.

As far as one can determine from the 1725 *livret*, the history painters, Jean-François de Troy, Lemoyne, Jean Restout, and Charles-Antoine Coypel entered into open rivalry. Lemoyne exhibited his famous *Bather* (fig. 2) and de Troy convinced the public of his inventiveness, his gifts as a colorist, and his keen sense of observation by showing his *tableaux de mode*. But these subjects – and others like *Leda and the Swan, Apollo and Daphne,* or the *Rape of Europa* – were not morally uplifting and must have looked disrespectful of the classical tradition to the untrained eye of the public – or at least different from the decorative canvases exhibited by François Desportes and Jean-Baptiste Oudry. Working tirelessly for the decoration of royal houses, Desportes and Oudry devoted themselves mainly to still lifes, the portrayal of live and dead game (nos. 58, 59), hunting scenes, and landscapes. Less profound than Chardin, both artists were nevertheless capable of stunning illusionistic and compositional effects, such as Oudry's *Vase of Flowers with a Parterre of Tulips* (Detroit Institute of Arts).

Deeply concerned by the rapidly growing demand for minor genres and the anarchy of the artistic situation, the duc d'Antin decided to organize a *Concours* (competition) in 1727 among twelve history painters. To further encourage these artists, a sum of 5,000 *livres* was to be awarded to the winner. (There may have been some additional reasons for this unusual event, such as confirming Lemoyne's leadership in the *grande manière*.) The outcome of the competition aroused controversy; the opinions of the connoisseurs, the public, and the establishment were divided. In the end, the prize was shared equally by Lemoyne and de Troy, who executed the *Continence of Scipio* and *Repose of Diana* respectively, both in the Musée des Beaux-Arts at Nancy. The king purchased the entry of the playwright-painter Charles-Antoine Coypel (*Perseus and Andromeda*, now in the Louvre). Coypel is represented in this exhibition by a religious subject (no. 7). The greatly admired *Rape of Europa* (fig. 6, now in the Philadelphia Museum of Art) painted by Noël-Nicolas Coypel was acquired privately by the comte de Morville.

In spite of his half-victory, Lemoyne was awarded the following year the most important royal commission since the Regency, the decoration of the ceiling in the Salon d'Hercule at Versailles. However, it was not until 1736, one year before his suicide, that the duc d'Antin's protégé became *Premier Peintre du Roi.* As to de Troy, he managed to work for the *chambre de la reine* in Versailles and produced cartoons for the Manufacture des Gobelins – above all, a magnificent series of works, recently restored, illustrating the *Story of Esther.* Although hoping for something more glorious, de Troy had to be content with the directorship of the Académie in Rome from 1738 until 1751, one year before his death, when the Marquis de Vandières, future Marquis de

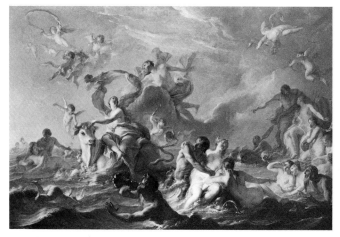

Fig. 6. Noël-Nicolas Coypel, *The Rape of Europa*, 1727, Philadelphia Museum of Art, gift of John Cadwalader.

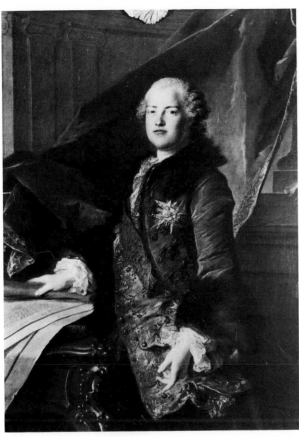

Fig. 7. Louis Tocqué, *The Marquis de Marigny*, 1755, Musée du Château de Versailles.

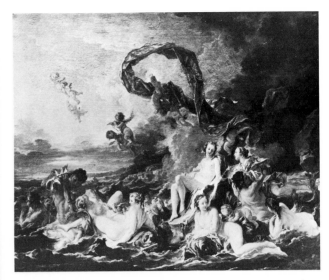

Fig. 8. François Boucher, *Triumph of Venus*, 1740, National Museum, Stockholm.

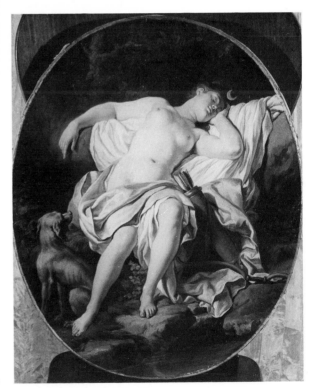

Fig. 9. Nicolas-Guy Brenet, *The Sleeping Diana*, 1771, Private Collection.

17

Marigny and brother of the Marquise de Pompadour, decided to replace him with Natoire. Upon his return from Italy, Marigny was appointed Superintendent of the Royal Buildings. In this position, as he was depicted by Tocqué (fig. 7), he played an essential role in French artistic life, assigning all royal commissions to his favorite artists.

In the 1727 *Concours*, Lemoyne and Jean Restout attempted to interpret moral subjects and treat them with classical grandeur. All the other works were more lighthearted, displaying the kind of seductive female nudes that would inspire artists for the next fifty years, from Boucher to Fragonard and from Pierre (no. 16) to Taraval (no. 21). If the most successful and eminently rococo painting of the century, François Boucher's 1740 *Triumph of Venus* (fig. 8, National Museum, Stockholm) was a direct heir to Noël-Nicolas Coypel's *Rape of Europa*, so were Nicholas-Guy Brenet's *Venus and Cupid* and *Diana Sleeping* (fig. 9) – shown at the 1771 Salon and recently rediscovered in a private collection.

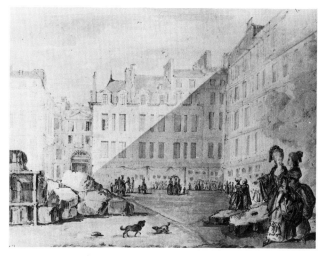

Fig. 10. Duché de Vancy, *Exposition de la Jeunesse*, 1780, Musée Carnavalet, Paris.

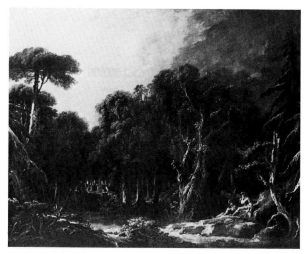

Fig. 11. François Boucher, *Forest Landscape,* 1740, Musée du Louvre, Paris.

Boucher's public career began after his reception by the Académie in 1734 with the suave *Rinaldo and Armida* (Louvre). Before his success at the Salon of 1737, he was reported to have exhibited at the *Exposition de la Jeunesse*. This event was held annually until 1789 on Corpus Christi (early June), in the open air on the Place Dauphine near the Pont Neuf (fig. 10). Chardin, Oudry, and Greuze also exhibited there. Outside the official Salon, there were few opportunities to exhibit, which explains the success of rival exhibition societies like the Académie de Saint-Luc between 1751 and 1774 and the Salon de la Correspondance between 1779 and 1787. Pahin de la Blancherie, who promoted "La Correspondance," should be remembered as the man who organized the first retrospective exhibition of French paintings since the time of Clouet, and the first retrospective for a contemporary artist, the marine painter Claude-Joseph Vernet. These various exhibitions naturally gave rise to the development of art criticism, notably the writings of La Font de Saint-Yenne, Caylus, and, above all, Diderot, whose *Salons* set a standard for this new literary genre.

Boucher's early works, painted during the 1720s, represented here by his 1723 Prix de Rome painting (no. 3), show the combined influence of Watteau, Sebastiano Ricci, and Lemoyne. Boucher also took an active part in Julienne's publication of Watteau's *Oeuvre gravé.* Apart from his well-known sensuous nymphs and glorious nude goddesses reclining indolently on waves, clouds, grass, or couches (no. 13),

Boucher excelled in the pastoral genre. He conceived brilliant decorative projects to be executed on a large scale, such as his cartoons for the Opéra and the Beauvais tapestry factory (*The Four Elements* at the Kimbell Art Museum, *The Noble Pastoral* at the J. Paul Getty Museum, and the Grenoble *Chinoiseries*). He created some of the most striking landscapes of the century, like the luminous canvases in the museum in Caen and Galleria Nazionale of Rome and especially the magnificent *Forest* (fig. 11, Louvre), painted in 1740. In Boucher's interpretation of the "natural," a complex aesthetic concern in eighteenth-century French art, there is always a feeling of poetry, either Arcadian in the tradition of Claude and Castiglione, or rustic in the tradition of Teniers, Berchem, and Bloemart.

At mid-century and thereafter, until the French Revolution (Louis XV died in 1774), the painters who helped make French rococo art an international phenomenon – a success at the courts of Frederick II of Prussia and Catherine the Great of Russia – became more ambitious. Conflicting trends began to develop. In 1747, Louis XV commissioned eleven history paintings for the decoration of the Château de Choisy, the subjects of which were derived from classical history. For Madame de Pompadour, Boucher created in 1750 the Rubensian *Sunset and Sunrise* now in the Wallace Collection, London. Pierre Subleyras, who arrived in Rome in 1728 and remained there for the rest of his life, undertook various important commissions, such as the *Mass of Saint Basil*

commissioned by the pope for St. Peter's in 1747. That altarpiece and a work in this exhibition (no. 8) reveal his personal style, employing a low-key and at the same time rich palette. Like so many of his contemporaries, he was extremely versatile, but the appreciation of his oeuvre demands an eye familiar with Italian painting. Jean-Baptiste-Marie Pierre, who played a major role in the administration of French artistic life under Louis XVI and became *Premier Peintre du Roi* after Boucher's death, was not just a charming painter of amorous fantasy (no. 16), but was also capable of producing extremely fine drawings and astonishingly powerful works, like the Metropolitan Museum's *Harmonia*.

All these artists and several others like Vien, Greuze, Vincent, the young Fragonard, and David – stimulated by the writings of Rousseau and Voltaire against artistic license and by a return to the ideals of classical antiquity promoted by the comte de Caylus in Paris and Johann Joachim Winckelmann in Rome – entered a transitional phase, stylistically neo-baroque. However, it was not until the 1760s that the new antiquarian interest and the themes of morality, heroic virtue, familiar daily activities, family life, and patriotism became dominant. Their sources ranged from the classicism of Carracci and Poussin to the romanticism of Guercino, Crespi, Giordano, and Rembrandt.

Unlike the rich and varied school of French landscape painting – which owed a great deal to traditional sources like Claude, Gaspard Dughet, Salvatore Rosa, Locatelli, and the seventeenth-century Dutch masters – genre painting is much more complex and seems to owe less to its seventeenth-century predecessors. A new emphasis was increasingly placed on the value of feeling – *la sensibilité*. The familiar and diverse activities of home or street or countryside are illustrated in the exhibition by works by Greuze, Fragonard, Aubry, Lépicié, and Trinquesse. The treatment is not anecdotal in the traditional sense but more elevated on both the artistic and the psychological levels. Some of these scenes have affinities with the art of portraiture, since the majority of those artists trained as history painters.

For Jean-Baptiste Greuze, to stir the emotions became an end in itself. Many critics, including Diderot, considered him a moralist with a tendency toward sensationalism. But the spectator could not fail to be affected by Greuze's exquisite surface realism and the intensity of his family-

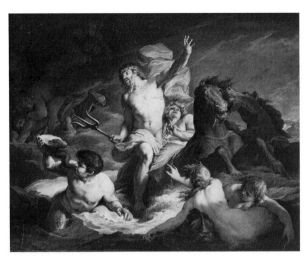

Fig. 12. Nicolas-Bernard Lépicié, *Neptune Unleashing the Winds*, 1771, Private Collection, Los Angeles.

related themes. By comparison, Aubry, a gifted painter with a delicate talent, looks unexaggerated (no. 54). Lépicié, also an esteemed history painter of such works as the *Neptune Unleashing the Winds* (fig. 12), whose talent was best displayed in depicting children, composed charming pictures (no. 53) which waver between Chardin's simplicity and Greuze's sentimentality. Lépicié's naturalness is not to be found in works of Trinquesse, who portrayed courtship scenes (no. 56) which belong more to the category of de Troy's *tableaux de mode*. Boucher's pupil, Jean-Baptiste Leprince, gave a new twist to genre painting by incorporating his experiences in Russia (nos. 52a and b). Both Fragonard (no. 51) and Hubert Robert (no. 50) interpret the popular genre subject of washerwomen as a pretext to enchant the male voyeur (the theme was often associated with erotic feelings).

Fragonard's debt to Boucher is unmistakable, not only because he sang the theme of love throughout his career, but because he was also obsessed with the techniques of painting and drawing. His canvases are admired, regardless of their subjects, for their brilliant, almost abstract, compositions and quickly-brushed colors. His sanguines and pen and ink drawings remain avidly collected. Varying his manner constantly, Fragonard was a true poet, fully aware of the inventiveness of Rubens, Rembrandt, Hals, Tiepolo, and Solimena. Under the influence of Boucher, his early works (no. 49) were brightly colored with strong pink and yellow accents. (See *The Bathers* in the Louvre or the *Blindman's Buff* in

19

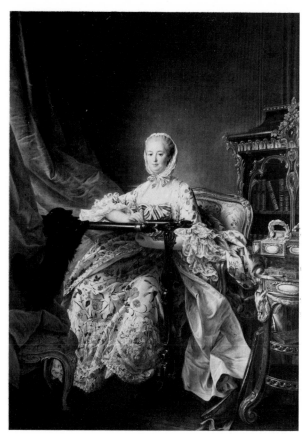

Fig. 13. François-Hubert Drouais, *Madame de Pompadour*, 1763-64, National Gallery, London.

accuracy and executed with great proficiency, not unlike the technical perfection of his great seventeenth-century Dutch models.

Lastly, there are the portraits. The works in this exhibition, some little-known, reveal an eighteenth century concern for truth and naturalism. The kind of ceremonial portraiture established by Hyacinthe Rigaud for Louis XIV in 1701 (Louvre) continued to be imitated throughout the century (no. 72) and even after the Revolution. A less formal and less idealized approach, executed with more dynamism and in warmer hues, was offered by Largillierre (no. 22), who also excelled in the *portrait historié* or allegorical portrait, where the sitter was portrayed in a mythological or literary guise. Jean-Marc Nattier, who had great success at the court of Louis XV, managed to continue the formality of the *Grand Siècle* in a relaxed manner and was courted by the aristocracy for his flattering allegorical portraits (no. 29). The financiers and royal administrators and their wives favored the simpler, more immediate and realistic form of portraiture developed by Aved, which is the direct ancestor of the spectacular *Madame de Pompadour* executed by Drouais in 1763 (fig. 13). Aved showed a canny introspective quality and a mordant sense of observation (no. 30). Conceived in the same vein are the portraits of a good-natured *Madame Saint-Maurice* (no. 31) by Duplessis, Greuze's *Madame Gougenot de Croissy* (no. 32), and David's *J.-F. Desmaisons* (no. 37), all masterpieces of naturalism. But the glamorous fashion of the court was not yet finished and found a last expression in the elegant styles of Mesdames Vigée Le Brun (no. 36) and Labille-Guiard (no. 38). Indeed, as the erotic bandinage of the magnificent gouache by Baudouin (no. 79) reveals, pleasure continued to be the keynote of the life of the leisured society in the Rococo Age.

the Toledo Museum of Art). Later his landscapes gently evoked the naturalistic bravura of Rubens, the twilight dear to Rembrandt, and the skies of Ruysdael (no. 66).

It is interesting to compare Fragonard, the landscapist, to Claude-Joseph Vernet, who specialized in views of ports, "sublime" shipwrecks and romantic moonlit scenes (nos. 63, 64). Everything in Vernet is rendered with great

I. History & Religion

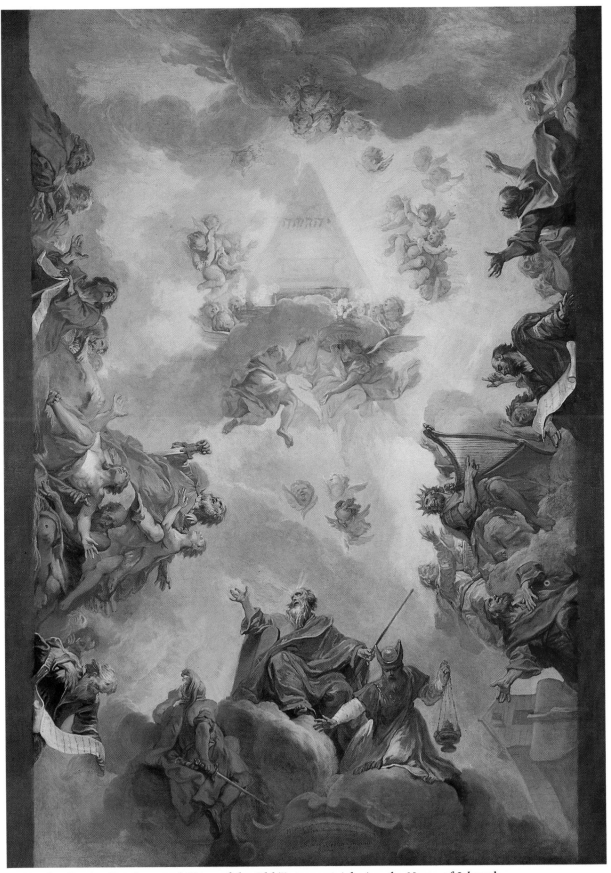

1. Nicolas Bertin, *Prophets and Kings of the Old Testament Adoring the Name of Jehovah*

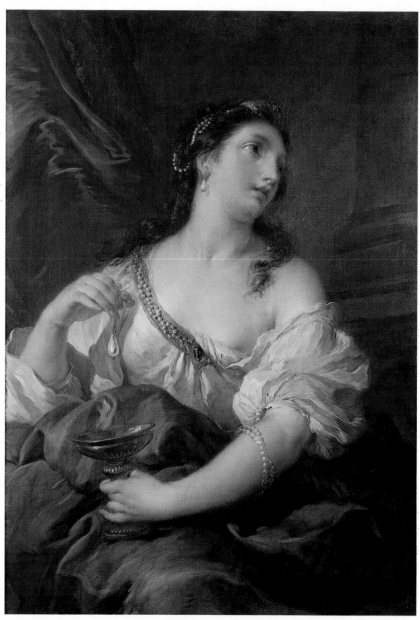

2. François Lemoyne, *Cleopatra*

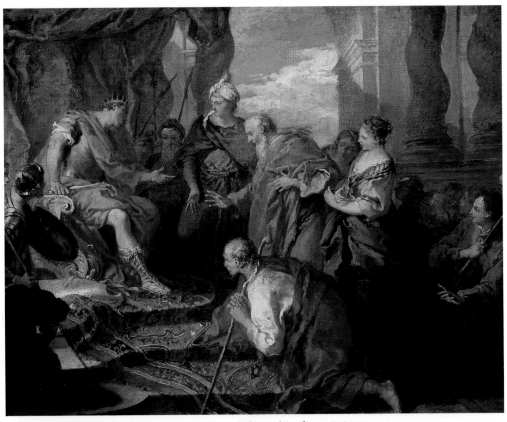

3. François Boucher, *Evilmerodach Frees Jehoiachin from Prison*

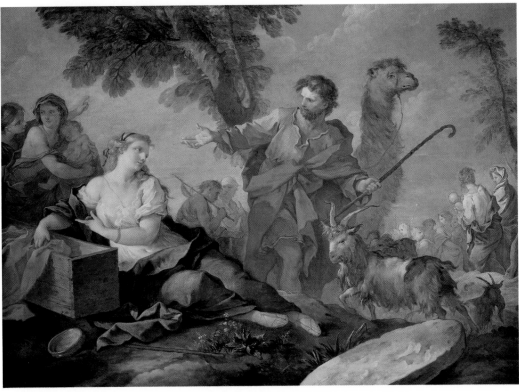

4. Charles-Joseph Natoire, *Jacob and Rachel Leaving the House of Laban*

5. Noël-Nicolas Coypel, *The Rest on the Flight into Egypt*

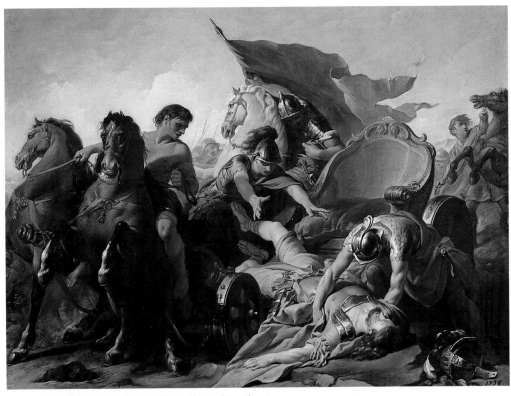

6. Noël Hallé, *Antiochus Falling from his Chariot*

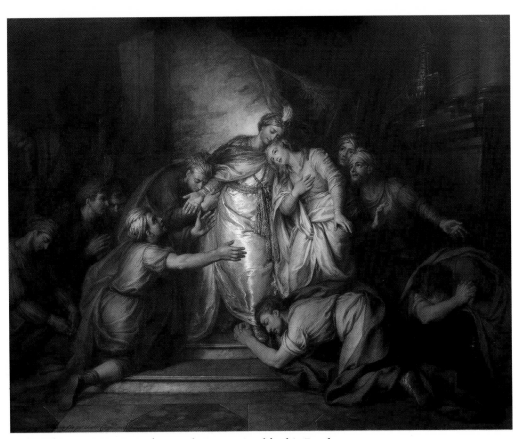

7. Charles-Antoine Coypel, *Joseph Recognized by his Brothers*

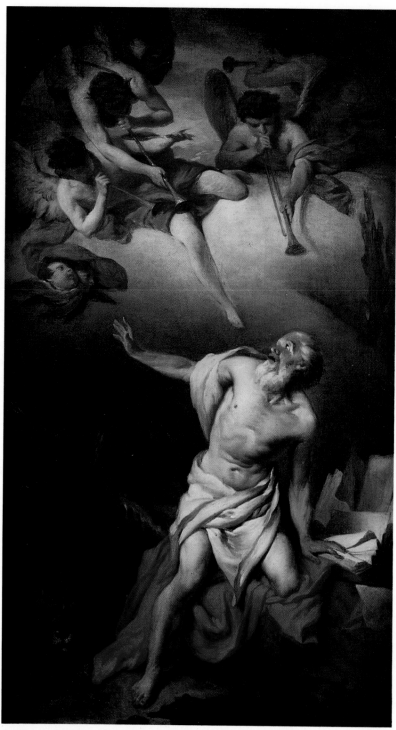

8. Pierre-Hubert Subleyras, *St. Jerome and the Angels*

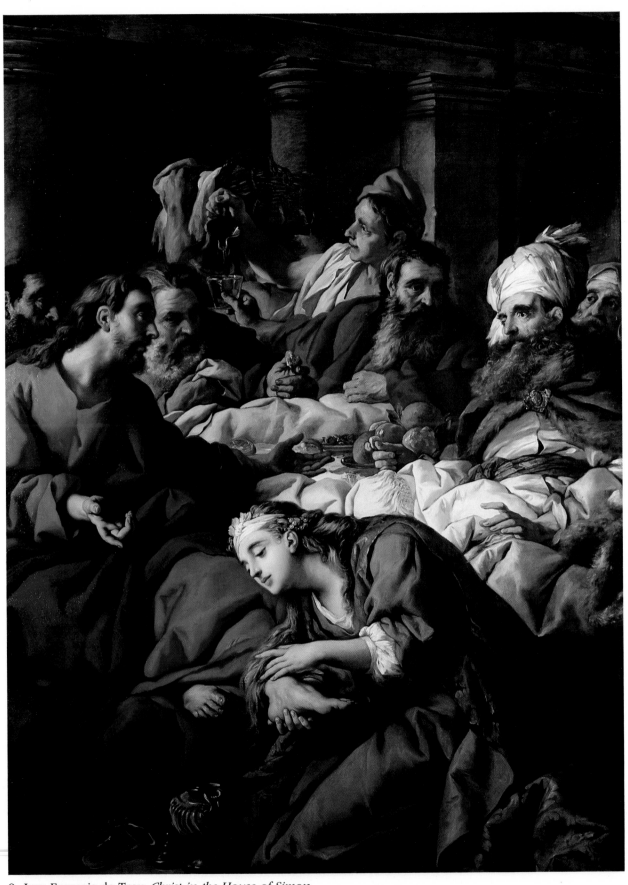

9. Jean-François de Troy, *Christ in the House of Simon*

30

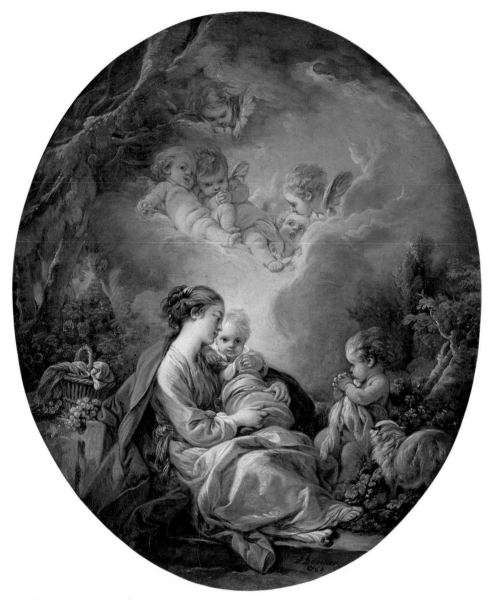

10. François Boucher, *Virgin and Child with Saint John the Baptist*

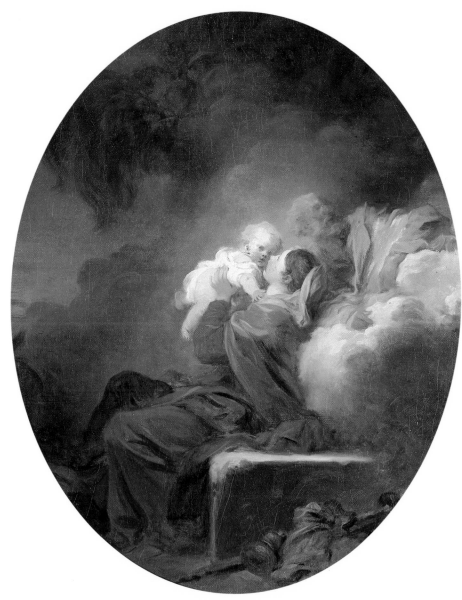

11. Jean-Honoré Fragonard, *The Rest on the Flight into Egypt*

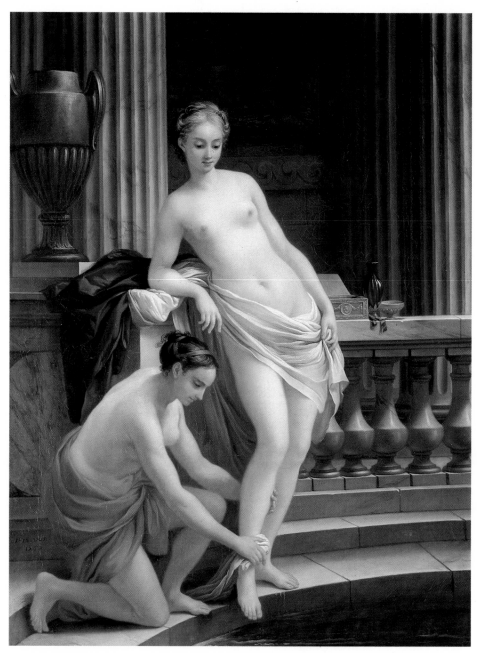

12. Joseph-Marie Vien, *Femme qui sort du Bain (Greek Woman at the Bath)*

Commentaries

Nicolas Bertin, 1668-1736

1. *Prophets and Kings of the Old Testament Adoring the Name of Jehovah,* 1718
Oil on canvas, 51¼ x 37⅞ inches (130 x 94.8 cm.)
Signed at lower edge: *N. Bertin invenit Pinxit*
Inscribed on the cartouche: *Virtutem operum suorum annuntiabit populo suo/videt sic illis hereditatem gentium* (He has proclaimed the power of His works to His people/He has given them the inheritance of the nation)

The Museum of Fine Arts, Houston. Purchase with funds provided by the Laurence H. Favrot Bequest Fund, 1969.

Provenance: Heim Gallery, London, 1969.

Bibliography: Thierry Lefrançois, *Nicolas Bertin, 1668-1736,* Paris, 1981, pp. 53-55, 145-146, no. 74; *The Museum of Fine Arts, Houston, A Guide to the Collection,* Houston, 1981, pp. 65-66, no. 117.

The son of a Parisian sculptor, the history painter Bertin carried on the tradition of large-scale ceiling decoration that he learned from the most important of his teachers, Jean Jouvenet. The four years he spent in Italy as the result of winning the Grand Prix in 1685 were also important in his formation. Following his return, he was *reçu* by the Académie in 1703 for his *Hercules Freeing Prometheus* and in 1705 was made a *professeur* of the Académie. Later, the duc d'Antin offered him the directorship of the French Académie in Rome, but the painter declined. He pursued instead an active international career. Among his major commissions were decorations ordered by Louis XIV for the Ménagerie and Trianon at Versailles, religious paintings for the church of Saint-Germain-des-Prés, and projects for the courts of Munich and Mainz, including the Badenburg of the Nymphenburg Palace.

This brilliant oil sketch is a study for one of Bertin's major religious decorative schemes – the ceiling of the chapel of the château of Plessis-Saint-Pierre, which was painted in 1718 and destroyed in 1827. The painter's biographer Dézallier d'Argenville described the ceiling as "one of the most beautiful works by the artist" and wrote a detailed description of its program. At the center of the composition, angels and cherubim, some with censers, support a pyramid inscribed with the Hebrew name of Jehovah. The Biblical figures shown in adoration of the name are to be read counterclockwise in chronological order from left to right. The group at the left side is dominated by the red – robed figure of Abraham with his son Isaac at his feet. To his right is the prophet Daniel and to his left the bearded figure with the scroll is Isaiah. The group at the lower edge comprises Moses, Aaron, and Joshua. In the corner to their left is the ark of Noah, which appears somewhat out of sequence below King David, on whose other side is the prophet Jeremiah.

According to d'Argenville, the subject of the ceiling was related to Bertin's altar painting of the *Adoration of the Magi,* and thus served to show the infant Jesus as the fulfillment of Old Testament prophecies, exemplified by the quotation in the cartouche from Psalm 111. Bertin's illusionistic ceiling owes a great deal to examples he would have seen in Italy, most notably Pietro da Cortona's in the Palazzo Barberini and Andrea Pozzo's in the Church of San Ignazio that was completed the very year Bertin arrived in Rome.

François Lemoyne, 1688-1737

2. *Cleopatra,* ca. 1725
Oil on canvas, 40½ x 29¼ inches (102.8 x 74 cm.)

The Minneapolis Institute of Arts. The William Hood Dunwoody Fund, 1969.

Provenance: Alberto di Castro, Rome, 1969.

Bibliography: Pierre Rosenberg, "A propos de Lemoyne," *The Minneapolis Institute of Arts Bulletin,* 1971-73, p. 55, ill. 3.

Lemoyne continued the grand French decorative tradition of Le Brun and Charles de la Fosse. He was of humble origin, his father having been a postilion in the service of the king. Following his father's death, Lemoyne's mother married Robert Tournières, a portrait painter who provided his first artistic instruction. He then studied for several years with Galloche. Although he won the Grand Prix in 1711, Lemoyne did not make the journey to Italy. His first large-scale project, in 1715, was the decoration of a church in Amiens. The following year he was *agréé* by the Académie and in 1718 he was *reçu* with a painting of *Hercules and Cacus.* Lemoyne painted *The Transfiguration* in the church of Saint Thomas d'Aquinas, and in 1723 finally went to Italy. Accompanying his patron François Berger, a former *Receveur-général des finances,* Lemoyne worked in Bologna, Rome, and Venice. The influence of Veronese, Parmigianino, and Roman ceiling painting was subsequently seen in his work. Among the projects in which Lemoyne displayed his gifts after his return in 1724 were the Hôtel du Grand Maître at Versailles, the 1727 *Concours,* in which his painting shared first prize with one by Jean-François de Troy, and a chapel of the Virgin at Saint-Sulpice of 1731-32. Following this, Lemoyne began his major creation, the *Apotheosis of Hercules* in the Salon de la Paix at Versailles. After it was completed in 1736, it so delighted the king that he made Lemoyne his *Premier Peintre.* The artist was not to enjoy his success for long. Driven by ambition and despairing over the death of his wife, he fell into madness and committed suicide in 1737.

33

In addition to his large-scale projects, Lemoyne painted many easel works, especially mythological and historical subjects which reveal a sweet and elegant manner that was to be further developed by his two leading pupils, Natoire and Boucher. In these easel works Lemoyne paid particular attention to what the *Mercure de France* described as *"les charmes volup-tueux"* of femininity. Pierre Rosenberg and Jean-Luc Bordeaux have recognized this painting of Cleopatra as a characteristic example of this genre. Rosenberg dates the work to just before the painter's Italian sojourn, and notes the similarity of the figure to those in the *Hercules and Cacus* and a *Tancred and Clorinda* of 1722. Bordeaux, calling attention to the treatment of "the lips, the half-open mouth, the drapery, the pudgy fingers, and the round boneless limbs,"[1] sees an analogy to the *Abduction of Europa* (1725) in the Pushkin Museum and *The Continence of Scipio* (1727) in the Museum of Nancy.

The subject of Cleopatra dissolving a pearl in her wine to show Mark Antony her indifference to riches was especially popular with Venetian artists of the eighteenth century. Several of them visited Paris, and there is a noticeable Venetian flavor to this painting by Lemoyne.

[1]In a letter to Anthony Clark of September 11, 1972, in the files of Minneapolis Institute of Art.

34 **François Boucher,** 1703-1770

3. *Evilmerodach Frees Jehoiachin from Prison,* 1723
Oil on canvas, 22¾ x 28⅝ inches (57.9 x 72.7 cm.)
Signed at lower left edge: *boucher*

Columbia Museums of Art and Science, Columbia, South Carolina. Samuel H. Kress Collection, 1956.

Provenance: Académie Royale de Peinture et de Sculpture, Paris; Private collection, London; Sale, Sotheby's, London, May 20, 1953, no. 99 (as *The Continence of Scipio*); H. D. Molesworth; Samuel H. Kress, 1957.

Exhibition: *François Boucher,* Tokyo Metropolitan Art Museum, and Kumamoto Prefectural Museum of Art, April-August 1982, no. 1.

Bibliography: Ananoff, 1976, I, pp. 3, 162-163, no. 9; Eisler, 1977, pp. 315-316, fig. 281; Ananoff, 1980, no. 9, pl. 1.

Boucher received his first art instruction from his father, a Parisian embroidery designer and minor painter. More importantly, he worked in the studio of François Lemoyne, who at that time was producing historical, mythological, religious, and pastoral compositions in a new, lighter manner much influenced by Venetian art. Although Boucher later declared he had learned little in his few months of apprenticeship, he was clearly marked by the older artist's style. After

leaving Lemoyne's studio, Boucher produced drawings for book illustrations in the shop of the printmaker François Cars. Both his dexterity and his ability to absorb new styles led to his employment on the project of engraving the works of the recently deceased Watteau.

Boucher very quickly gained official recognition as a painter. At the age of twenty, he entered the competition for the Premier Prix of the Académie, and won it with this painting. The subject chosen that year was an incident described in II Kings 25:27 and Jeremiah 52:31: "Evilmerodach, son and successor of Nebuchadnezzar, frees Jehoiachin from the chains in which he had been kept for so long." Jehoiachin, who had become King of Judah at the age of eighteen, was imprisoned in the eighth year of his reign by the Babylonian king Nebuchadnezzar. Thirty-seven years later, Evilmerodach, the new king of Babylon, ordered him freed.

Although there was no precedent for this unusual subject, Boucher was familiar with other scenes of pardon such as the Continence of Scipio or Alexander and the Wives of Darius. Three years earlier, in *The Judgement of Daniel* (the work, now lost, that probably gained him admittance to Lemoyne's studio), he had treated a similar theme. In 1721 he had executed a series of drawings (Louvre) for use in P. Gabriel-Daniel's *Histoire de la France,* several of which show scenes of supplication. Ruch, who first attributed these drawings to Boucher,[1] and Eisler and Ananoff following his lead, have singled out drawing no. 25174 as particularly close. However, *Requête des Huguenots preséntée au roi par l'amiral d'Andelot,* no. 25176 (fig. I.1), seems even closer, since it shows the seated crowned monarch holding a mace, in a pose very similar to Evilmerodach's in this painting.

[1]John E. Ruch, "An Album of Early Drawings by François Boucher," *The Burlington Magazine,* July 1954, p. 206.

Fig. I. 1

Charles-Joseph Natoire, 1700-1777

4. *Jacob and Rachel Leaving the House of Laban,* 1732
Oil on canvas, 39½ x 56 inches (103 x 142.3 cm.)

High Museum of Art, Atlanta. Purchase, 1983.

Provenance: Louis-Antoine de Gondrin de Pardaillan, duc d'Antin (d.1736) from 1732; Eglise de Saint-Antoine, Compiègne, sold in 1857; M. de Laporte, Senlis; Private Collection, New York.

Bibliography: F. Boyer, "Catalogue raisonné de l'oeuvre de Charles Natoire," *Archives de l'Art Français,* 1949, p. 34, under no. 3, and p. 63, no. 235 (as lost); Patrick Violette, "Chronologie," *Charles-Joseph Natoire,* exhibition catalogue, Troyes, Nîmes, Rome, 1977, p. 41.

Natoire received his first training from his father, an architect and sculptor in Nîmes. He went to Paris in 1717 to continue his studies, working first with Galloche and then with Lemoyne. He won the Grand Prix de Rome in 1721 for his *Sacrifice of Manoah,* enabling him to stay at the French Académie in Rome from 1723 to 1729. The director Vleughels was impressed by Natoire's talent and had him copy works by Veronese and Pietro da Cortona. Natoire was awarded the first prize of the Accademia di San Luca in 1725 for his drawing *Moses Descending from Mt. Sinai.*

Not long after his return to France, Natoire was *agréé* in September 1730 as a history painter. In 1731, he painted two works devoted to the history of Clovis (Musée de Troyes) for Philibert Orry, the newly appointed *directeur des bâtiments,* who was trying to revive interest in subjects taken from French history. Even before being *reçu* by the Académie in December 1734, Natoire received a royal commission for allegorical subjects for the rooms of the queen at Versailles. Boucher was *reçu* in the same session and both artists received the status of *professeur* in 1735. Boucher and Natoire had similar styles and conducted a friendly rivalry, collaborating on a number of major decorative schemes at royal and aristocratic residences. Most notable was the Hôtel de Soubise, in which the *Histoire de Psyché,* painted by Natoire in the *Salon ovale* between 1737 and 1739, represents the epitome of a rococo interior in its architecture, *boiserie,* and painting. Natoire's decorative skills were also displayed in drawings for the Gobelins and Beauvais tapestry manufacturers. His *Histoire de Don Quichote,* for Beauvais, is particularly distinguished.

Natoire exhibited frequently at the Salons, primarily with mythological subjects, but also on occasion with a portrait such as his 1749 likeness of the dauphin. In 1751, he was appointed director of the Académie de France at Rome, replacing J.-F. de Troy. This was a great honor and for a short period the artist continued to be highly regarded in France. In 1753, for example, the Marquis de Marigny, *directeur des bâtiments,* requested a nude subject by Natoire to go with paintings by van Loo, Boucher, and Pierre that he had already installed in his *cabinet particulier.* Natoire complied

with a *Leda and the Swan.* In 1756, he was ennobled by the king for his painting of the ceiling of the church of San Luigi dei Francesi in Rome, but gradually his reputation went into eclipse. Following administrative problems at the Académie de France and the departure of Marigny, Natoire was forced to resign his post in 1775. He remained in Italy, however, residing at Castelgandolfo. He had outlived his era, but his sweet elegant style was adapted for more modern tastes by students of the next generation such as Pierre and Vien.

The High Museum's painting is from one of Natoire's earliest decorative schemes, and was one of the three paintings (for which the artist received 850 *livres* on December 10, 1732) commissioned by the influential duc d'Antin for his Paris hôtel. The other two paintings are *The Meeting of Jacob and Rachel at the Well* (fig. I.2, private collection, New York), which forms a pendant to the High Museum's painting, and *Hagar and Ishmael in the Desert* (fig. I.3, Louvre). Lemoyne, who had previously worked for the duc d'Antin, may have recommended his former student for this commission. The young artist responded by producing paintings of entrancing delicacy and refinement.

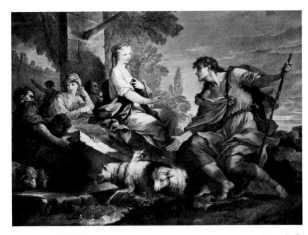

Fig. I. 2

Fig. I. 3

The story of Jacob had long been an attractive one for artists, because of the opportunities for painting caravans, landscapes, animals, and lovely women. The subject is taken from Genesis 31, especially verse 17, in which "Jacob arose and set his sons and his wives on camels and he drove away all his flocks." Natoire depicts the commanding figure of Jacob and his two wives, Rachel and Leah, as well as their serving women (by whom Jacob also had children). Prominence is given to the mottled goat which represents the large flock that Jacob, despite the machinations of his father-in-law Laban, was able to breed. A preliminary drawing at the Musée de Strasbourg (fig. I.4) shows the composition already well established.

The fluency of Natoire's brushwork, the bright palette, and even the composition reveal his study of Pietro da Cortona. But Natoire was probably also aware of the style of contemporary Italian painters such as Pellegrini and Sebastiano Ricci, both of whom passed through Paris.

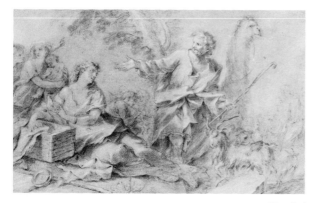

Fig. I. 4

Noël-Nicolas Coypel, 1690-1734

5. *The Rest on the Flight into Egypt,* 1724
Oil on canvas, 39 x 28¼ inches (99 x 71.5 cm.)
Signed and dated lower right: *N. Coypel f. 1724*

Mr. and Mrs. Arthur Frankel, New York.

Provenance: Fröhlich Collection, Vienna, 1936; Barbara B. von Goetz, 1969.

Bibliography: David Lomax, "Noël-Nicolas Coypel (1690-1734)," *Revue de l'Art*, 1982, p. 42, fig. 24.

Noël-Nicolas Coypel was born in Paris, the son of the painter and Director of the Académie Noël Coypel (1628-1707). Antoine Coypel (1661-1722) was his half-brother and Charles-Antoine Coypel (1694-1752) was his nephew. His own career as a painter must have seemed predetermined, and he was *agréé* in 1716 with his *Transfiguration* and became a full *académicien* in 1720 with the presentation of his *Neptune Abducting Amymone* (Musée des Beaux-Arts, Valenciennes). He competed in the *Concours* of 1727, ordered

by the king, who offered a substantial cash prize to the winner. Although many critics judged Noël-Nicolas's *Abduction of Europa* (Philadelphia Museum of Art) the most beautiful work, it did not win. The prize was instead shared by Lemoyne and J.-F. de Troy. To compensate, a *secretaire d'état*, the comte de Morville gave Coypel the same amount the king had promised. Coypel went on to become a *professeur* at the Académie in 1733. In his short career, the artist produced mythological paintings, and also worked for many churches in Paris, Versailles, and Chantilly. His major creation was the altarpiece and cupola decorations painted in 1731 for the chapel of the Virgin in the Church of Saint-Sauveur, Paris, which were destroyed in 1776.

The original location of this *Rest on the Flight* is unknown, as is that of the *St. James the Great and the Magician* of 1726 (Cleveland Museum). Both of these paintings have a powerful dramatic quality. The types used for the bearded figures of St. Joseph and St. James and for the infants are nearly identical in the two works. The violence of the action in the *St. James* is equalled by the brooding solemnity of the *Rest on the Flight*. Since Noël-Nicolas never made the trip to Italy, his sources are to be sought in earlier French painting. The work has a certain Poussinesque grandeur, and the impressive seated St. Joseph is not unlike the figure of God the Father in Noël Coypel's *Vision of a Saint* (Lisbon).[1] In both the Cleveland *St. James* and this *Rest on the Flight*, Coypel uses a background with architectural structures. Here the three distinctive buildings may be a reference to the three traditional eras of history – pagan, Jewish, and Christian.

[1] Reproduced in Antoine Schnapper, *Jean Jouvenet*, Paris, 1974, fig. 226.

Noël Hallé, 1711-1781

6. *Antiochus Falling from his Chariot,* ca. 1738
Oil on canvas, 39¼ x 53½ inches (85.5 x 135 cm.)
An old inventory number inscribed at lower right corner: *1798*

Virginia Museum, Richmond. The Williams Fund.

Provenance: Private collection, Sweden; Heim Gallery, London, 1977.

Bibliography: David Lomax, "The Early Career of Noël Hallé," *Apollo*, February 1983, p. 105, fig. 1.

Both Hallé's father and grandfather were painters and, although he first studied architecture, he eventually followed in their footsteps. An important influence on him was the history painter Jean Restout, who had become his brother-in-law in 1729. Hallé competed unsuccessfully for the Prix de Rome in 1734 and won in 1736, departing for Rome late in 1737. Supervised by the Académie's *directeur*, Jean-François de Troy, he copied frescoes by Raphael in the Stanze and painted

his own historical and biblical compositions before returning to France in 1744. He had a distinguished career as a dedicated *académicien*, being *agréé* in 1746 and *reçu* as a history painter in 1748 with his *Dispute of Minerva and Neptune over the Naming of the City of Athens*. He was appointed a *surinspecteur* of the Gobelins manufactory, then *professeur* of the Académie, and was sent to Rome to reorganize the Académie there. He was awarded the Order of Saint-Michel by the king and in 1781 became *recteur* of the Académie. In addition to the history paintings which made his reputation, Hallé also painted portraits and genre subjects.

Antiochus Falling from his Chariot, painted in Rome, is Hallé's earliest known surviving work. He made an etching after it in 1739. The year before, he had made an etching after its now-lost pendant, *Antiochus after his Fall Dictates his Will* (fig. I.5). The subject is taken from the Apocrypha, II Maccabees, ch. ix, which relates how King Antiochus IV of Syria (175-164 BC), on his way to massacre the Jews, "gave order to his charioteer to drive without ceasing.... But it came to pass that he fell from his chariot as it rushed along, and having a grievous fall was racked in all the members of his body."

As David Lomax has pointed out, the composition was closely based upon the 1735 reception piece by Dandré-Bardon of *Tullia Driving her Chariot over the Body of her Father*, which Hallé undoubtedly studied. Certainly the rearing horses and the fallen man are extremely close. Hallé's innovation was to give prominence to the empty chariot, which serves as a potent visual exemplar of evil power unseated. The fluent handling of the paint and the bright tonality recall the style of Jean-François de Troy. After he returned to France, Hallé's works lost some of their brilliance and richness of coloration.

Fig. I. 5

Charles-Antoine Coypel, 1694-1752

7. *Joseph Recognized by his Brothers,* 1740
Oil on canvas, 50½ x 63½ inches (128 x 162 cm.)
Signed and inscribed at the lower left edge: *Peint pour la seconde fois par Charles Coypel avec beaucoup de changements, 1740*

Mr. and Mrs. Morton B. Harris, New York.

Provenance: Sale of the Coypel de Saint-Philippe collection, Paris, June 11, 1777, no. 25; Trevelyan Turner, London; Walker Art Center, Minneapolis; Sale, Parke-Bernet, New York, October 22, 1970, no. 52.

Exhibitions: Salon of 1741, Paris; University of California, Los Angeles, March-April 1961.

Bibliography: Antoine Schnapper, "Le Chef-d'oeuvre d'un muet ou La Tentative de Charles Coypel," *La Revue du Louvre*, 1968, pp. 259-260, fig. 6.

Charles-Antoine Coypel was the son of Antoine Coypel (1661-1722), the highly respected *Premier Peintre du Roi* and *directeur* of the Académie. He also pursued an artistic career and succeeded to the same positions in 1747. A precocious student, he was *reçu* at the age of twenty-one with his exuberant *Departure of Medea*. The following year, 1716, he began his important career as a designer of tapestry cartoons for the Gobelins factory, with the first of a series of twenty-eight Don Quixote subjects that was completed in 1751. Charles-Antonie was also called upon to complete tapestry design projects left unfinished by his father. These included a series from the *Iliad* and one from the Old Testament – for which his painted cartoon *Joseph Recognized by his Brothers* was exhibited at the Salon of 1725. His cartoon of the *Sacrifice of Iphigenia* was so well received in 1730 that the duc d'Antin had it shown in the apartment of Louis XV at Versailles and presented Coypel to the king and queen. Coypel soon became the favorite painter of the queen, Maria Leczinska, and painted many works for her private apartments at Versailles and Compiègne. In 1727, at the *Concours* organized by the duc d'Antin, Coypel showed perhaps his most renowned painting, *Perseus Rescuing Andromeda*, which was acquired for the king and is now in the Louvre.

The young artist's grandiose manner was inspired by his other chief interest, the theater. Coypel began a second career as a playwright in 1718, writing both comedies and tragedies. His plays met with only limited critical success, but several were performed before the royal family. His passion for the theater is reflected in many other areas of his work, such as his portraits of the famous actress Adrienne Lecouvreur and a series of impressive paintings based upon the tragedies and operas of Racine, Corneille, and Quinault, as well as works in the satirical vein of Molière.

37

Even Coypel's various religious subjects are conceived in a highly theatrical manner. At the Salon of 1737 he showed a vividly dramatic *Joseph Accused by Potiphar's Wife*. Three years later, he painted *Joseph Recognized by his Brothers*, which he showed in the Salon of 1741. His somewhat ingenuous inscription on the painting is intended to point out his originality. Schnapper has drawn attention to a tragedy entitled *Joseph* by the abbé Genest, which was performed in 1710 and 1711, in which this recognition scene based on the account in Genesis 45 was the high point of the last act. Whether or not Coypel was inspired by this play, his painting (especially compared to his earlier treatment) has the look of a stage tableau. As a contemporary reviewer noted:

> The principal figures, Joseph and Benjamin, are strikingly illuminated by a burst of light from the back which focuses on them and imparts an inexplicable glow. This group is appealing and notable for its contrast with the large area of shadows which engulfs by degrees the other brothers, and contrasts with the lively, sparkling color he has given to the garments of the central pair. Finally there are few paintings in which the chiaroscuro is more successfully handled. Especially fine is the way in which Joseph and Benjamin are united skillfully by a spirited embrace in a most theatrical manner that allows us to observe all of their action. On these two noble faces we can easily read their emotions; the tender surprise of one and the generous sensitivity of the other. One perceives the tears they are about to shed and the contrasting emotions behind them. The other brothers of Joseph are suitably distributed in enchanting poses. Everything about the painting is vivid and despite the contrasts it has a wonderful harmony.[1]

[1]*Lettres à M. de Poiresson Chamarde... au sujet des tableaux exposés au Salon du Louvre*, Paris, 1741, pp. 29-30.

Pierre Subleyras, 1699-1749

8. *St. Jerome and the Angels*, 1739
Oil on canvas, 29¾ x 17½ inches (75.6 x 44.5 cm.)

Channing Blake, New York, New York.

Provenance: C. Molesworth, London; Sale, Sotheby's, London, April 4, 1962, no. 22.

Subleyras's father, a painter at Uzès, sent his son to be trained in the studio of Rivalz at Toulouse. Subleyras soon became a collaborator with Rivalz on various works, including a depiction of the coronation of Louis XV. Having mastered the painting of religious subjects as well as portraiture, Subleyras was ready in 1726 to move to Paris. The next year, at the age of twenty-five, he won the Grand Prix de Rome for his *The Brazen Serpent* (Louvre). This allowed him to go to Rome, where he was to live the remainder of his life. His first residence was at the French Academy in the Palazzo Mancini. It was then under the rigorous direction of the painter Vleughels, who set Subleyras to copying works by Raphael, the Carracci, and Pietro da Cortona. Through the intercession of the Princess Pamphili and the Duchess of Uzès, he received an extension of his stay. Settling in Rome, he received several important commissions, including a *Descent of the Holy Spirit* for the duc de Saint-Aignan (Musée de la Légion d'Honneur, Paris) and, for the refectory of the Order of Saint-Jean de Latran, an enormous *Christ in the House of Simon* (Musée du Louvre) in 1735, which won him great fame.

In 1739, he married the miniature-painter Felice Maria Tibaldi, the daughter of a well-known musician and sister-in-law of the painter Trémollières, who also went to Rome in 1728. Presumed portraits of his wife are in the Worcester Museum and the Walters Art Gallery. Cardinal Valenti Gonzaga, a counselor of the pope, became Subleyras's protector and was the first of an important line of sitters – culminating with the pope – who made Subleyras the most fashionable portrait painter in Rome.

Commissions for religious paintings continued to come from both France and Italy. In 1741, he painted a *Holy Family* for the Church of Saint-Etienne in Toulouse. Probably his most famous works were two

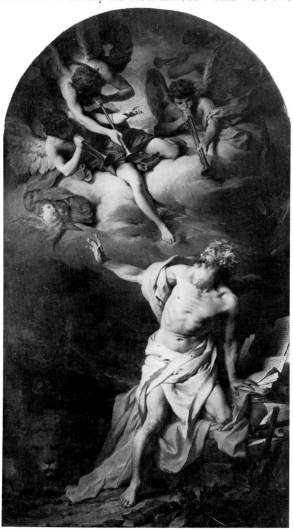

Fig. I. 6

1744 altarpieces for the Olivetan Church of Monte Morcino Nuovo in Perugia: *St. Benedict Reviving a Peasant* (Santa Francesca Romana, Rome) and *St. Ambrose Absolving Theodosius* (Perugia Museum). In his final year, he was most occupied with the completion of a *Mass of St. Basil* for St. Peter's which was executed in mosaic. Subleyras also painted some genre subjects and a self-portrait of disarming directness. A master of the classical tradition, he created compositions with a noble clarity and a subtle range of sombre colors.

Among the many commissions Subleyras received from Italian churches and religious orders was one for the Church of Saints Cosmos and Damien in Milan, for which he executed two altar paintings – a *St. Jerome with Angels* which he signed and dated *Petrus Subleyras Gallus fecit Romae 1739* (fig. I.6)[1] and a *Christ on the Cross with Saints* of 1744. Since 1809 both paintings have been in the Brera Museum in Milan.

The subject of St. Jerome and the Angels of Judgement derives from the saint's account of his vision at Antioch in 374 when, asked to identify himself, he was accused of not yet being a true Christian. In the seventeenth century, especially in the works of Ribera, the pattern had been established of depicting the saint at this moment as an old gaunt hermit with his attributes, the lion and the manuscripts he used for his translation of the Bible into Latin.

Like many eighteenth-century masters, Subleyras prepared for his major paintings by executing preliminary oil sketches. These remarkably spontaneous works were recognized as masterpieces at the time and they have remained popular. This sketch for *St. Jerome* shows greater freedom than the finished painting and omits some details, such as the roughhewn cross and the lightning. The frenzied surprise of the saint at the sound of the trumpeting angels, however, is vividly portrayed.

[1]Noted in d'Argenville, IV, p. 454; Also see Odette Arnaud, "Subleyras," in Dimier, 1930, II, pp. 63 and 78, no. 3.

Jean-François de Troy, 1679-1752

9. *Christ in the House of Simon,* 1743
Oil on canvas, 76¾ x 57½ inches (195 x 146 cm.)
Signed at lower left on the base of the urn: *1743 De Troy à Rome*

The Chrysler Museum, Norfolk. Gift of Walter P. Chrysler, Jr.

Provenance: The artist's estate sale, Paris, April 9, 1764; Frances Lady Ashburton; Sale, Christie's, London, December 16, 1949, no. 18; Leger Gallery, London; Newhouse Galleries, New York, 1954; Walter P. Chrysler, Jr.

Bibliography: Daniel Ternois, "En marge du 'Jugement de Solomon' de Jean-François de Troy," *Bulletin des Musées et Monuments Lyonnais*, 1978, pp. 128 and 129, fig. 7.

The son of François de Troy, a distinguished portrait painter and *directeur* of the Académie Royale, Jean-

François only gradually came to devote himself to painting. He became a *pensionnaire* at the Académie in Rome and with this training – and his father's influence – he was both *agréé* and *reçu* as a history painter in 1708. His *morceau de reception* was a *Death of the Children of Niobe* (Montpellier), but at this phase of his career his finest works were a series of *tableaux de modes*, fashionable genre scenes of upper class society such as *The Reading From Molière*, 1710 (Marchioness of Cholmondely collection).

De Troy was a versatile artist and in the 1720s produced such diverse works as *The Plague in Marseilles* (1722) and a *Group Portrait of the Officials of Paris* (1726). At the Salon of 1725, where his work was first widely exhibited, he showed seven paintings ranging from mythological to genre subjects. Two years later, he was one of the artists chosen to compete in the *Concours* organized by the duc d'Antin for a special prize offered by the king. De Troy's *Repose of Diana* shared first place with Lemoyne's *Continence of Scipio*, marking the beginning of a keen rivalry for important commissions in the following years. Among the projects undertaken by de Troy were scenes from the life of Saint Vincent de Paul for the Maison de Saint Lazare, a series of mythological subjects for François duc de Lorraine, and in 1736 a set of tapestry cartoons for the Gobelins factory. For the royal family, he painted an *Allegory of the Children of Louis XV* for the queen's private rooms, and for the dining rooms at both Versailles and Fontainebleau de Troy painted several fine scenes of hunting and feasting. It was Lemoyne, however, who was named *Premier Peintre du Roi* in 1736. Two years later, following the death of Vleughels, de Troy reluctantly accepted the post of *directeur* of the Académie Royale à Rome, a position he retained until the last year of his life. Although he never returned to France, he continued to send his works for exhibition at the Salon.

During this period in Rome, de Troy developed a grandiose style suitable for the commissions he received for large-scale projects. This style was based in part on French masters such as Jouvenet and Subleyras and, following a trip to Naples in 1742, on Italian baroque painters such as Preti, Solimena, and Luca Giordano. For King Christian VI of Denmark he executed a series of mythological subjects and for Cardinal de Tencin of Lyon produced a set of six life-size paintings, divided into three pairs: two subjects of ancient history, two from the Old Testament, and two from the New Testament. Engravings exist of only the first two pairs, and not for the lost New Testament paintings, *Christ and the Adulterous Woman* and *Christ and the Samaritan Woman*. They have on occasion been identified as the pair of paintings now in the Chrysler Museum. These, however, are probably a different pair, described in the artist's estate sale of 1764 as a "Feast in the house of Simon of eight figures" and a "Jesus and the Canaanite Woman of nine figures." The

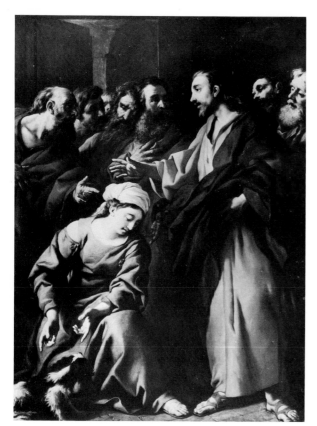

Fig. I. 7

40 latter is definitely the subject of one of the Chrysler paintings (fig. I.7), for it is traditionally distinguished by the presence of the dog.

The incident depicted in the painting which is exhibited here – *Christ in the House of Simon* – is recounted in all four gospels. In Luke 7:36 the host is called Simon the Pharisee and in the others Simon the Leper. While Christ ate with Simon, a sinful woman entered with an alabaster jar of ointment. She washed Christ's feet with her tears, then dried them with her hair and applied the ointment. This horrified Simon and the disciples, who thought the money spent on the ointment could be better used to feed the poor, but Christ chided them, saying, "The poor you will always have with you, but me you will not always have."

The closely packed composition, the bearded figures in turbans, and the architectural background in de Troy's painting all suggest that he was inspired by Jouvenet's monumental 1706 painting of the same subject for the Church of Saint-Martin-des-Champs in Paris (now in Lyon). The date on the *Christ in the House of Simon* has traditionally been read as 1748, but a recent cleaning had revealed that it is actually 1743. The two Chrysler pictures are thus from the same period as the Tencin works and with that lost pair of New Testament paintings comprise a fascinating group devoted to Christ's encounters with fallen, bereaved, and outcast women.

François Boucher, 1703-1770

10. *Virgin and Child with Saint John the Baptist,* 1765
Oil on canvas, 16⅛ x 13⅝ inches (41 x 34.6 cm.)
Signed and dated lower right: *f. Boucher/1765*

The Metropolitan Museum of Art, New York. Gift of Adelaide Milton de Groot in memory of the de Groot and Hawley families, 1966.

Provenance: Chariot Collection, Paris; A. J. Paillet, Paris; Sale, Paris, January 28, 1788, no. 56; Sale, London, March 3, 1848, no. 31; Joseph R. Bowles, Portland, Oregon; his daughter, Mrs. William H. Hollis, San Francisco, until 1959; Wildenstein and Co., 1959-1965; Adelaide Milton de Groot, New York, 1965-1966.

Exhibition: *François Boucher*, Wildenstein and Co., New York, 1980, no. 32.

Bibliography: Ananoff, 1976, II, no. 617, fig. 1639; Idem, 1980, no. 632.

Beginning in 1728, Boucher spent three years in Italy, in and out of the company of Carle, François, and Louis van Loo, Charles Natoire, and Nicolas Vleughels. He also studied the works of the Italian baroque artists Castiglione and Pietro da Cortona. Boucher returned to Paris in 1731 and was *agréé* by the Académie. He was *reçu* as a history painter in 1734 for his *Rinaldo and Armida* (Louvre) and was appointed *professeur* in 1737. He exhibited in all genres at the Salons from the mid-1730s until 1769. After 1735, under the patronage of Madame de Pompadour, Boucher became the leading decorator of royal palaces and private residences. He enjoyed immediate success with the first of his many designs for tapestries, the *Fêtes Italiennes*, produced by the Beauvais manufactory in 1736. In 1755, he was appointed director of the tapestry works at Gobelins. Boucher also contributed designs to the Sèvres and Vincennes porcelain factories, created book illustrations, and designed theater and opera sets.

In 1765, Boucher was appointed *directeur* of the Académie and *Premier Peintre du Roi*. The same year, he produced this small painting, which reveals how far his style in the treatment of a religious subject had evolved since the early *Evilmerodach* (no. 3). Despite their rococo charm, Boucher's few religious works reflect the pietistic attitudes of Madame de Pompadour and her circle.

Diderot, usually a severe critic of Boucher, wrote in his review of the painter's *Nativity*, exhibited at the Salon of 1759, that although it had "false, gaudy coloring…the Virgin is so beautiful, so tender, so touching…It is impossible to imagine anything finer or more roguish than the young St. John…as well as more animated, cheerful, and lively than the angels or a more lovely Christ child."[1] The same is certainly true of this later work in the Metropolitan. Boucher manages to weave into his composition such traditional iconographic details as the lamb of St. John and the eucharistic grapes, which here seem part of a picnic

luncheon. The serene intimacy of the mother and two children within the oval format was employed by Boucher four years later for a secular *Idyllic Scene* (now in the Walters Art Gallery, Baltimore).

[1] Seznec and Adhémar, I, 1957, pp. 68-69.

Jean-Honoré Fragonard, 1732-1806

11. *The Rest on the Flight into Egypt,* ca. 1750
Oil on canvas, 21⅝ x 17¾ inches (55 x 45 cm.)

Yale University Art Gallery, New Haven. Lent by the Barker Welfare Foundation.

Provenance: Oger de Brearf; Sale, May 17-22, 1886, no. 19; Charles Pillet; Chevalier collection; Mme. Feuillet; Henri Rouart; Sale, Paris, December 10, 1912; Ernest Rouart; Wildenstein and Co., New York, Mr. and Mrs. Charles V. Hickox.

Bibliography: G. Wildenstein, 1960, p. 196, no. 22, fig. 13; D. Wildenstein and Mandel, 1972, p. 86, no. 23.

Born in Grasse in 1732, Jean-Honoré Fragonard came to Paris with his family at an early age. Though he was apprenticed to a notary, his parents recognized his inclinations toward art and arranged to have him enter the studio of Chardin. Soon after, about 1747, he entered the studio of Boucher, where he was to become that master's most promising protégé.

Boucher encouraged Fragonard toward a conventional accademic career as a history painter. At his teacher's insistence, Fragonard competed for the Prix de Rome, which he won in 1752 with his *Jereboam Sacrificing to the Idols* (Ecole des Beaux-Arts, Paris). He then spent three years in the Ecole Royale des Elèves Protégés, where Carle van Loo was director and where he was influenced by Nicolas-Bernard Lépicié. By late 1755, when Fragonard departed for Rome, he had received a thorough academic training and achieved a considerable reputation.

Rome proved an especially fertile experience for Fragonard. Charles Natoire, director of the Académie in Rome, granted the artist two extensions beyond the normal three-year study period. Fragonard copied the works of Tiepolo, Pietro da Cortona, Solimena, and Giordano, and seems to have been particularly influenced by his contemporary Jean-Baptiste Greuze during that artist's trip to Italy. He spent a half-year travelling through the countryside and major cities of Italy in 1761. Particularly important was his association with the abbé de Saint-Non; on their visit to the Villa d'Este, Fragonard made many landscape and architectural studies that were to be incorporated into his paintings.

Upon his return to France, Fragonard sought official recognition. In 1761, he was *agréé* with the presentation of the large *Corésus et Callirhoé*, which was shown at the Salon of 1765. On the verge of success, Fragonard voluntarily withdrew from the official scene. He never submitted a reception piece to the Académie, nor did he exhibit at the Académie's Salons after 1767. Following the success of his famous *Swing*, painted for the Baron de Saint-Julien, he concentrated on private commissions; these ranged from sensual *scènes galantes* to sentimental and moralistic genre pieces. As taste changed, Fragonard's popularity declined, symbolized by Madame du Barry's rejection of his 1771-73 *Progress of Love* series (The Frick Collection). Fragonard, however, was to enjoy considerable success among middle-class patrons until the Revolution, and afterward served the new regime as an official on the museum commission and was appointed by David to be curator of the Muséum des Arts in 1793.

Fragonard's few religious works date from the first part of his career, when he copied paintings by earlier masters. For example, there are several versions, including one that belonged to Boucher, of the *Virgin and Child* after the painting by Rembrandt (now Hermitage) which was then in Crozat's collection. There are also several versions of *The Rest on the Flight into Egypt*. Another nearly identical oval one, perhaps a bit more finished in details, is in the Baltimore Museum; a sketchier rectangular version with somewhat different poses is in the Musée des Beaux-Arts, Troyes. An oval watercolor version (Blumenthal Collection, Ananoff, no. 1773), similar in composition to the two oval paintings, was shown at the Salon de la Correspondance of 1781, but probably dates from earlier, as it became Fragonard's practice to exhibit older works. The combination of exuberance and intimacy found in this composition, however, is typical of Fragonard throughout his career.

41

Joseph Marie Vien, 1716-1809

12. *Femme qui sort du Bain (Greek Woman at the Bath,* 1767
Oil on canvas, 35½ x 26½ inches (90.2 x 67.3 cm.)
Signed and dated at lower left: *j.m. vien, 1767*

Museo de Arte de Ponce, Puerto Rico. The Luis A. Ferré Foundation.

Provenance: Duc de Choiseul; Sale, Paris, April 6-10, 1772, no. 137; Servatius Sale, 1854; Rhône Sale, 1861; Sir George Roberts; Mme. Elisa Doucet; Sale, Sotheby's, London, June 19, 1957, no. 188.

Exhibition: *France in the Eighteenth Century*, Royal Academy of Art, London. 1968, no. 705.

Bibliography: Thomas Gaehtgens, "Oeuvres de Vien," *Etude de la Revue du Louvre*, 1980, pp. 77-78, fig. 10.

Vien's lengthy career encompassed training in the decorative rococo style of Natoire, developing a neo-classical manner highly sought after by such notable patrons as Madame du Barry and the duc de Choiseul, becoming the mentor of David, and ultimately being made a Count of the Empire by Napoleon. Vien was born in Montpellier and was in Paris by 1740. He won the Grand Prix in 1743 and went to Rome the next

Fig. I. 8

year. His stay in Italy extended until 1750 and was of the utmost importance for his future development. On one hand, he discovered the seventeenth century Italian masters of *ténébrism* such as Mola and Guercino, and, on the other, the contemporary artists Batoni and his own compatriots J.-F. de Troy and Subleyras, who painted heroic religious subjects. These diverse styles are reflected in works such as *The Sleeping Hermit* (1750), which he exhibited at the Salon of 1753, and in the large paintings for the Church of Sainte-Marthe in Tarascon (1747-51), which mark the beginning of a series of large-scale religious works that continued into the 1760s. However, the style that was to make the artist fashionable derived from familiarity with the discoveries at Herculaneum and Pompeii, which he was probably encouraged to study in engraved form by his antiquarian friend, the comte de Caylus. This nascent neo-classicism can already be detected in the *Daedalus and Icarus* with which the painter was *reçu* by the Académie in 1754.

Vien's *style à la grecque,* as it was called, reached its apogée in 1773, when Madame du Barry commissioned a series of paintings on the theme of love for her château at Louveciennes, to replace those by Fragonard (now Frick Art Museum) that she had rejected.

A gifted teacher, Vien was appointed director of the Ecole des Elèves Protégés in 1771 and four years later was sent to Rome to head the Académie de France. He brought with him his most talented pupil, David, who was later to deliver Vien's eulogy. Following the death of Pierre in 1789, Vien was named director of the Académie and *Premier Peintre du Roi.*

Vien's *style à la grecque* made its first full-fledged appearance in the Salon of 1761 when he exhibited a *Greek Girl decorating a Bronze Vase with Garlands of Flowers.* Diderot admired its "purity of design, great simplicity in the drapery, and infinite elegance of the figure" but concluded that the work seemed more like a bas-relief than a painting.[1] Two years later, all of Vien's entries in the Salon were in this style, and Diderot was full of admiration for their "elegance, grace, ingenuity, innocence, delicacy, simplicity, and purity of design." For the painting *Femme qui sort du Bain,* which he noted the duc d'Orléans had purchased during the course of the exhibition, he had but one word: "exquisite."[2] This painting was engraved by Glairon.[3] It was apparently admired by the duc de Choiseul, who in 1767 commissioned from Vien a copy of it that he hung in his bedroom. There, along with other suggestive works by Greuze and Raoux, it can clearly be seen in the brilliant miniature adorning a snuff box painted by van Blarenbergh (fig. I.8).[4] The painting, engraved by Nicolas Ponce in the year before the sale of the collection, is the one exhibited here. All the attributes of the neoclassical style are in evidence: the chaste, slightly insipid women with their enamel-like skin, the pure, cool colors, and the accumulation of authentic artifacts and decor. The taste for antiquity has here been transformed by a penchant for erotic themes derived from Natoire and Boucher.

[1]Seznec and Adhémar, 1957, I, p. 119.
[2]Ibid., pp. 209-211.
[3]See Gaehtgens, fig. 11; several preliminary drawings are also reproduced.
[4]See F.J.B. Watson, *The Choiseul Box,* New York, 1963, p. 13, fig. 4.

II. Mythology & Allegory

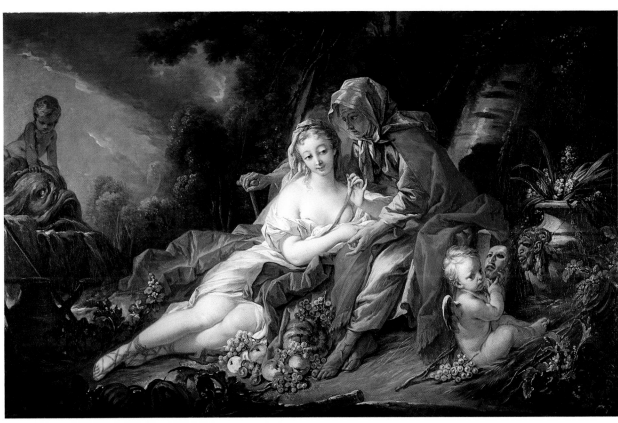

13. François Boucher, *Earth: Vertumnus and Pomona*

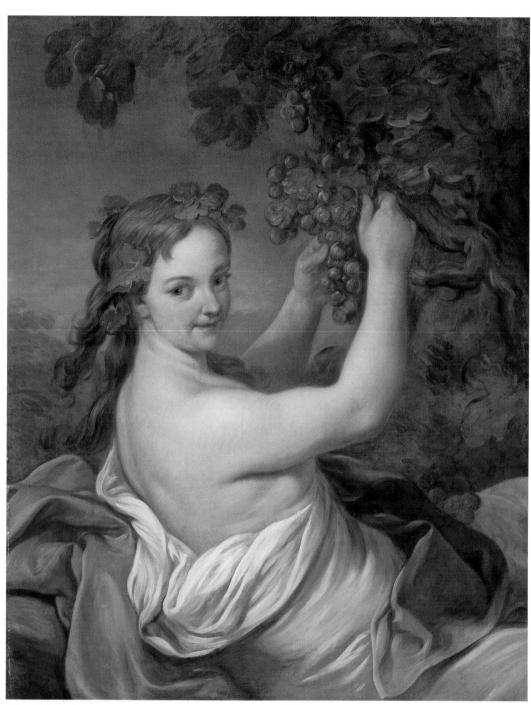

14. Carle van Loo, *Erigone*

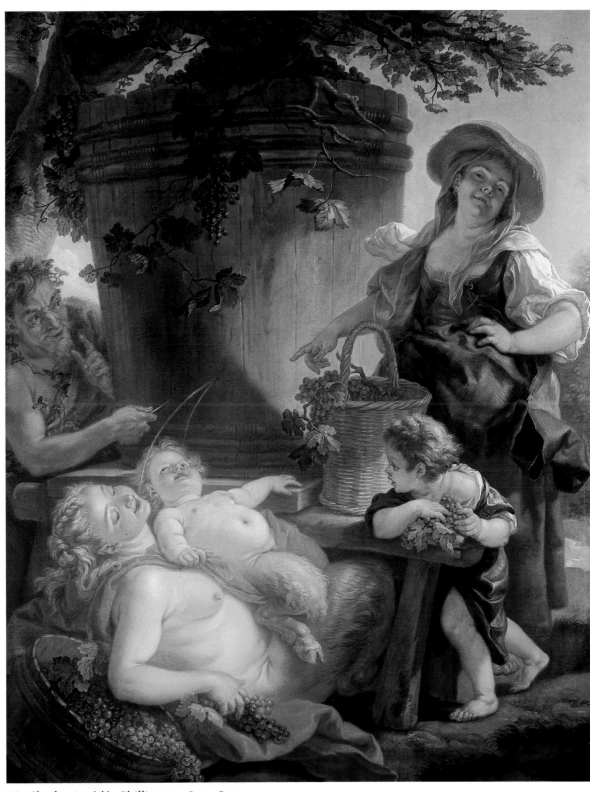

15. Charles-Amédée-Phillipe van Loo, *Satyrs*

16. Jean-Baptiste-Marie Pierre, *Bacchus and Ariadne*

17. Jean-Baptiste-Marie Pierre, *Allegorical Figure*

50

18. Louis-Jean-François Lagreneé, *Justice Disarmed by Innocence and Applauded by Prudence*

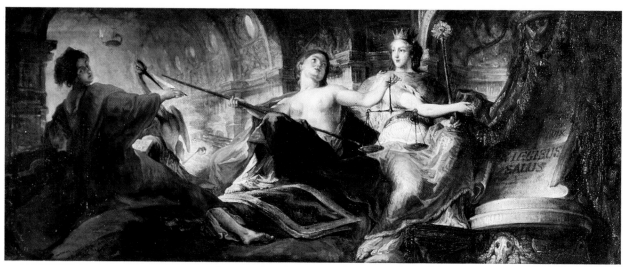

19. Gabriel-Jacques de Saint-Aubin, *Allegory of the Law*

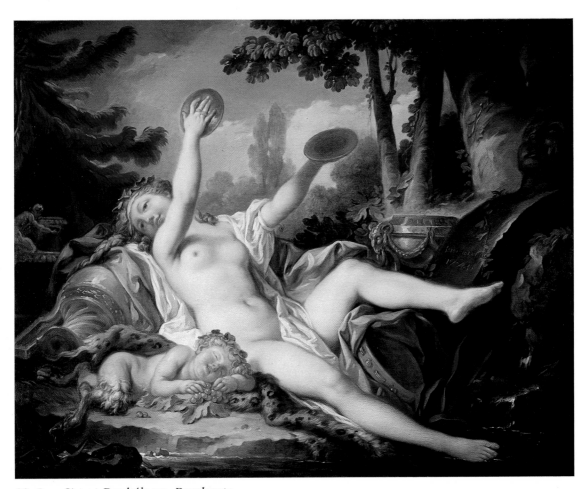

20. Jean-Simon Berthélemy, *Bacchante*

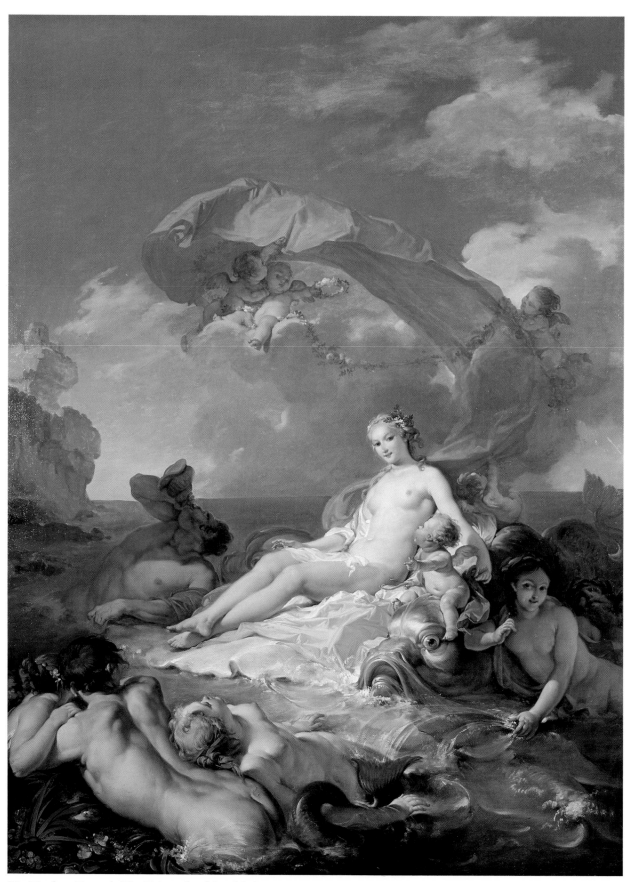

21. Hughes Taraval, *The Triumph of Amphitrite*

Commentaries

François Boucher, 1703-1770

13. *Earth: Vertumnus and Pomona,* 1749
Oil on canvas, 34¼ x 53⅝ inches (86.6 x 136.2 cm.)
Signed and dated in the vase at lower right:
F. Boucher 1749

Columbus Museum of Art. Purchase, Derby Fund, 1980.

Provenance: French Royal Collection, 1749; Pierre-Jacques Onésyme Bergeret de Grancourt, Paris, ca. 1764; Sale, Paris, April 24, 1786, no. 49; Private collection, Paris; Artemis, London, 1978.

Bibliography: Ananoff, 1976, I, p. 44, II, pp. 25-27, no. 329; Idem, 1980, no. 342.

In 1748 Boucher received a commission from Lenourment de Tournehem, *directeur des bâtiments de sa majesté,* for a set of paintings representing the four elements. Boucher's records note the completion of two of these, "Arion carried on a Dolphin Accompanied by Triton and Nereids and other Sea Gods," which represents Water, and "Vertumnus and Pomona in a Pleasant Landscape where the trees are filled with flowers and fruits" to represent Earth. For these works he was paid 1400 *livres* on September 28, 1749. The set was intended for overdoors in a room at La Muette, but the design may have been altered, so that Boucher did not paint the two other elements. This pair was acquired by the *Receveur général des finances* Bergert de Grancourt, an avid collector. Then they were lost for many years, known only from the engravings by Augustin de Saint-Aubin and poor copies. The paintings reappeared in 1978 and have now been separated, with the *Arion* (fig. II.1) at The Art Museum, Princeton University, and the *Vertumnus and Pomona* at Columbus.

The story of the two Roman divinities Vertumnus and Pomona was given its best known form in Ovid's *Metamorphoses.* Pomona, a nymph who loved to tend her fruit trees and flowers, shut herself away from men. Vertumnus, the god of orchards, desired her passionately and used various disguises to enter the garden refuge. At last he came disguised as a very old woman who, after admiring Pomona's fruit, complimented her on her beauty and began to kiss her. Then, seating himself on the grass, he explained his passion by pointing out an elm tree in which was intertwined vines bearing bunches of shining grapes, saying "if this tree trunk stood by itself and was not wedded to the vine, it would be of no interest to anybody and the vine would lie trailing on the ground. And yet you are unmoved by the example of this tree! You shun marriage and do not care to be wed." Having pled his cause, he transformed himself back into his normal form, and the nymph was more than willing to yield to his entreaties.[1]

Boucher, who may have known the theme from Flemish paintings, was to treat it a number of times in his career. A painting of 1758 (Ananoff 385) is the basis for a Beauvais tapestry and a 1763 painting in the Louvre (Ananoff 482) served for a tapestry from the Gobelins. For a French edition of Ovid's text, published in 1769-71, Boucher again produced an illustration of the myth.

In this earliest treatment of the subject, the symbol of deception, through which love achieves its fulfillment, is the mask held by the winged *amor* at the lower right. Allegorical use of the story to represent the element Earth is most probably related to the January 15, 1749 presentation at Versailles of a ballet *Les Eléments,* with text by Roi and music by Destouches. The last act of the ballet was entitled *La Terre ou Vertumne et Pomone;* the designer was probably Boucher, and the role of Pomona was played by Madame de Pompadour. In the painting, the features of the young woman may be based on those of the king's mistress. Another connection to the royal family is the presence of a stone *dauphin* water spout in Pomona's garden. In the pendant painting, *Water,* it is also the *dauphin* which is given prominence.

[1] *The Metamorphoses of Ovid,* trans. by Mary M. Innes, London, 1955, Book XIV, pp. 328-332.

Fig. II. 1

53

Carle van Loo, 1705-1765

14. *Erigone*, ca. 1747
 Oil on canvas, 39⅜ x 31½ inches (100 x 79.8 cm.)

High Museum of Art, Atlanta. Gift of Harry Flackman, 1966.

Provenance: Collection of the painter Peters, Brussels; Madame de Jullienne, Paris; Sale, Paris, November 5, 1778, no. 43; Boyer de Fonscolombe, Aix-en-Provence; Sale, Paris, January 18, 1790, no. 79; Sale, Munier-Jolain, Hôtel Drouot, Paris, April 17, 1920, no. 54; Harry Flackman, New York City.

Bibliography: Pierre Rosenberg and Marie-Catherine Sahut, *Carle van Loo, Premier Peintre du Roi*, exhibition catalogue, Nice, Clermont-Ferrand, and Nancy, January 21-August 15, 1977, p. 65, no. 108.

Born at Nice of Dutch origin, Charles-André (called Carle) van Loo was to become the most famous member of an extensive family of artists. After the death of his father Abraham-Louis in 1712, his brother Jean-Baptist became his teacher and they travelled together to Rome in 1716. There Carle also studied with the painter Benedetto Luti and the sculptor Pierre Legros. Returning to Paris, he worked on the restoration of the Galerie of François I at Fontainebleau and was painting independent works by 1723. The very next year he won the Grand Prix of the Académie, but since it lacked funds he was not sent to Rome. Having amassed his own money from the painting of portraits, he was able to make the trip in 1728. He was well received in Italy – the pope honored him in 1729 – and in 1732 he was invited to work for the King of Sardinia, Charles-Emmanuel III, at Turin.

When he returned to Paris in 1734, his brilliant reputation preceding him, van Loo resided in the hôtel of the Prince de Carignan and was *agréé* by the Académie. He was *reçu* the next year and even allowed to choose the subject of his reception piece, *Apollo Flaying Marsyas*. Van Loo received his first royal commission in 1736. In the same year he became a *professeur* at the Académie. He was made *gouveneur* of the Ecole Royale des Elèves Protégés in 1749, ennobled in 1750, made *recteur* of the Académie in 1752, appointed *Premier Peintre du Roi* in 1762, and then director of the Académie in 1763.

During his lifetime, van Loo, who benefitted from the early deaths and departure to Rome of most of his potential rivals, was regarded as one of the greatest of French masters. He was able to work in several styles and mastered all areas of painting from portraiture to religious and mythological subjects as well as *fêtes galantes*. His many commissions included royal portraits, decorations for Madame de Pompadour's rooms at Bellevue (1753), and a painting of the actress Mademoiselle Clarion as Medea for the Princess Galitzine, which was the sensation of the Salon of 1759.

Van Loo participated in the *Concours* of 1747, exhibiting a *Drunkenness of Silenus*, which showed a heartiness of color and sensuality clearly inspired by works of Rubens and Jordaens. The *Erigone* is in this same vein. The subject was derived from a brief mention in Ovid's *Metamorphoses*. The god of wine Bacchus conquered the nymph Erigone by transforming himself into a grape which she ate. As Panofsky has shown, the subject was given currency in the seventeenth century through glosses in French such as that illustrated by an engraving of Sebastien Le Clerk and by a painting by Guido Reni, a version of which was in the collection of the Regent Philippe II d'Orléans (also made well known through an engraving).[1] Reni's work depicted the semi-nude nymph lifting the cloth off a bunch of grapes on a table.

In van Loo's treatment, Erigone is in an outdoor setting, coyly eyeing the viewer as she reaches for the luscious fruit. Van Loo's painting was engraved by P.-Ch. Lévesque (fig. II.2) as *La Gaieté*, when, as the inscription records, it was in the "*cabinet de M. de Peters, Peintre de S. A. Le Prince Charles, Gouverneur des Paybas.*" Van Loo's original painting was believed lost until Pierre Rosenberg identified it as the work in the High Museum. The subject, with its erotic overtones, certainly must have appealed to eighteenth century taste. Natoire treated it in a painting exhibited at the Salon of 1747. Van Loo's work was copied by other artists including J.-S. Berthélemy, who also painted two of his own versions.[2]

[1]Erwin Panofsky, *A Mythological Painting by Poussin*, Stockholm, 1960, pp. 23-33.
[2]Berthélemy's copy is in the Musée Municipal, Laon; his own signed version was sold at the Galerie Georges Petit, Paris, April 23-24, 1974, no. 54 and a variant of it, attributed incorrectly to Jean-François de Troy, is at the Sterling and Francine Clark Art Institute. See the illustrations in Nathalie Volle, *Jean-Simon Berthélemy*, Paris, 1979, figs. 5, 18, and 19. An *Erigone* by an anonymous eighteenth century French artist is also at the Musée de Picardie, Amiens.

LA GAIETÉ

Fig. II. 2

54

Charles-Amédée-Philippe van Loo, 1715-1795

15. *Satyrs*
Oil on canvas, 57¼ x 44¼ inches (146 x 112.4 cm.)

Milwaukee Art Museum.

Provenance: F. de Ribes-Christofle; Sale, Galerie Georges Petit, Paris, December 10-11, 1928, no. 57; Sale, Galerie Charpentier, Paris, April 6, 1960, no. 24.

Exhibitions: Salon of 1761, Paris, no. 38; *France in the Eighteenth Century*, Royal Academy of Arts, London, 1968, no. 444.

Charles-Amédée-Philippe was another member of the widely travelled van Loo family. The son of Jean-Baptiste and brother of Louis-Michel, he was born in Turin, *reçu* by the Académie in 1745, and rose there to *recteur*. But he achieved his greatest distinction by accepting the position of court painter to Frederick the Great at Berlin. Charles-Amédée was a regular exhibitor at the Salon from 1747 to 1785, and his entries showed the typical wide range of the period's painters. In 1761, he presented two religious subjects – *The Baptism of Christ* and *Miracle of St. Roche* – and two paintings of *Satyrs*. Saint-Aubin's sketches in his Salon *livret* (fig. II.3) and the following appreciation by Diderot allow us to identify the painting in Milwaukee as one of these:

> The "Two families of Satyrs" gave me true pleasure... Herein are poetry, passion, flesh and character. Noteworthy is the idea of the wine barrel pierced by the Satyr;...[Look at] the streams of wine which flow into the mouths of his small children stretched out on the straw-covered ground; these fat, chubby children; his wife, who is splitting her sides with laughter at the way that he nourishes the children. Don't they delight you? And also, see how it is painted. Don't all of the bizarre beings have a physiognomy appropriate to their goat-footed nature?[1]

The lively, fleshy character that Diderot was responding to undoubtedly reflects the artist's familiarity with works by seventeenth century Flemish painters such as Jacob Jordaens. A similar sort of subject, *The Drunkenness of Silenus*, had also been treated by his uncle Carle van Loo in a work shown at the Salon of 1747 and now in the Musée des Beaux-Arts, Nancy.

[1]Seznec and Adhémar, 1957, I, p. 123.

Fig. II. 3

Jean-Baptiste-Marie Pierre, 1714-1789

16. *Bacchus and Ariadne*
Oil on canvas, 31⅝ x 25⅝ inches (81 x 65 cm.)

Stanford University Museum of Art, Stanford, California. Gift of the Committee for Art at Stanford, 1971.

Provenance: Galerie Rossini, France; Von Steiger and Dobiaschofsky, Switzerland; Galerie Meissner, Zurich.

Bibliography: Monique Halbout and Pierre Rosenberg, "A Propos de Jean-Baptiste-Marie Pierre," *The Stanford Museum*, 1975, pp. 11-19.

Pierre was born in Paris and received his early training from Natoire, who imbued in him a taste for flowing draperies and decorative compositions. In 1734 the twenty-one-year-old Pierre won the Prix de Rome and the following year departed for Rome, where he studied for five years. The Académie at Rome was from 1738 under the direction of Jean-François de Troy, who encouraged Pierre to pursue large scale history painting. As was the custom, the young artist studied Renaissance works, and the influence of Michelangelo and Raphael was seen in his work for many years.

Immediately upon his return to France, Pierre began to show in the Salon. In 1741, the year he was made *agréé*, he exhibited a *Schoolmistress and Children*, a genre picture in the manner of Chardin, as well as a "bambochade" and a mythological picture, *Psyche Abandoned by Cupid*. The next year Pierre was *reçu* by the Académie as a history painter with a *Hercules and Diomedes* (Montpellier). In the Salon, Pierre showed *Sacrifice of Elijah*, *Birth of Venus*, and *Cephalus and Aurora*. Thus, in addition to genre subjects, which he continued to paint, Pierre was beginning to make a name for himself as a painter of religious and history paintings. In 1743 he showed a *St. John the Baptist Preaching*, a *Journey* (now in the Dijon Museum), and a *Ganymede*. Pierre's *Martyrdom of St. Stephen* (Marseille) dates from 1745 or before since it was shown in the Salon of that year. A 1746 *Punishment of Herod* is in St.-Germain-des-Près in Paris, and from the same year came a *Pilgrims at Emmaus* and *Medea Killing her Sons*, which is of the same proportions as the *Harmonia* exhibited in 1751 (now in the Metropolitan Museum of Art, New York). Pierre continued to show works of heroic religious and mythological subjects as well as decorative projects for public monuments and tapestry designs for Gobelins, where he was named superintendent in 1765.

Pierre's dedication – combined with his good family connections and a charming, if somewhat obsequious, personality – advanced him through the ranks of the Académie, so that in 1770, following the death of Boucher, he was appointed *Premier Peintre du Roi* and Director of the Académie. Having worked for the royal family since 1747, he was ennobled by Louis XVI, and eventually abandoned painting for his administrative duties. Pierre's sense of self-importance and severity were a source of displeasure among fellow pain-

55

ters, and Diderot even went so far as to call him the vainest of artists.

The Stanford *Bacchus and Ariadne* was identified by Halbout and Rosenberg as the work by Pierre which was copied in a 1757 etching by Louis-Simon Lempereur. Another version of the painting, dated 1755, is reported by them to be in a Parisian private collection. It should be noted that there are slight differences between the Stanford painting and Lempereur's print. For example, in the painting, Ariadne, perhaps reacting to Bacchus's interest in the grapes, has a rather despairing attitude unlike her more lively one in the print. The meshing of the bodies and the smooth painting of the flesh and foliage shows that at this stage of his career Pierre could emulate the piquant, erotic manner of Natoire and Carle van Loo.

Jean-Baptiste-Marie Pierre, 1714-1789

17. *Allegorical Figure,* ca. 1755
Oil on canvas, 35¾ x 28¾ inches (90.8 x 73 cm.)

Mead Art Museum, Amherst College, Amherst, Massachusetts. Purchase, 1978.

Provenance: Neville Orgel, Ltd., London.

Pierre, like most painters of his period, on occasion depicted allegorical female figures. The one exhibited here is closest in type, pose, and treatment to the figure of *Clemency* in his series of the four Virtues painted for the *Salle du Conseil* at Fontainebleau in 1753.[1] It most likely dates from the same decade of Pierre's activity in Paris.

The subject of the Amherst painting has previously been identified as Sculpture, but no representatives of the other Liberal Arts with which it would have composed a set have been located.[2] Moreover, despite the fact that the young woman holds a hammer and chisel, she does not have about her the other traditional attributes of Sculpture – such as the compass, crayon, and classical torso – detailed in contemporary iconographic guides.[3] Instead this lovely figure seems totally absorbed in regarding the inscription she has just engraved into the stone plaque. It says in Latin, "Heartfelt gratitude is more long-lasting than bronze." The plaque is probably intended for placement on the large sepulchral monument behind her, supported by the ferocious stone lion, reminiscent of those in Lemoyne's 1725 *Continence of Scipio* (Nancy).

[1]See Colombe Samoyault-Verlet, "Précisions Iconographiques sur la Salle du Conseil de Fontainebleau," *La Revue du Louvre,* 1974, p. 291, fig. 8.
[2]The painter did exhibit an *Atelier of a Sculptor* in the Salon of 1747 and this is probably the work engraved by Marie-Madeleine Igonet in 1752, an impression of which is in the Print Department of The Metropolitan Museum of Art, New York.
[3]See the *Iconologie Française,* 1766 (reprint 1976), p. 120.

Louis-Jean-François Lagrenée, 1739-1821

18. *Justice Disarmed by Innocence and Applauded by Prudence,* 1766
Oil on canvas, 38½ x 57⅝ inches (98 x 145.5 cm.)
Signed and dated at lower left: *L. Lagrenée/ 1766*

The Art Museum, Princeton University, Princeton, New Jersey. The John MacLean Magie and Gertrude Magie Fund, 1975.

Provenance: Mazade de Saint Bresson, Aix-en-Provence; Sale, Christie's, London, July 18, 1974, no. 96; Central Picture Galleries, New York.

Exhibition: Salon of 1767, Paris, no. 24.

Bibliography: Marc Sandoz, "Louis-Jean-François Lagrenée," *BSHAF,* 1961, p. 133; Seznec and Adhémar, III, 1976, pp. 21-22; Else Marie Bukdahl, *Diderot Critique d'Art,* Copenhagen, 1980, I, pp. 90-91, 265, fig. 24.

Lagrenée was born in Paris and studied with Carle van Loo. He won the Académie's Grand Prix in 1749 for his now-lost painting *Joseph Interpreting Dreams.* He went to Rome and, although he only stayed a short time, he absorbed a great deal. Having copied works by Domenichino, he was especially partial to the Bolognese school and was himself referred to as the "French Guido Reni." His polished, refined style, however, makes him seem more a French counterpart of Batoni. Lagrenée became an *académicien* in 1755 with his *Nessus Abducting Deianeira and Shot by Hercules* (Louvre). After two years spent as *Premier Peintre de l'Impératrice* at St. Petersburg, he returned to be made *professeur* at the Académie in 1762. A frequent contributor to the Salon, he received many important commissions from churches, aristocrats, and the king. In 1781, Lagrenée was appointed Director of the Académie de France in Rome and remained there until 1787. During this time he wrote to d'Angiviller a surprising letter protesting the interference of bureaucrats in the arts and asserting a painter's need for freedom.[1]

From 1765, when he exhibited a pair of allegorical works, *Justice and Clemency* and *Goodness and*

Fig. II. 4

Fig. II. 5

Generosity, Lagrenée established himself as a specialist in such subject matter. Two years later, he presented at the Salon a set of four paintings commissioned by Mazade de Saint Bresson, treasurer of the Languedoc *Parlement*, for his mansion in Aix-en-Provence. The subjects of these were The Four Estates and their individual titles were given as:

The Clergy: the figures of Religion and Truth; The Military: Bellona presenting to Mars the reins of his horses; The Magistracy: Justice disarmed by Innocence and applauded by Prudence; The Third Estate: Agriculture and Commerce which leads to Abundance.

As the critic Bachaumont observed in his review, there were traditionally only three Estates, but apparently for the sake of something new to flatter the patron, the fourth, "the magistracy" (which we present here), was devised by the artist.[2] Both this painting and *The Military* (fig. II.4) are now at Princeton. The other two paintings were last recorded in the Penard y Fernandez sale.[3]

All four paintings can be seen in the sketch of the grand gallerie made by Gabriel de Saint-Aubin of the 1767 Salon.[4] The works were generally praised for their refinement and grace. Diderot, however, who had supported Lagrenée as a master of serious historical works, came now to regard him as cold and lacking in imagination. He protested that such elevated concepts as Truth, Virtue, Justice, and Religion had been "*ajustées* for the boudoir of a financier," and attacked each of the paintings in his Salon notice. Of *The Magistracy*, which he calls *La Robe* (*Justice*), he is highly critical:

> Is it possible to imagine anything more meager, cold and flat? And if one did not write the title underneath the picture, who would understand the subject? In the center is 'Justice' if you wish, Mr. Lagrenée, because you make her appearance youthful, gracious – everything that will please you; the Virgin, a St. Geneviève, a nymph, a shepherdess, it is only a question of the name…To the left behind Justice – Prudence stands on the ground, leaning on her elbow, her mirror in hand, she regards the two

other figures with satisfaction. In this I agree with her, for everything in the painting reveals a fine technical skill; but there is little character, and a small-mindedness without judgement or imagination. It appeals to the eyes, but says not one word to the spirit or heart. If one thinks or dreams about anything here, it is the beauty of the finish, the drapery, the heads, the feet, the hands and the coldness, obscurity and ineptness of the composition. The devil take me if I understand anything of this genre, the laurels, or the sword.[5]

To prepare for painting these subjects, Lagrenée made four preliminary oil sketches and these were bought by Mazade de Saint Bresson's daughter. The sketch for *The Magistracy* (fig. II.5), which recently was with the Galerie Joseph Hahn, Paris, differs slightly from the final composition in the grouping of the figures.[6]

[1]Quoted in Sandoz, op. cit., p. 126.
[2]Bachaumont, 1780, pp. 20-21.
[3]Hôtel Drouot, Paris, December 19-20, 1960, no. 84.
[4]See Seznec and Adhémar, 1767, III, fig. 1.
[5]Ibid., p. 90.
[6]See *Four Guest Galleries from Paris*, exhibition catalogue, Paul Rosenberg and Co., New York, 1982, p. 52.

Gabriel-Jacques de Saint-Aubin, 1724-1780

19. *Allegory of the Law,* 1769
Oil on canvas, 24⅛ x 54 inches (60 x 125 cm.)
Initialed and dated on the plaque at the left:
Gde S A / 1769

Utah Museum of Fine Art, University of Utah, Salt Lake City. Gift of the Marriner S. Eccles Foundation in honor of Marriner S. Eccles.

Provenance: Rattier; Leblanc; Fould family; Mme. de Montal; Sale, Nouveau Drouot, Paris, December 15, 1980; Newhouse Gallery, New York.

Bibliography: E. Dacier, *Gabriel de Saint-Aubin, Peintre, dessinateur, et graveur*, Paris, and Brussels, 1931, I, p. 45 and II, p. 24, no. 112.

Gabriel de Saint-Aubin was perhaps the most compulsive artist of the eighteenth century. His hundreds of drawings and sketches recording the activities on the streets, in the theatres, and at the fairs of Paris are an invaluable record of the period, as are his sketches of works of art in the margins of his Salon *livrets* and sales catalogues. His father had the post of embroiderer to the king and most of Gabriel's five brothers and two sisters were also painters, artisans, or engravers. At the age of twenty-three, Saint-Aubin was already listed as a "professor" of proportion and anatomy in the prospectus of the Ecole des Arts of Jacques-François Blondel, which specialized in architecture. Saint-Aubin himself became a student attempting to follow the route of official success at the Académie Royale. He studied with Etienne Jeaurat and Colin de Vermont, and probably with Boucher, whose style and subject matter seem to have influenced Saint-Aubin's earliest

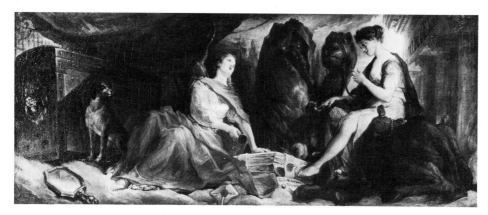

Fig. II. 6

known painting, *Day Break* (Museum of the Rhode Island School of Design, Providence). He also painted religious subjects which are now lost. Having competed unsuccessfully in 1752, 1753, and 1754 for the Académie's Grand Prix, he renounced any hope of an official career and devoted himself primarily to printmaking and drawing. He continued to paint sporadically, specializing in genre and allegory.

In 1774 Saint-Aubin exhibited eight works in the Salon held by the Académie de Saint-Luc, including a painting of the *Aftermath of the Earthquake at Lisbon* which attracted attention. By 1776, the year this Académie was suppressed, he was recorded as one of its directors and teachers. That same year he exhibited with others of its former members, showing fifteen works in the *Salon des grâces* in the Colisée Palace.

Saint-Aubin devoted himself completely to his art; he never married, paid no attention to his dress or appearance, lived simply, and died in near poverty. Eighty paintings and stacks of drawings were found in his studio.

Charles-Germain de Saint-Aubin characterized his younger brother Gabriel as "full or erudition," and at the school of Blondel his duties included teaching "historical attribute and allegory for the ornament of religious and secular buildings and fêtes." The first known dated drawing by him is an allegorical subject done in 1747, and he continued throughout his life to produce such subjects. Although it has been said he sold only two paintings during his career, specific works such as the unusual pair of overdoor allegorical paintings *The Law* and *Archaeology* (fig. II.6) – first recorded by the Goncourts and now in Utah – must have been commissioned. His etching *A Gathering of Lawyers* of 1777, also shows an allegory of Justice hovering over the room. In the *Allegory of the Law* he combines three different allegorical figures. At the right, Law is crowned to indicate her sanctity. She carries a sceptre, in which an eye symbolizes the law's ability to see far and well. She draws back a curtain to reveal on the dais a scroll inscribed [*In*] *Legibus Salus*

which, as a French edition of Ripa states, signifies the reward that she promises to those who obey her.[1] This seems to be repeated in French in another inscription above the Latin one. The Law proudly indicates this message to her two companions: Justice, the central figure, who holds the scales and a long staff, and Vigilance, whose attributes are the open book on her lap, the lamp, and the crane with one leg raised holding a stone. This last detail is derived from a legend related by Aristotle in his *Historia Animalium* (and repeated by Pliny and naturalists throughout the middle ages): if the crane fell asleep, it would drop the rock and awaken itself. Thus this bird is a symbol of watchfulness.

Charles-Germain de Saint-Aubin described most of his brother's paintings as being "frightfully overworked," but in this example we can observe that delicacy of touch found in his paintings of fairs and street scenes as well as an almost voluptuous use of color and form reminiscent of Boucher.

[1]*Iconologie Française*, 1766, reprint Garland Publishing, N.Y., 1976, p. 160.

Jean-Simon Berthélemy, 1743-1811

20. *Bacchante,* 1778
 Oil on canvas, 24 x 32 inches (63.7 x 80 cm.)
 Signed and dated at right of center: *Berthélemy 1778*

 Private Collection, New York.

 Provenance: Marquis de Véri, Paris; Sale, Paris, December 12, 1785, no. 47; Sale, Parke-Bernet, New York, September 29, 1972, no. 22.

 Bibliography: Nathalie Volle, *Jean-Simon Berthélemy (1743-1811)*, Paris, 1979, p. 82, nos. 47 and 48, fig. 33.

Berthélemy was born at Laon into a family of artists. About 1758 he went to Paris to live with an uncle who was a sculptor. He was admitted as a student at the Académie Royale under the protection of Noël Hallé. After three unsuccessful attempts, he won the Grand Prix in 1767 with an *Alexander Cutting the Gordian Knot*. This granted him entry to the Ecole Royale des Elèves Protégés. Even before his departure for Rome

he had achieved success as a painter of decorative schemes with an allegorical ceiling for the Paris hôtel of the comte de Saint-Florentin. For the celebration of the marriage of the Dauphin and Marie Antoinette, he created a temporary decoration in the manner of Lemoyne, depicting the couple presented to the gods of Olympus.

In October of 1770, Berthélemy arrived in Rome. The Académie's director, Charles-Joseph Natoire, in correspondence with Marigny, praised the progress of his new *pensionnaire*. When the collector Bergeret de Grancourt and his travelling companion Fragonard visited Rome, they reviewed Berthélemy's work, and noted that it showed a study of Raphael and Michelangelo. Berthélemy returned to Paris in 1774 and was *agréé* in 1777 as a painter of history. His work in this early period shows a variety of influences, especially the styles of van Loo and Boucher.

Mythological erotic subject matter such as this *Bacchante* (and its lost pendant *Jupiter and Antiope*) were inspired by works such as van Loo's *Erigone* (no. 14), which Berthélemy is known to have copied.

Such frivolous themes were abandoned after the artist was *reçu* in 1781. With the encouragement of the *directeur des bâtiments* d'Angiviller, Berthélemy and other artists of the Académie painted patriotic subjects inspired by French history and antiquity. A number of these were done as tapestry designs. The painter also continued his religious decorative schemes and at the time of the Revolution was working for several convents. In 1791 he turned his talents to the theater and became official costume designer for the Opéra. Then in 1796 he was appointed to a commission for the research of science and art in Italy and spent time there gathering works for exhibition in Paris. From 1798 to 1810, he was in effect curator of the Central Museum of Arts, and among his last artistic creations were frescoes for the Musée des Antiquités at the Louvre.

Hughes Taraval, 1729-1785

21. *The Triumph of Amphitrite*, 1780
Oil on canvas, 50¾ x 38¼ inches (129 x 97 cm.)

Mead Art Museum, Amherst College, Amherst, Massachusetts. Purchase, 1976.

Provenance: The Artist's estate sale, no. 1; Arsène Houssaye; Sale, Hôtel Drouot, Paris, May 22-23, 1896, no. 99; Sale, Paris, June 14-15, 1920: Lamy Collection; L.-A. Gaboriaud; Sale, Hôtel Drouot, Paris, June 25, 1929, no. 54; Heim Gallery, London, by 1975.

Exhibition: Salon of 1781, Paris, no. 50.

Bibliography: Marc Sandoz, "Hughes Taraval," *BSHAF*, 1972, pp. 235-236, no. 112; Seznec and Adhémar, 1967, IV, pp. 317-318; Else Marie Bukdahl, *Diderot Critique d'Art*, Copenhagen, 1980, pp. 97 and 266, ill. 28.

Taraval was one of the last eighteenth century masters of "*la grande décoration.*" His father, a painter in the employ of the King of Sweden, was his first teacher. Following the father's death in 1750, the family returned to Paris. Here the twenty-one-year-old Hughes entered the school of the Académie in the atelier of J.-B. Pierre, who helped point him in the direction of his future career as a master of grand decorative projects. In 1756, he won the Grand Prix for his *Job Reproached by His Wife* (Musée des Arts, Marseille). He thus was able to enter the Ecole Royale des Elèves Protégés, under the direction of Carle van Loo, and three years later in 1759 he departed for Rome. There Natoire was the director of the Académie de France, and he encouraged this diligent *pensionnaire*. Taraval's *Venus and Adonis*, painted in 1760, shows he had carefully absorbed the lessons of antiquity, Raphael, Domenichino, and Annibale. This painting was subsequently exhibited at the Salon of 1765. Diderot judged the rendering of Venus's nude back "beautiful, very beautiful," and that same year the painter was *agréé* by the Académie.

Having returned to Paris in 1763, Taraval had already launched, with the help of Pierre, his career as a painter of decorative schemes. He began with works in the residence of the duc d'Orléans. Then he received a commission for mythological scenes for the bedroom of the royal château of Gustave III at Stockholm. In 1767, Taraval had his first commission from the French royal family – for overdoors for the château of Bellevue – again of mythological subjects. In 1769, to gain full admittance to the Académie, he exhibited one of his most ambitious works, *The Triumph of Bacchus* or *Autumn* for the ceiling of the Gallery of Apollo in the Louvre. Other major commissions included religious subjects such as *The Marriage of Saint Louis* (1773) for the chapel of the Ecole Royale Militaire. In 1781, Louis XVI commissioned two religious subjects for the Chapel of the Trinity at Fontainebleau. In 1783, Taraval was appointed by the *directeur des bâtiments* d'Angiviller to be artistic director of the Gobelins manufactory. In the year of his death, Taraval exhibited at the Salon another major work, *The Infant Hercules Strangling the Serpents in his Cradle*.

Taraval received one of his most important royal commissions in 1776. It was for a large painting to serve as a design for a tapestry in a series devoted to *The Loves of the Gods*. The project, devised by comte d'Angiviller, consciously imitates his predecessor, the marquis de Marigny, who in 1757 had commissioned four tapestry designs on this subject. The works produced on that occasion were Carle van Loo's *Neptune and Amymone*, Boucher's *The Forge of Vulcan*, Pierre's *Abduction of Europa*, and Vien's *Abduction of Proserpine*. The 1776 commissions included, in addition to Taraval's *Triumph of Amphitrite*, a *Cephalus and Aurora* by van Loo. Taraval's painting, exhibited at the Salon of 1777 and now at the Louvre, was generally

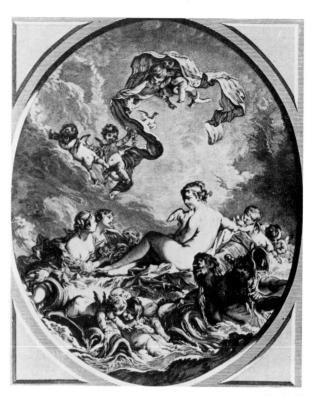

Arc de Triomphe & autres Monu-
mens de Rome.

Tableau de 3 pieds & demi de large, fu
2 pieds 6 pouces de haut.

Veſtibule d'un Palais Romain, d
côté des Jardins.

Tableau de 3 pieds & demi de large
ſur 2 pieds 10 pouces de haut.

Pluſieurs Deſſins coloriés de Vues &
Monumens Romains, & d'autre
ſujets compoſés, ſous le mêm
numéro.

r M. TARAVAL, *Académicien.*

Triomphe d'Amphitrite.

Ce Tableau, de 10 pieds de haut, ſu
7 de large, eſt pour le Roi.

On peut voir, du même Artiſte, dans
Salle des Actes du Collége Royal, Place d
Cambrai, un Plafond dont le ſujet eſt un
allégorie à la gloire des Princes. L'explicatio
en ſera donnée inceſſamment, dans le Journe
des Sçavans, par M. de Lalande.

Fig. II. 7

Fig. II. 8

a great success,[1] it was woven several times as a tapes-
try, and several oil replicas and sketches of it were
made.[2] The most important was a smaller version
which Taraval showed at the Salon of 1781 with a pen-
dant *Diana Surprised at Her Bath by Acteon.* It was
sketched by Saint-Aubin (fig. II.7) and again it elicited
praise.[3] It is this second Salon version which is now at
Amherst.

In Greek mythology, the Nereid Amphitrite was the
wife of the sea god Poseidon. Taraval's painting may
represent the moment when Amphitrite was brought
from her retreat in the Atlas mountains to be wed to
Poseidon. She is seen in triumphal procession as
queen of the sea, gliding over the waves on the backs
of Tritons and dolphins, assisted by nereids and putti.
This subject had previously been treated by other
French painters such as Nicolas Coypel and Bon
Boullongne.

In this work more than any other, Taraval closely ap-
proached the manner of his aesthetic forebears in dec-
orative painting, Boucher and Natoire. There were in
fact many Boucher scenes of sea-borne triumphs avail-
able as models – the most important being *The
Triumph* or *Birth of Venus* (National Museum, Stock-
holm), but one of the engravings (fig. II.8) after
Boucher's oval *Birth and Triumph of Venus* of 1743
(now in a private collection in New York) would have
been an especially accessible source. The engraving
focuses in a similar way on the single central nude,
supported by sea deities, with a silken canopy borne
aloft above her.

In a better state of preservation than the earlier
Louvre version, this replica allows us to fully ap-
preciate the brilliant tonality, the voluptuous forms,
and the exquisite finish of one of the final flowerings
of the rococo manner.

[1] *La Prestesse ou Nouvelle manière de Prédire*, Paris, 1778, p.
15, called it "a bad parody of Boucher," but Bachaumont
(1777), 1780, p. 247, praised its freedom.
[2] See Peter Walch, "French Eighteenth Century Oil Sketches
from an English Collection," exhibition catalogue in *New
Mexico Studies in the Fine Arts*, 1980, p. 35, no. 60.
[3] Although Diderot dismissed the artist's work that year with
a few derogatory remarks, the other critics, while acknowl-
edging the debt to earlier artists, found it effective. See Sez-
nec and Adhémar, 1967, IV, p. 318; *La Peinturomanie, ou
Cassandre au Salon, Comédie-Parade en Vaudevilles*, Paris
and Rome, 1781, p, 19; *Réflexions Joyeuses d'un garçon de
bonne humeur sur les tableaux exposés au Salon en 1781*,
Paris, 1781, p.15; *Galimatias Anti-Critique des Tableaux de
Salon*, The Hague, 1781, p. 17.

60

III. Portraiture

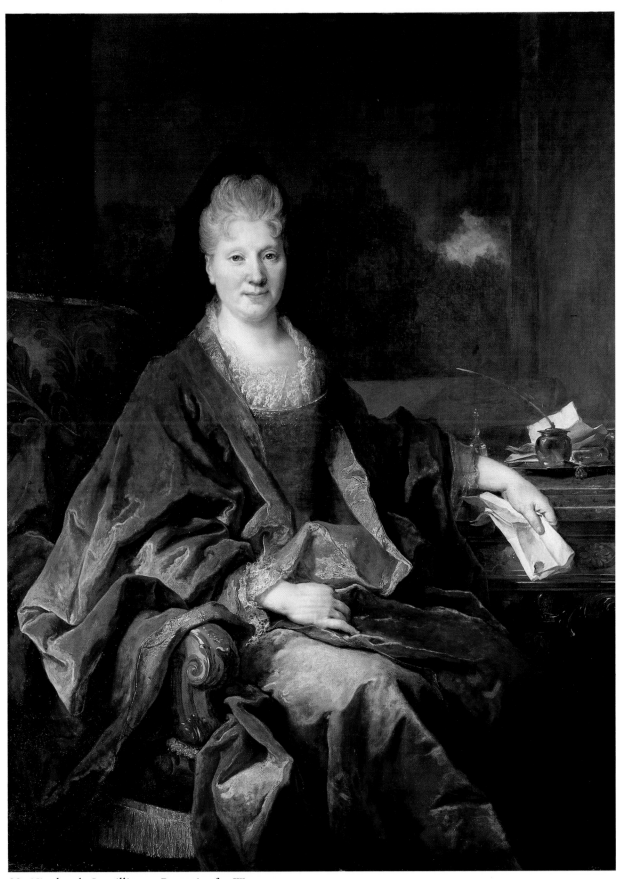

22. Nicolas de Largillierre, *Portrait of a Woman*

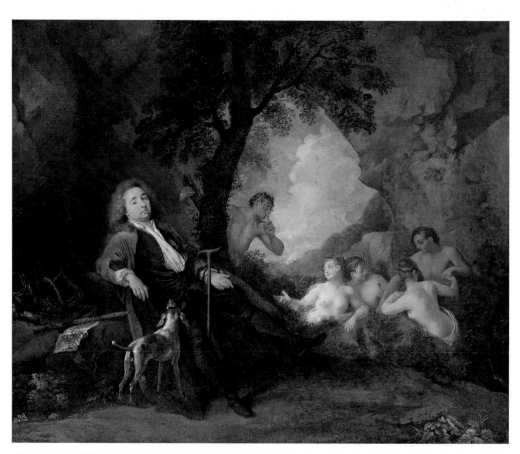

23. Antoine Watteau, *Antoine de la Roque*

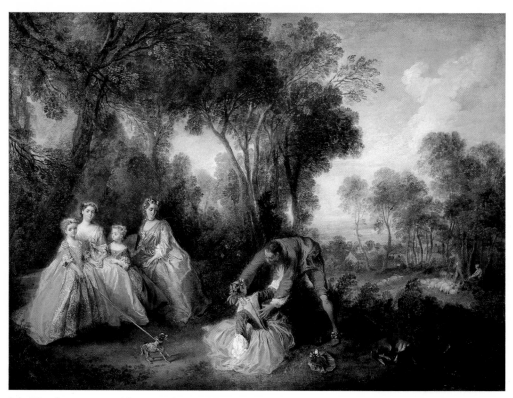

24. Nicolas Lancret, *The Bourbon-Conti Family*

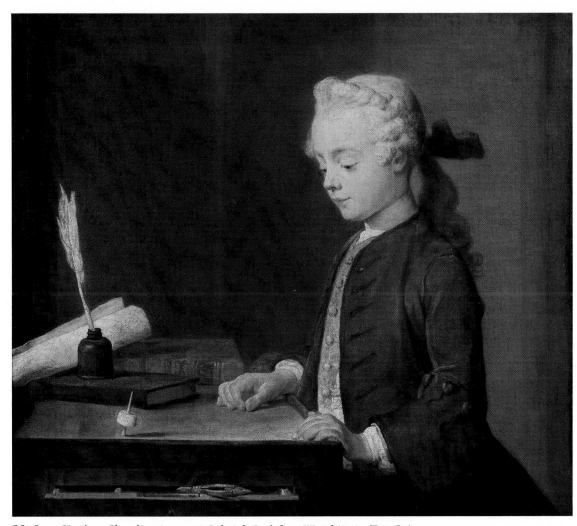

25. Jean-Siméon Chardin, *Auguste-Gabriel Godefroy Watching a Top Spin*

66

26. Alexis-Simon Belle, *Louis XV in his Coronation Robes*

27. Pierre-Hubert Subleyras, *Pope Benedict XIV*

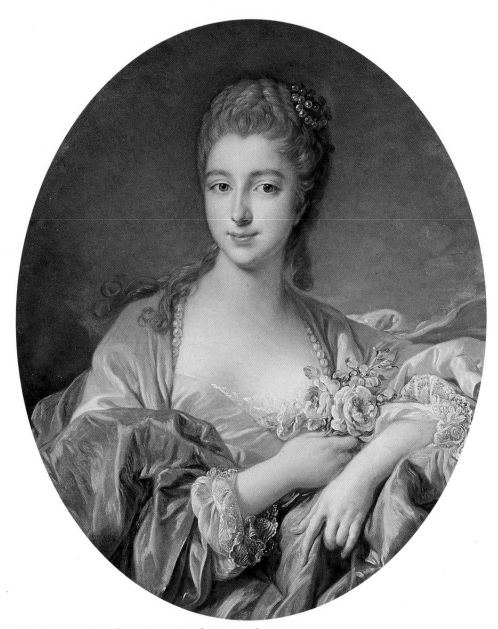

28. François Boucher, *Marquise de Pompadour*

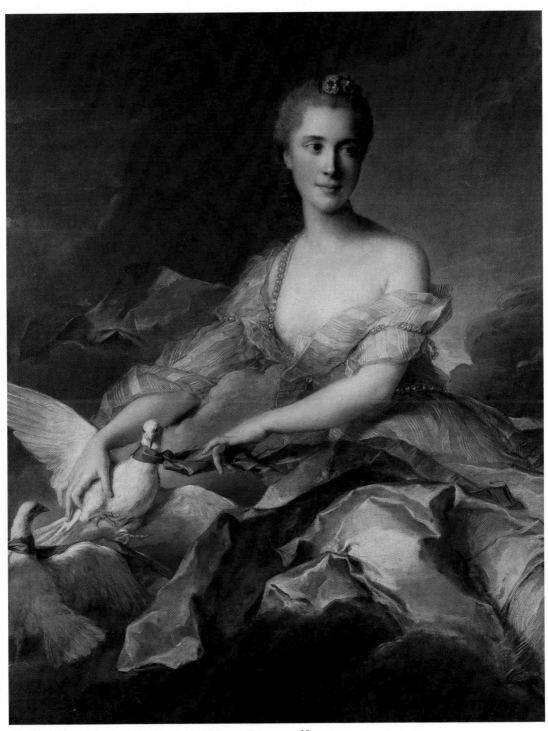

29. Jean-Marc Nattier, *Madame de Maison Rouge as Venus*

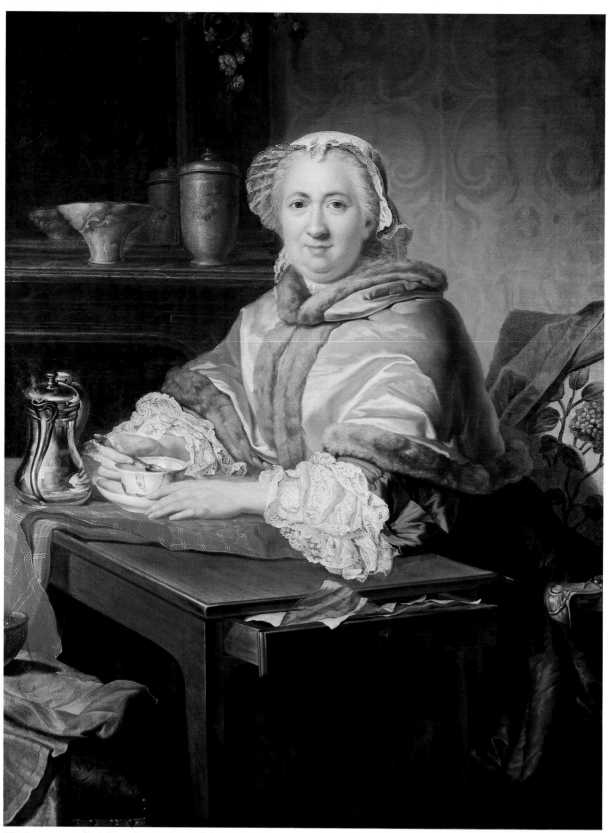

30. Jacques-André-Joseph Aved, *Madame Brion*

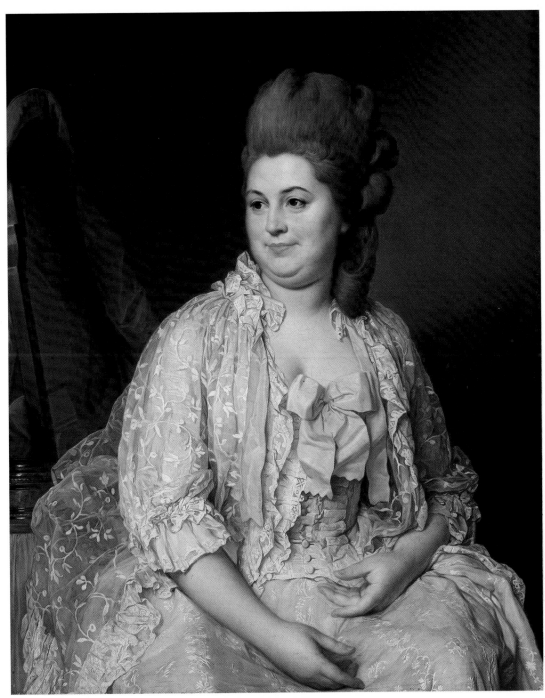

31. Joseph-Siffred Duplessis, *Madame de Saint-Maurice*

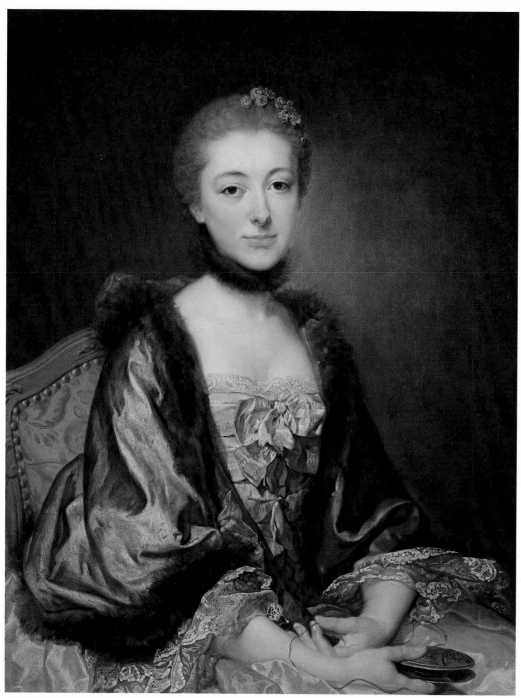

32. Jean-Baptiste Greuze, *Madame Gougenot de Croissy*

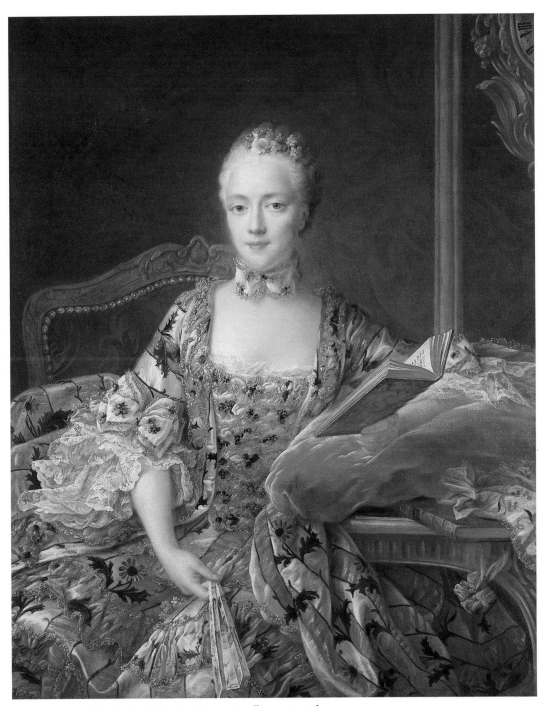

33. François-Hubert Drouais, *La Marquise d'Auguirandes*

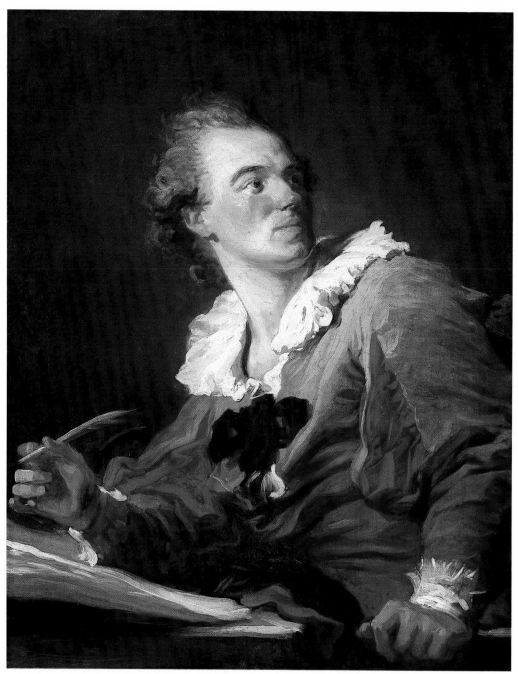

34. Jean-Honoré Fragonard, *L'Inspiration (Portrait of a Writer)*

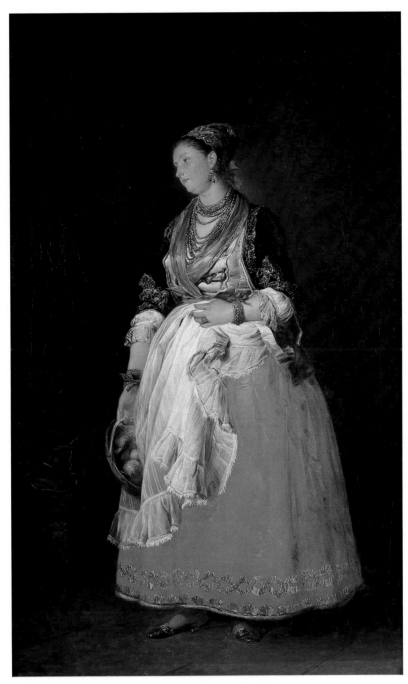

35. François-André Vincent, *Neapolitan Woman*

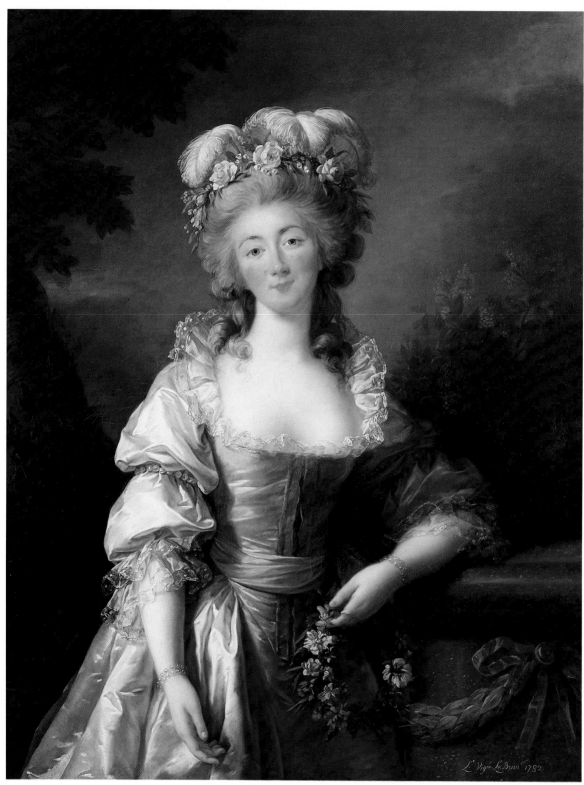

36. Elisabeth Louise Vigée Le Brun, *Madame du Barry*

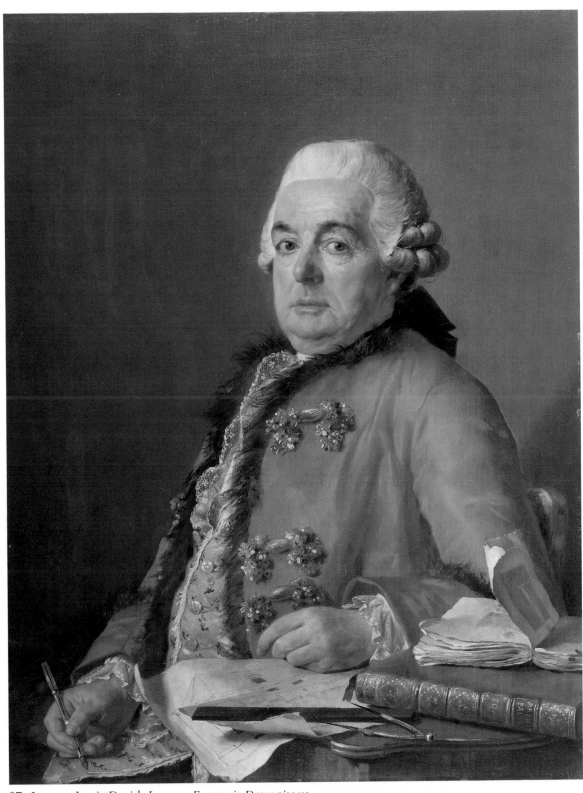

37. Jacques-Louis David, *Jacques-François Desmaisons*

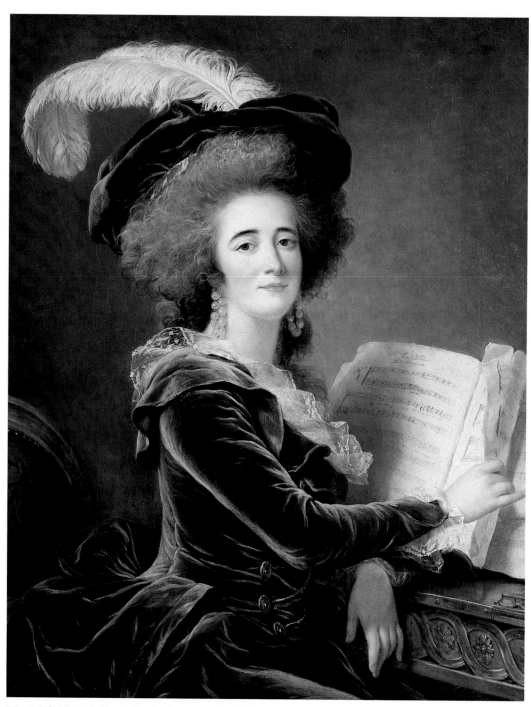

38. Adélaïde Labille-Guiard, *Comtesse de Selve*

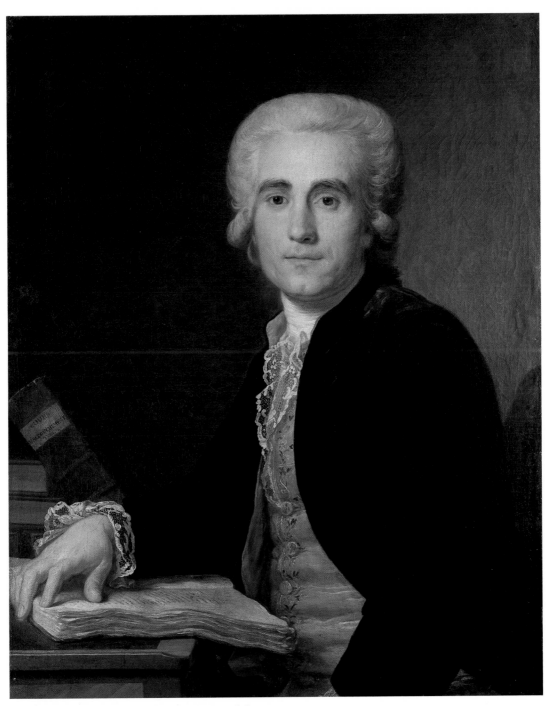

39. Antoine Vestier, *Dr. Jean-Louis Baudelocque*

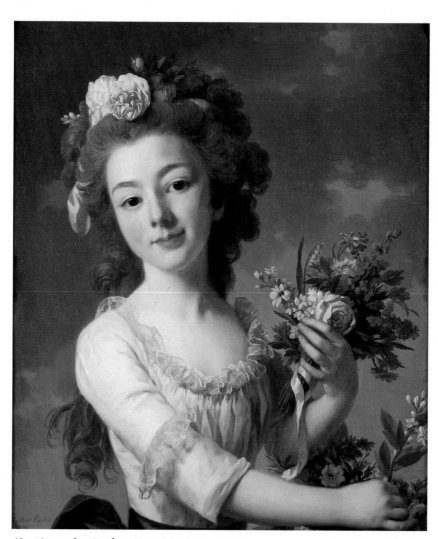

40. Alexandre Roslin, *Henriette Begouen*

Commentaries

Nicolas de Largillierre, 1656-1746

22. *Portrait of a Woman,* ca. 1715
Oil on canvas, 55 x 42¾ inches (139 x 108 cm.)

Museo de Arte de Ponce, Puerto Rico. The Luis A. Ferré Foundation.

Provenance: O. Stettiner, 1926; Mrs. H. L. Bischoffsheim, London; Sale, Christie's London, May 7, 1926, no. 55; Mrs. Whitelaw Reed; Sale, Associated American Artists, New York, May 2, 1934, no. 300; Sale, Charpentier, Paris, Nov. 30, 1954, no. 39.

Exhibition: *Examples of French and English Painters of the 18th Century,* Guildhall, London, 1902.

Bibliography: Julius S. Held, *Museo de Arte de Ponce: Catalogue of the European and American Schools,* Ponce, 1965, pp. 97-98.

Largillierre was born in Paris. His training, more varied than that of most French artists of the period, included studies in still life with Antoon Goubau in Antwerp and portraiture with Sir Peter Lely in London. After his return to Paris in 1682, he achieved his first success with large history paintings such as *The Delivery of Paris from Drought by Ste. Geneviève* and the *Reception of Louis XIV at the Hôtel de Ville.* In 1686 Largillierre was *reçu* by the Académie, where more than forty years later he served as director. Although he continued to paint landscapes and still lifes throughout his long career, he achieved renown for his portraits. While Rigaud, his only serious rival as a portraitist, worked primarily for the court at Versailles, Largillierre found most of his clientele among the bourgeoisie, city councilors, and successful artists who resided in Paris. Unlike Rigaud, Largillierre painted many depictions of women, either in fanciful garments and allegorical guises or, as in this case, dressed in their finest gowns and striking a grand pose in their own homes. In this painting, sometimes identified as a portrait of the marquise de la Roche Boussau, the composition and pose are similar to his *Portrait of Marguerite Bécaille,* known only from a 1715 engraving by Desplaces. Myra Nan Rosenfeld has pointed out that Georges Sortais (in his Largillierre dossiers of ca. 1912 in the Bibliothèque Nationale) reproduces a reduced version of the composition as a *Portrait of Countess Hulin.*

Antoine Watteau, 1684-1721

23. *Antoine de la Roque,* ca. 1715
Oil on canvas, 18⅛ x 21½ inches (46 x 54.5 cm.)

Private Collection, New York.

Provenance: Antoine de la Roque; Bernise Calvière, Château de Vézénobres (the descendants of la Roque); Lévy de Strasbourg.

Bibliography: E. Camesasca, *Tout l'oeuvre peint de Watteau,* Paris, 1982, p. 106, under no. 118.

Antoine Watteau studied briefly with Jacques-Albert Gerin in Valenciennes, where the younger artist was born in 1684. With little money and a few possessions, Watteau made his way to Paris, where he subsisted by copying the works of old masters in a hack studio. He became a pupil first of Claude Gillot and, by 1708, of Claude Audran. Watteau finished second in the Académie's student competition for the Prix de Rome in 1709; by that time he had already established his reputation. In 1712 Watteau presented a number of paintings to Charles de la Fosse and other senior members of the Académie for which he was made *agréé.*

Watteau's greatest contribution to the history of French art is as the inventor of the *fête galante,* the category of genre created especially for him upon the presentation of his reception piece *Le Pélerinage à l'île de Cithère* (Louvre) to the Académie in 1717. He painted a wide variety of genre scenes, however, including military subjects. The Valenciennes landscape in particular seems to have held a special place both in his imagination and in his compositions. Audran, who was chief keeper of the collections in the Luxembourg, gave Watteau access to the works therein, especially the *Marie de Médicis* series by Rubens. Though he never visited Italy, Watteau studied the works of the Italians Titian, Veronese, Rosalba and Ricci in the royal collections.

Plagued by poor health, Watteau travelled briefly to England in hopes of a cure. Slowly making his way back to Valenciennes, he died at Nogent only four years after being made *reçu.* His importance, however, was singular and lasting; his style was perpetuated and disseminated through engravings and drawings by other artists and through a number of painters specializing in *fêtes galantes.*

Watteau painted only a few portraits, but each one is striking. Antoine de la Roque (1672-1744) served as a *gendarme du Roi* until the battle of Malplaquet in 1709, where the loss of a leg ended his military career.

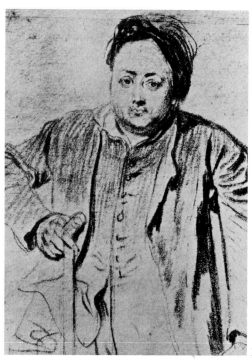

Fig. III. 1

As if to suggest how little the loss of the leg impeded la Roque's abilities, Watteau has rendered his face with great vitality. Its radiance dominates the painting.

Watteau employed a similar composition of a figure seated on a bank in his painting *L'Indiscret* (Museum Boymans van Beuningen, Rotterdam). Lancret must have been impressed by the portrait of la Roque, whom he also knew, for he made a drawing after it and incorporated the figure of la Roque in two of his paintings of hunt parties.[2] Watteau's painting established a prototype for such works as Gainsborough's *Mr. Plampin* (The National Gallery, London) and perhaps even Tischbein's *Goethe in the Campagna* (Städelisches Kunstinstitut, Frankfurt).

There is also a red chalk drawing by Watteau at the Fitzwilliam Museum, Cambridge, showing la Roque leaning on his crutches (fig. III.1).[3] Less flattering than the painting, it shows him without full wig and with a round face remarkably like that of the figure who appears at the far right of Watteau's painting *L'Amour au théâtre français* (Staatliche Museen, Berlin).

He turned his interest to literature and the arts, writing libretti for two operas, *Medée et Jason* (1713) and *Théonoé* (1715). In June 1721, he became one of the founders and editors of the important journal the *Mercure Galant* (later the *Mercure de France*). Watteau could have met la Roque as early as 1709, when the wounded soldier was convalescing at Valenciennes, or they may have been introduced by their mutual acquaintance Pierre Crozat around 1714. They became friends; la Roque collected Watteau's works and wrote his obituary for the *Mercure*.

Watteau's portrait of la Roque, which for many years was believed lost and was rediscovered only in 1921, has been given various dates in the period 1712-1719. The emphasis on the musical attributes would seem to indicate some time about 1715. It is a work with a rather unusual combination of realistic portrait and mythological figures. The arcadian setting suggests a modern Parnassus. La Roque's gesture toward his wooden leg and the armor which has been set aside seems to acknowledge his former military career. The dog looking fixedly at him suggests both that he is no longer able to indulge in the hunt and that he is now loyal to another profession, namely music and the arts, symbolized by the instruments and manuscripts on the bank by his side. As a new Orpheus, he awaits inspiration from the three muses, who are conversing with one faun and being quieted by another. This sense of la Roque's dedication was made explicit in the inscription on François-Bernard Lépicié's 1734 engraving of the painting:

> Victim of the god Mars, the muses now occupy his heart and mind. He fought for Glory and now he writes for it.[1]

[1]See Y. Sjöberg and F. Garden, *Inventaire du Fonds Français: Graveurs du XVIIIe siècle*, Paris, 1977, XIV, pp. 385-386, no. 30. A painted copy after the print is in the Musée de la Fère (Aisne).
[2]See G. Wildenstein, *Lancret*, Paris, 1924, nos. 442 and 446, pls. 106 and 109.
[3]See the exhibition catalogue *European Drawings from the Fitzwilliam*, The Pierpont Morgan Library, December 1976-February 1977, pp. 76-77, no. 122.

Nicolas Lancret, 1690-1743

24. *The Bourbon-Conti Family,* 1737
Oil on canvas, 19⅜ x 26¼ inches (49.2 x 66.7 cm.)

Krannert Art Museum, University of Illinois, Champaign. Gift of Mrs. Herman C. Krannert, 1967.

Provenance: Bourbon-Conti family, Paris; Comtesse d'Hautpoul, Paris; Sale, Hôtel Drouot, Paris, June 29, 1905, no. 44; Paul Cailleux, Paris, by 1930; Timary de Binkum; Sale, Palais Galleria, March 16, 1967, no. 28; Cailleux, Paris.

Exhibitions: Salon of 1737, Paris; *France in the Eighteenth Century*, Royal Academy, London, 1968, no. 380; *Paintings from Midwestern University Collections, Seventeenth-Twentieth Centuries*, Wildenstein and Co., Inc., New York, October 1973, no. 14.

Bibliography: Georges Wildenstein, *Lancret*, Paris, 1924, p. 107, no. 562, fig. 145.

Lancret was born in Paris to a family of artisans, but the source of his earliest training is unknown. He did, however, work for a time in the atelier of Pierre Dulin (1699-1748), a painter of history subjects and a teacher at the Académie Royale. In 1708 the young Lancret was expelled from the Académie for quarrelling. He then worked in the studio of Gillot, whose popular theatrical subjects had already influenced Watteau. Lancret also acquired a taste for theatrical subjects and was

befriended by Watteau, who encouraged him to leave Gillot and work in a more naturalistic manner.

In 1711 Lancret competed for the Grand Prix of the Académie in the category of history painting but failed. He was finally admitted in 1719 but as a painter of *fêtes galantes* – modern subjects in the style of Watteau. Following Watteau's death in 1721, Lancret's clientele came to include such great *amateurs* of the period as Crozat, the duc d'Antin, Count Tessin, and Frederick II of Prussia. He also received royal commissions for Versailles. He exhibited at the *Exposition de la Jeunesse* in 1722 and 1723, at the Salon of 1725, and the Salons in the later part of his life. He was made a *conseiller* of the Académie in 1735.

Lancret established his fame with his theatrical and *galant* subjects, but he also painted historical scenes, illustrated La Fontaine's *Fables*, and did some portraits. This work, identified as the Bourbon-Conti family, which Lancret exhibited at the Salon of 1737, is both charming and unconventional, and is perhaps influenced by such Northern artists as Gonzales Coques and Jan Mytens. The women seated at the left seem somewhat distracted by the activity of the man and woman in the center. As Mary Tavener Holmes has noted (in correspondence), the artist's choice of colors – cool ones for the older women and young girls, green and yellow for the girl of marriageable age, and deep red for her suitor – conveys subtle sexual connotations. Lancret also typically emphasizes the hands, which seem to carry the drama of the relationships. The figures are set in a verdant landscape. Dézallier d'Argenville's description of Lancret's works as "always distinguished by great truth, fine execution, rich composition, well arranged groupings, gracious figures, and a surprising lightness of touch"[1] is especially apt for this painting.

[1]D'Argenville, 1762, p. 438.

Jean-Siméon Chardin, 1699-1779

25. *Auguste-Gabriel Godefroy Watching a Top Spin,* 1738
Oil on canvas, 26⅜ x 29⅞ inches (67 x 76 cm.)
Signed and dated at the lower left: *Chardin 17..*

Musée du Louvre, Paris. Purchase, 1907.

Provenance: Commissioned by Charles Godefroy (d. 1748), father of the subject; passed to his son Charles; Auguste-Gabriel Godefroy (d. 1813); bequeathed to his first cousin Pierre Torras, Tracy-sur-Mer (Calvados) to 1858; Dr. Boutin, Versailles, 1867; to his daughter Mme. Emile Trépard.

Exhibitions: Salon of 1738, Paris, no. 116; *Chardin 1699-1779*, Grand Palais, Paris, The Cleveland Museum of Art, and Museum of Fine Arts, Boston, Jan.-Nov. 1979, No. 75.

The son of a carpenter, Chardin was born in Paris. In 1718 he was apprenticed to Pierre-Jacques Cazes, and in 1720 he began working with Noël-Nicolas Coypel.

He entered the Académie de Saint-Luc in 1724 and absorbed its standards of conscientious craftsmanship. Chardin painted humble still lifes which, when shown at an exhibition in the Place Dauphine in 1728, attracted considerable attention, notably from the painter Largillierre. That same year, Chardin had the unusual honor of being made both *agréé* and *reçu* by the Académie Royale on the same day. He was received as a "painter of animals and fruits" and his reception pieces were two large still lifes now in the Louvre – *La Raie* and *Le Buffet*.

Chardin became a regular contributor to the Salon. About 1733, he enlarged his repertoire to include figural subjects – portraits and genre scenes of bourgeois life, often influenced by seventeenth-century Dutch works. Though never able to attain a higher rank in the categories of painting, Chardin was a dedicated *académicien*. He was elected *conseiller* to the Royal Académie in 1743 and Treasurer in 1755. From then until 1774, he held the often difficult post of *tapissier* or official hanger of the Salons.

After 1751 Chardin again limited his output primarily to still lifes. These had become extremely popular and, though he was a slow painter, he often had to make several replicas. In 1752, the king gave him a royal pension and in 1757 provided lodgings for the painter and his family in the Louvre. In 1766 Empress Catherine the Great of Russia commissioned an impressive still life, *The Attributes of the Arts*, to grace the Academy of Fine Arts in St. Petersburg. Between 1771 and 1775, Chardin began producing portraits in pastel, a medium to which he turned because of failing eyesight. Despite his poor health, he continued working and exhibiting until his death.

In the Salon of 1738, Chardin exhibited a significant group of paintings, including two portraits of children, *Portrait of the daughter of M. Mahon, merchant, amusing herself with her doll* (now lost) and *Portrait of the son of M. Godefroy, jeweller, watching a top spin*. The banker and jeweller Charles Godefroy had earlier commissioned from Chardin a portrait of his older son and namesake, a work usually called *Young Man with a Violin* (Louvre). While that work dates from the period when Chardin was just beginning his figural compositions and is somewhat naive and clumsy, this boy with a top is a remarkably skilled combination of realistic still life details and an insightful portrait.

In 1742 François-Bernard Lépicié made an engraving after this painting and inscribed on it the following caption:

In the hands of caprice, to whom he abandons himself man is truly a top endlessly spinning;
His fate often depends on the movement which fortune gives to his turning.

Chardin has cast the portrait in the form of a *vanitas* theme. The elegantly dressed and coifed young man

ignores such serious pursuits as drawing, reading, or writing, represented by various implements, and is totally absorbed in his game. Another version of the painting, dated 1741 (museum at São Paulo), may be the one that was in the sale of the Chevalier de la Roque collection in 1745 or the one listed in the estate inventory of Chardin of 1779, but it is not possible to determine.

Alexis-Simon Belle, 1674-1734

26. *Louis XV in his Coronation Robes,* 1723
Oil on canvas, 88⅞ x 70⅞ inches (226 x 180 cm.)
Inscribed on the verso: *Louis XV/Rêve[t]u des/Habits d[u] jour/ de son sacre/le 25 8bre 1722/peint l'an 172[3] PAR AS/Belle*

Musée National du Château de Versailles.

Provenance: Dowager Lady Swinton, Yorkshire; Sale, Christie's, London, November 28, 1975.

Exhibition: *Cinq Années d'Enrichissement du Patrimonie National 1975-1980*, Grand Palais, Paris, October 15, 1980-March 2, 1981, no. 42.

Bibliography: F. J. B. Watson, "The Missing Coronation Portrait of Louis XV?," *The Burlington Magazine*, September 1974, pp. 534 and 537, ill. 36.

The son of a painter of Scottish origin, Belle apprenticed with François de Troy. In 1700 he won the Grand Prix of the Académie for his *Joseph Recognized by his Brothers*, but he declined the trip to Italy. The following year he was *agréé* by the Académie, married, and settled in Saint-Germain-en-Laye, where he worked for the exiled English monarch James II and his son. In 1703, Belle was *reçu* by the Académie as a portrait painter. One of his *morceaux de reception* was a portrait of his teacher de Troy (now at Versailles). In the next year, Belle exhibited at the Salon.

Belle's somewhat old-fashioned style of portraiture, with great attention to rich materials, made him a popular painter with the French and Polish royal families as well as the English. His first employment for the French court dates from 1722, when he painted portraits of the nobility attending the coronation at Reims. The inscription on the present painting indicates he must have also received a commission to paint the coronation portrait of the king himself. Possibly this is based on a sketch of "the king on his throne the day after the Coronation receiving the respects of the grand master of the Order of the Holy Spirit," commissioned by the duc d'Aumont in 1722.[1] This 1723 painting may well be, as Francis Watson has suggested, the portrait of the king for which it is recorded that the artist was paid 700 *livres*.[2]

For this portrait of the king in his coronation robes, Belle relied to some extent on the well-known portrait (ca. 1717) of the youthful monarch by Rigaud, which is now at Versailles and of which one of several versions

Fig. III. 2

is in The Metropolitan Museum of Art (fig. III.2). In both, the enthroned figure wears the coronation robes and regalia, the ermine-trimmed *manteau royal* of blue velvet embroidered with gold fleurs-de-lis and lined with scarlet, and the chain with the Order of The Holy Spirit. While in the Rigaud, the king holds a short sceptre, in the Belle he holds the great long staff of Charles V; instead of white stockings, he wears boots decorated with fleurs-de-lis. The most notable change is that whereas in Rigaud's work the figure is simply a child dressed up, in Belle's painting he is clearly a self-aware young man who looks directly out at the viewer, having literally assumed the mantle of kingship.

[1]Jean Messelet, "Belle," in Dimier, 1930, I, p. 289.
[2]Engerand, 1901, p. 19.

Pierre-Hubert Subleyras, 1699-1749

27. *Pope Benedict XIV,* ca. 1741
Oil on canvas, 47½ x 37 inches (120.5 x 94 cm.)

Snite Art Museum, University of Notre Dame. Gift of Morris L. Kaplan, 1955.

Provenance: Morris L. Kaplan, Chicago.

Exhibition: *Eighteenth Century France, A Study of its Art and Civilization*, Art Gallery of Notre Dame, 1972, no. 83.

Benedict XIV (Prospero Lambertini) was pope from 1740 to 1758. He was both a scholar and a patron of the arts. He collected prints and antiquities, founded the Egyptian Museum of the Vatican, and ordered the restoration of several important churches for the Holy Year of 1750. Something of a Francophile, he corresponded with Voltaire and gave support to Subleyras. Shortly after his coronation, the pope asked Subleyras

84

and the popular Italian portraitist Masucci to compete in producing his official likeness. Masucci's standing effigy of the pontiff (Accademia di San Luca, Rome) presented him, in Anthony Clark's memorable phrase, as "a chilled hippopotamus."[1] Subleyras's painting, completed early in 1741, was the one given preference.

Subleyras's original was given by Benedict XIV to the University of Paris in 1757 and is now in the Musée Condé, Chantilly.[2] A simplified version can be seen in Subleyras's painting of his studio (Vienna). There are several recorded replicas of the portrait produced by Subleyras and his workshop. One was sent to Spain by Cardinal Acquiviva, leading to an invitation to Subleyras from the Spanish king to enter his service, but the painter declined. This version at the Snite Museum appears to be of better quality than those in the Museum of Ferrara and the Palazzo Spada, Rome. Other copies are recorded at the Church of the Salute, Venice, the Library of Bologna, and at Versailles.[3]

Subleyras's composition is very impressive. The pose of the seated pope may summon up memories of such Renaissance papal portraits as Raphael's *Leo X* and Titian's *Paul III*, but Subleyras's Benedict XIV is endowed with an engaging directness and humility. The pope's power is represented subtly through the richness of his garments and his surroundings, emblazoned with his family coat of arms.

[1] Anthony M. Clark, "Agostino Masucci," in *Studies in Roman Eighteenth-Century Painting*, Washington, 1981, p. 98.
[2] See *Cent Tableaux du Musée Condé*, Château de Chantilly, n.d., pl. LXXIV.
[3] Odette Arnaud, "Subleyras," in Dimier, 1930, II, pp. 62, 83.

François Boucher, 1703-1770

28. *Marquise de Pompadour,* ca. 1750
Oil on canvas, 29⅜ x 24⅛ inches (74 x 61 cm.)

Portland Art Museum, Portland, Oregon. Purchase with anonymous funds, 1965.

Provenance: Frouville; Baron d'Achon; Lamolere-Boisfleury; Favier; S. R. Berton, New York (ca. 1928); Wildenstein, New York (ca. 1933); William Randolph Hearst; Marion Davies; Schaeffer Galleries, New York; Mrs. Edwin Binney, Jr., and Dr. and Mrs. Edwin Binney.

Exhibition: *Paris-New York, A Continuing Romance,* 1977, Wildenstein, New York, no. 31.

Bibliography: Ananoff, 1976, II, pp. 31-32, no. 334, fig. 946; Idem, 1980, no. 348.

The woman who became Madame de Pompadour was of bourgeois origin. She was the wife of the *fermier général* Lenormant d'Etoiles when Louis XV first espied her one day in 1744. She was attractive, intelligent, witty, a marvelous dancer, and was able to amuse the bored monarch. Towards the end of the year, following the death of Madame de Chateauroux, the *maîtresse déclarée*, the king began his liaison with Madame d'Etoiles. In the following year, she was named Marquise de Pompadour and established in apartments at Versailles as the king's official mistress. There she remained until her death on April 15, 1764, even though she had ceased being the royal mistress in 1752. In place of sexual relations, she continued to offer him devotion and generally sound advice on both political and cultural matters. Her brother, the marquis de Marigny, was appointed *directeur des bâtiments*. She was a friend of Voltaire's, had a private theatre built at Versailles where she herself often performed, and also studied the art of engraving. Her greatest passion, however, was for building and decorating houses, which produced many projects for her favorite artists. None was more favored than Boucher, who through her patronage received most of his major commissions and appointments.

Madame de Pompadour was portrayed by several artists, including van Loo, La Tour, and Drouais, but it is in depictions by Boucher that her mercurial features are best captured. In this painting, which according to Ananoff may be the one she sent to her brother between December 1749 and September 1751, there is a casual air, quite different from the formality of that showing her at her *toilette*, which is now at the Fogg Art Museum, or the grandiose painting in Munich. Her costume could almost be that of one of the classical nymphs or goddesses whom she liked to impersonate on the stage. Here, as in most portraits of her, a floral motif has been worked into the picture, undoubtedly reflecting her own love for flowers.

Jean-Marc Nattier, 1685-1766

29. *Madame de Maison-Rouge as Venus,* 1757
Oil on canvas, 48½ x 38 inches (123.2 x 96.5 cm.)
Signed and dated at lower left corner: *Nattier pinxit, 1757.*

Mr. and Mrs. Stewart Resnick, Los Angeles.

Provenance: Baron Maurice de Rothschild, Paris, and by descent in the Rothschild family; P. and D. Colnaghi & Co., Ltd., London.

Exhibition: Salon of 1757, Paris.

Bibliography: Pierre de Nolhac, *Nattier*, Paris, 1925, pp. 222, 227, 228.

Nattier's father was a portrait painter and his mother a talented miniaturist. After studying with his parents, he displayed a remarkable facility as a draughtsman, winning a prize for drawing at age fifteen. With his older brother Jean-Baptiste, he was granted permission by Louis XIV to prepare drawings after Rubens's *Marie de Médicis* cycle which were then engraved. On the advice of Jean Jouvenet (with whom Nattier had also studied), the duc d'Antin offered the young artist the opportunity to study at the Académie in Rome, but Nattier declined. In 1715 he was *agréé* at the Académie as

a painter of history. In 1717 he was called by Czar Peter the Great to his court, then in residence in Holland; Nattier painted portraits as well as a battle scene featuring the Czar, who invited him to Russia, but Nattier chose to return to Paris. In October of 1718 he presented his reception piece to the Académie, *Perseus Turning Phineus to Stone* (Tours).

Primarily for financial reasons, the painter began specializing in portraiture. He achieved his first success with a portrait commissioned in 1723 by the Maréchal de Saxe, and followed with a famous portrait of Mademoiselle Clermont in 1729. Nattier was employed by the duc d'Orléans, le Grand Prieur du Temple, to succeed Raoux as his official painter. He refined Raoux's manner of depicting women in the guise of classical goddesses into the full-fledged genre of the *portrait déguisé*, and it was these works that brought him great fame. Beginning in 1740, Nattier was employed by the royal court and painted numerous allegorical likenesses of the "Mesdames de France" as well as sensitive realistic portraits of the queen, Marie Leczinska.

In this portrait, Madame de Maison-Rouge is represented as Venus tying ribbons on doves. The painting was shown at the Salon of 1757 and has been justly described by Nolhac as one of the artist's *chefs d'oeuvres*. It is an excellent example of Nattier's conception of idealized female beauty. The figure, seated on clouds, displays perfectly powdered hair, cheeks with a strong flush, bare arms and a bosom of flawlessly smooth skin, and is swathed in yards of the finest materials in pastel pinks and blues.

Jacques-André-Joseph Aved, 1702-1766

30. *Madame Brion,* 1750
Oil on canvas, 50⅝ x 38⅛ inches (128.6 x 97 cm.)

Private Collection, New York.

Provenance: Paul André by 1935.

Exhibitions: Salon of 1750, Paris, no. 79; *French Portraits: XVII-XX Century*, Wildenstein, London, June 16-July 30, 1982.

Bibliography: Georges Wildenstein, *Le Peintre Aved: sa vie et son oeuvre*, Paris, 1922, I, p. 74, and II, p. 31, no. 17; Idem, "Le Peintre Aved, premier supplément," *GBA*, March 1935, p. 162, no. 17.

Though he is little known today, Jacques-André-Joseph Aved was one of the finest portraitists of the eighteenth century. He was a close friend of Chardin, who painted his portrait. Aved's work is notable for its lack of idealization; he presented his sitters realistically in an appropriate environment. In part this can be explained by his taste for Dutch art. Born near the Flemish city of Douai, he was trained in Amsterdam by the exiled French printmaker Bernard Picart, and later formed a notable collection of seventeenth-century Dutch paintings. Arriving in Paris in 1721, Aved found

his *métier* working with the portrait painter Alexis-Simon Belle. He was *agréé* by the Académie in 1731 and *reçu* as a portrait painter in 1734, the same year that Belle died. His reception pieces were portraits of the painters Cazes and Jean-François de Troy.

Aved began exhibiting at the Salon in 1737 and had his first great success with a portrait of the poet Jean-Baptiste Rousseau. He developed a clientele of distinguished collectors, diplomats, and nobility. Already in 1739 a critic could write, "Aved and Tocque dispute for primacy among portrait painters."[1] Although his commissions included a portrait of Louis XV completed in 1774 and one of the Dutch Stadhouder William IV (for which he travelled to the Hague in 1751), Aved was primarily a painter of the bourgeoisie. His painting of Madame Crozat, shown at the Salon of 1741 and now in the Museum of Montpellier, established a prototype of candid portraiture. The woman is shown removing her glasses as she pauses in her sewing; the elaborate garments and profusion of detail create a grand, almost architectural, composition.

The same approach was adopted in this portrait of Madame Brion. She has paused momentarily, looking up from her tea to regard us with sparkling eyes that convey her satisfaction with her comfortable – if slightly disorganized – home. As in many of Chardin's paintings, there is the suggestion of work put aside (a basket of sewing to the left) and details such as the open drawer in the foreground. Aved, however, is clearly an independent master in the painting of fabrics and materials. *Madame Brion* does not seem to have impressed the Salon critics. One writer described Aved's portraits on view that year as "colder and more monotonous than those of Perroneau," but did end on a positive note by asserting that "his likenesses were accurate" and "his simplicity had merit."[2]

[1]*Description raisonnée des tableaux exposés au Salon du Louvre*, Paris, 1739, pp. 7-8.
[2]*Lettres sur la Peinture à un Amateur*, Geneva, 1750, p. 28.

Joseph-Siffred Duplessis, 1725-1802

31. *Madame de Saint-Maurice,* 1776
Oil on canvas, 39½ x 31⅞ inches (100.3 x 81 cm.)

The Metropolitan Museum of Art, New York City.
Bequest of James A. Aborn, 1968.

Provenance: Carleton Gates, New York; Sale, Leavitt, New York, December 21, 1876, no. 479 (as *Portrait of Mme. Necker*); James A. Aborn, New York (d. 1968).

Exhibitions: Salon of 1777, Paris, no. 123; Salon of 1779, Paris, no. 130.

Bibliography: *J.-S. Duplessis, Peintre du Roi, 1725-1802*, Chartres, 1913, pp. 82, 326, 333, no. 129, p. 336, no. 144.

The son of a surgeon who had become a painter, Duplessis was born at Carpentras in Provence. After

studying with another local painter, Duplessis journeyed to Rome and worked closely for four years with Subleyras. He then returned to France, working in Carpentras and Lyon before finally going to Paris in 1752. He first exhibited his portraits at the Académie de Saint-Luc in 1764, and was *agréé* by the Académie Royale in 1769, when his portraits were acclaimed at the Salon. He was only *reçu* as a portraitist in 1774, the year of Louis XVI's accession. He was the favorite portraitist of the king, who appointed him Director of the Galleries of Versailles. Duplessis's skill in the presentation of character and the depiction of elaborate garments made his portraits popular not only with royalty (including Marie Antoinette) and aristocrats such as the comte d'Angiviller, but also with the bourgeoisie. His two 1778 portraits of the visiting American statesman Benjamin Franklin found such favor that his studio made many replicas. Duplessis was also chosen by artists and musicians such as Gluck, Allegrain, and Vien to paint their portraits.

The identification of this sitter is made possible by reviews of the Salon of 1777 and by Saint-Aubin's sketch of the painting in his copy of the 1777 Salon *livret*. The painting was exhibited as one of "several portraits," but fortunately Saint-Aubin not only made his rapid study (fig. III.3, opposite catalogue number 123) but also identified it as "*Madame de St. Maurice Femme d'un Conseiller au parlement.*"[1] Although the painter's full-length *Portrait of the King* (also sketched by Saint-Aubin) received the most attention, the *Mercure de France* in its Salon review wrote that "Duplessis's portrait of a woman dressed in part in muslin is astonishing for the truth and freshness of the skin tone, the modelling of the face and hands, the delicacy and the lightness of the garments."[2] It is probable that the painting was also exhibited again by Duplessis at the Salon of 1779 as number 130, *Portrait de Madame ****, for a *salonnier* of that year referred to it as "a portrait of a woman at her dressing table which was exhibited previously."[3]

Duplessis's depiction of Madame de Saint-Maurice is a *tour de force* of the portraitist's art. The bravura of the painting, especially the transparency of the material, conveys a remarkable delicacy. Mlle. Lesuire in her review of the work in 1777 described it as a "woman of fine countenance at her toilette." Praising Duplessis as "the genius [*l'aigle*] of portrait painting," she goes on to say that the woman in this painting "has such naturalness that it is almost like a mirror in which one views the person who is reflected."[4]

[1] *Dacier, Saint-Aubin,* 1910, IV, pp. 42, 49.
[2] *Mercure de France,* October, 1777, p. 188.
[3] *Ah, ah! Encore une critique du Salon,* Paris, 1779, p. 28.
[4] Mlle. Lesuire, *Jugement d'une demoiselle…sur le Salon, 1777,* Paris, 1777, p. 20.

Jean-Baptiste Greuze, 1725-1808

32. *Madame Gougenot de Croissy,* 1757
Oil on canvas, 31½ x 24¾ inches (80 x 63 cm.)

New Orleans Museum of Art. Purchase, Ella West Freeman Foundation Fund and Women's Volunteer Committee Fund, 1976.

Provenance: Baron de Soucy, Paris, 1888; Sale, Galerie Jean Charpentier, Paris, December 14, 1937, lot B (bought in); his daughter, comtesse Joachim de Dreux-Brézé, Paris, 1953; her son, comte Charles Evrard de Dreux-Brézé, Paris, 1958; Galerie Cailleux, Paris, 1968; Private collection, New York; Dr. Klaus Virch, Kiel.

Exhibition: *Jean-Baptiste Greuze, 1725-1805,* Wadsworth Atheneum, Hartford, Connecticut, 1976-1977, no. 18.

Greuze played a pivotal role in the history of French painting. Immensely popular during the middle part of the eighteenth century, his reputation went into eclipse at the end of his life and has only recently been reestablished. Born in Tournus to a merchant of masonry and tile, he studied first at Lyon under Charles Grandon, a specialist in portraiture. He came to Paris and enjoyed almost immediate success with his *Family Bible Reading*, which he may have begun in Lyon, and which was bought by an *amateur* who exhibited it privately before its public debut at the Salon of 1755. Having been *agréé* earlier that year, Greuze left for Rome with his first important patron Louis Gougenot, abbé de Chezal-Benoît. In Italy he met Natoire and studied the work of Guido Reni as well as his contemporaries Subleyras, Fragonard, and the Scotsman Gavin Hamilton. Greuze returned to Paris in 1757.

His second great success came at the Salon of 1761 where his *A Marriage Contract* (Louvre) was exhibited. In this work the cult of *sensibilité* found its supreme visual expression. Diderot hailed its "high principles" and in 1765 called him "the first who had endowed art with morality." Greuze, however, conscious of the hierarchy of genres, wished to be accepted by the Académie as a history painter. He attempted to transfer the moralizing parable of filial piety into a more classical and severe setting for his reception piece of 1769, *Septimius Severus Reproaching Caracalla* (Louvre), but he was *reçu* as a genre

87

ortrait de M. le Préfident d'Or-
meſſon.
121. Portrait de M. Ducis, Secrétaire de
MONSIEUR, & Aſſocié à l'Aca-
démie de Lyon.
122. Portrait de M. le Marquis de Bièvre.
123. Pluſieurs Portraits, ſous le même
numéro.

Par M. AUBRY, Académicien.

Fig. III. 3

Fig. III. 4

88

painter. This disappointment caused Greuze to break with the Académie, and he did not exhibit at the Salon again until after the Revolution. Working and exhibiting privately in his own studio, he was able to achieve even greater financial reward and public notoriety for his many sentimental subjects. In the final decades of his life, he received the patronage of the Bonapartes.

Following his return from Rome, Greuze was much sought after as a portrait painter. Among those he painted in 1757 were his patron Louis Gougenot (Dijon) and his younger brother George Gougenot de Croissy and his wife. The painting of Gougenot de Croissy, who succeeded his father as *conseiller-secrétaire* to the king, is now in the Musée Royale des Beaux-Arts, Brussels (fig. III.4). This portrait is of his wife, who was born Marie-Angélique de Varenne in 1737, the daughter of Marie-Jacques Vérany de Varenne, squire and *conseiller-secrétaire* to the king.

Greuze's portraits concentrate attention on the faces of his sitters, who regard the viewer with disarming candor. Greuze has represented both Gougenot de Croissy and his wife with tokens of their interests. He is shown with an open volume identifiable as Addison and Steele's *The Spectator* of 1753, and she is shown holding a *navette*, a type of ornamental shuttle for lace knotting. This served little real purpose, but was carried by fashionable women of rank to indicate their diligence.

François-Hubert Drouais, 1727-1775

33. *La Marquise d'Aiguirandes,* 1759
Oil on canvas, 39¾ x 31½ inches (101 x 80 cm.)
Signed at upper left: *Drouais fecit 1759.*

The Cleveland Museum of Art. John L. Severance Collection, 1942.

Provenance: M. de Cailleux, Lyon descendant of the sitter; Wildenstein & Co., New York; John L. Severance, Cleveland.

Bibliography: *The Cleveland Museum of Art Catalogue of Painting, Part Three, European Paintings of the 16th, 17th and 18th Centuries,* Cleveland, 1982, p. 67, no. 28, fig. 28.

Drouais was both the son and father of a painter. He was trained by the leading artists of his youth – Carle van Loo, Natoire, and Boucher – from whom he learned the requisite style of elegance and high finish for his career as a portraitist of the fashionable court of Louis XV. Drouais, *agréé* in 1754, began exhibiting at the Salon that same year and painting for the court in 1756. He was *reçu* in 1758 with two portraits. Despite harsh criticism from Diderot, he was an immensely popular artist, rivaling Nattier, whose style of allegorical portraits he occasionally attempted. Drouais's talents, however, were better suited to straightforward representation, especially of children. His figures, dressed in their most luxurious garments, were placed in richly decorated interiors, as in the present example or the equally elaborate 1767 *Portrait of the Marquise de Caumont-La Force* (Ball State University). His quintessential works are his portraits of the royal mistresses Madame de Pompadour and Madame du Barry. Writing of one of his portraits of Madame de Pompadour, Baron Grimm observed that all the major artists had painted her, but Drouais was "the only man who knows how to paint women, because he knows how to capture that delicacy and grace which gives charm to their features."[1]

The Marquise d'Aiguirandes was the daughter of Mademoiselle Leduc de Jourvoie and Louis de Bourbon-Condé, comte de Clermont and a prince of royal blood. Her husband was a cavalry captain in her father's regiment and also his master of the hunt. It is possible that this painting, dated 1759, is the one shown at the Salon of that year as *Un Portrait de femme,* the pendant to *Le portrait de M le Comte de...en Hussard.*[2] Of these Diderot observed, "If you are curious to see insipid faces, you ought to take a look at the paintings by Drouais. Wherever this falsehood comes from, it is certainly not from nature."[3]

[1]Grimm, *Correspondance,* August 15, 1764, quoted C. Gabillot, "Les Trois Drouais," *GBA,* 1906, p. 156.
[2]Salon of 1759, nos. 89, 90. See Seznec and Adhémar, I, 1957, p. 50.
[3]Ibid, p. 67.

Jean-Honoré Fragonard, 1732-1806

34. *L'Inspiration (Portrait of a Writer),* ca. 1769
Oil on canvas, 31½ x 25⅝ inches (80 x 65 cm.)

Musée du Louvre, Paris. Gift of Dr. La Caze, 1869.

Provenance: Dr. Louis La Caze.

Bibliography: G. Wildenstein, 1960, p. 254, no. 241; Charles Sterling, *An Unknown Masterpiece by Fragonard,* Sterling and Francine Clark Art Institute, Williamstown, Mass., 1964, fig. 3; D. Wildenstein and G. Mandel, 1972, p. 97, no. 257; "Fragonard," *Le Petit Journal du Louvre,* Paris, 1974, no. 10.

In 1769, the year Fragonard married the miniaturist Anne Gérard, he painted a series of marvelously exuberant bust-length figures, the *têtes* or *figures de fantaisie.* Fourteen of these are known and at least four were painted for his friend and patron the abbé de Saint-Non. There is good reason to believe that these works are based on real people. In the miniaturist Pierre-Adolphe Hall's 1778 inventory of his collection, he notes "a head of me from the time that Fragonard did portraits in one fell-swoop for one Louis."[1] Hall's portrait has not been identified but two of the *têtes de fantaisie* in the Louvre have eighteenth-century inscriptions on the back indicating that they are portraits of Saint-Non (fig. III.5) and his brother La Bretèche painted by Fragonard in 1769 "in one hour's time." Among the other *têtes de fantaisie* in the Louvre are portraits of Marie-Madeleine Guimard and the philosopher Denis Diderot. All these figures are dressed in

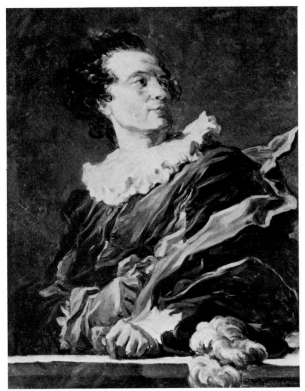

Fig. III. 5

extravagant theatrical costumes called at that time "*à l'espagnole,*" a practice which, as Charles Sterling has pointed out, was probably inspired by such Venetian artists as Liss and Fetti, whose work Fragonard would have seen in Venice in 1761. Fetti's *Portrait of an Actor* was in the Crozat collection in Paris until 1772.

Although the subject of this painting has formerly been identified as Saint-Non, there is no basis for this. Rather, just as other of the *figures de fantaisie* can be characterized by their attributes as an "artist," "musician," or "warrior," so this man seems to be a writer, perhaps a poet. He is poised, pen in hand, in mid-thought. The title *Inspiration* is, as far as we know, of nineteenth century origin, but it seems appropriate to the pose of the figure, derived from ancient conventions for representing the evangelists and prophets. Here Fragonard suggests the spiritual process of creativity in which the genius is seized by inspiration, an extremely important notion in eighteenth century thought. The painting itself seems a result of what Diderot described as a *"moment de l'enthusiasme."*[2]

[1] Quoted in Sterling, p. 1.
[2] See Herbert Dieckmann, "Diderot's Conception of Genius," *Journal of the History of Ideas,* April 1941, p. 164.

François-André Vincent, 1746-1816

35. *Neapolitan Woman,* 1774
Oil on canvas, 32 x 19¾ inches (81.2 x 50 cm.)
Signed and dated illegibly at lower left: ... *nt f. Naple 177..*

Jacqueline and Matt Friedlander, Moultrie, Georgia.

Provenance: Pierre-Jacques-Onésyme Bergeret de Grancourt, Paris; Sale, Paris, April 24, 1786, no. 93; Desmaret collection; Count Potocki; Mrs. Dora Alderson Curtis; Wildenstein and Co., New York.

Exhibition: Salon of 1777, Paris, no. 192.

Vincent was one of the artists who most successfully bridged the Revolutionary period, moving from the rococo technique of his early work to a more severe neo-classical manner for his many scenes of French and Roman history. The son of a miniature painter of Swiss origin, he had also studied with Vien. At the age of nineteen, he placed second in the Grand Prix competition and two years later he won first place with his painting of *Germanicus.* He then spent a brief time at the Ecole Royale des Elèves Protégés before departing for the French Académie in Rome in 1771. Following his return to France in 1775, he was *agréé* in 1777, and exhibited at the Salon a *Belisarius* painted in Rome. His reputation was definitely established in 1779 with his first major painting of French history, *President Molé stopped by Insurgents.*

During the time Vincent was in Rome, the collector Bergeret de Grancourt, travelling with Fragonard, visited the city. According to Bergeret's diary, they invited

Vincent to show some of his works in their rooms in March of 1774.[1] The following month Bergeret and Fragonard went to Naples and, based upon the inscription on the painting exhibited here and on a drawing at the Metropolitan Museum,[2] Vincent was there at the same time. Whether he actually accompanied them, Bergeret's journal does not confirm, but it does mention the singular style of dress of the Neapolitan women. The visitors witnessed the feast days of the city's patron saint, Januarius, and the King of Naples, so local costumes were at their most brilliant.[3] The same woman who served as a model for Vincent's painting is the subject of a full-face wash drawing by Fragonard (fig. III.6, Mr. and Mrs. Eugene Victor Thaw, New York), which is inscribed *Naples 1774 femme de Ste. Lucie*. As Eunice Williams has pointed out, this refers to the famous Passeggiata di Santa Lucia, a popular gathering place for Sunday strollers and carriages.[4] In addition to this drawing and painting, there are three other drawings of the same figure which have been attributed to Fragonard – a full-length depiction of the woman seated (fig. III.7) also inscribed *femme de Ste. Lucie* (Ananoff 181, in the Städelesches Kunstinstitut, Frankfurt),[5] one of her standing (fig. III.8) in a pose very similar to Vincent's painting (Ananoff 718, formerly in the Gasc collection),[6] and another sold in 1898 (Ananoff 719). Ananoff suggests that the last is by Vincent.[7] We think that all three are Vincent's preparatory studies for this painting. Vincent prepared a *Liber Veritatis* with watercolor illustrations of the works he painted in Italy and among these are both a copy of this painting of the Neapolitan woman and an oval bust-length study of her as well.[8]

Following his return to France, Vincent exhibited at the Salon of 1777 a painting described in the *livret* as

90

Fig. III. 7

Fig. III. 8

Fig. III. 6

deux Tableaux ont 3 pieds & demi,

ôme, retiré dans les déferts;
nd l'Ange de la mort qui lui
nce le Jugement dernier.

leau de 7 pieds & demi de large, fur
s & demi de haut.

Figure en pied : coftume Na-
tain.

leau de 3 pieds 11 pouces de haut,
pieds de large.

Fig. III. 9

"Une figure en pied: costume Napolitain." From the sketch after it by Saint-Aubin (fig. III. 9) we can identify the composition as that of the present painting. The dimensions given for the Salon painting are larger than those of our painting, but as Jean-Pierre Cuzin has pointed out, it was often the practice during this period to include the dimensions of the frame in the measurement, and there is little doubt that there was only one painting by Vincent. Most of the Salon reviewers commented on a *St. Jerome* that Vincent also exhibited, but one writer noticed the *"petite Napolitaine"* and described it as "worthy of the great masters."[9] Indeed the richness of the work is almost Rembrandtesque.

It is probable that at the time of the Salon the painting already belonged to Bergeret de Grancourt, who had commissioned Vincent to do his portrait and had also acquired another of his works of the Italian period, *The Drawing Lesson.* In the catalogue of the sale of Bergeret de Grancourt's collection, the painting of *Une jeune Napolitaine* was described in detail and the following appreciation offered: "The simple and gracious pose, the elegance of the painting, and the charm of the color all in harmony makes this a painting of the greatest interest."[10]

[1]See A. Tournézy, *Bergeret et Fragonard: journal inédit d'un voyage en Italie,* Paris, 1895, p. 245.
[2]The drawing, *Martyrdom of St. Bartholomew* after Preti, is reproduced in E. Williams, *Drawings by Fragonard in North American Collections,* exhibition catalogue, National Gallery of Art, Washington, D.C., 1978, no. 71.
[3]See the description in the edition of Bergeret edited by M. de Romilly, *Voyage d'Italie, 1773-1774,* 1948, pp. 111-113.
[4]Williams, p. 94.
[5]Reproduced also in Jean-Jacques Lévêque, *Fragonard,* Paris, 1983, p. 156.
[6]Ibid., p. 63.
[7]Ananoff, 1961-1970, II, p. 66. It should also be noted that a very similar figure appears in a drawing attributed to Hubert Robert, who visited Naples in 1760. See *Hubert Robert (1733-1808) Dessines et Peintures,* exhibition catalogue, Galerie Cailleux, Paris, 1979, no. 8.
[8]These have been published by Georges Wildenstein, *Oeuvres romaines de François-André Vincent, un essai de Liber Veritatis,* Paris, 1938.
[9]*La Prêtresse ou nouvelle manière de Prédire,* 1777, p. 20.
[10]*Catalogue des tableaux des trois écoles, M. Bergeret,* Paris, April 24, 1768, p. 46, no. 93.

Elisabeth Louise Vigée Le Brun, 1755-1842

36. *Madame du Barry,* 1782
Oil on canvas, 43 x 35 inches (114.3 x 89 cm.)
Signed and dated at lower right: *E. Vigée Le Brun 1782*

Corcoran Gallery, Washington, D.C. Gift of William A. Clark, 1926.

Provenance: Jacques Seligmann: Sold 1917 to William A. Clark.

Bibliography: Joseph Baillio, "Identification de quelques Portraits d'Anonymes de Vigée Le Brun aux Etats-Unis," *GBA,* November 1980, pp. 158-160, 167, fig. 3.

Elisabeth Louise Vigée was born in Paris, the daughter of a minor portraitist and pastellist. Largely self-taught, she followed the advice of Vernet to look at works of Flemish and Italian masters, and she studied paintings by Rubens, van Dyck, Domenichino, and Reni. In Paris she was particularly influenced by the work of Greuze.

At age nineteen Vigée was received by the Académie de Saint-Luc as a portraitist. The following year she married the artist, dealer, and connoisseur Jean-Baptiste-Pierre Le Brun. Their combined interests helped to make Elisabeth's literary and musical salons among the most fashionable in Paris.

Six years before the Revolution, Vigée Le Brun painted her first portrait from life of Marie Antoinette, marking the beginning of an association which crystalized the painter's fame. During the same year she was, by royal command, *agréée* and *reçue* on the same day by the Académie Royale. She exhibited in both history and portraiture at the Académie's Salons until 1789 when, sensing danger caused by her connection with the royal family, she fled Paris. Travelling across the continent, she worked for twelve successful years as a portraitist to royal and aristocratic patrons in Italy, Austria, Germany, and Russia. While in exile she also composed her famous autobiography, *Souvenirs.* She returned to France after the turn of the century and was able to regain much of her popularity.

Known as the most powerful and beautiful woman in France during the later part of Louis XV's reign, Madame du Barry (1743-1793) had begun life as the illegitimate daughter of a seamstress and a monk in Lorraine. She was raised in a Paris convent and at age fifteen became a companion to the widow of a *fermier-général,* Madame de la Garde. In this position she met a number of men and began her remarkable career as a *demoiselle du monde.* Through her stepfather, she was introduced to the dissolute comte du Barry, who established her in his apartments and collected a great deal of money as commission from the men who wished to sleep with her. She entertained many important noblemen, including the maréchal de Richelieu, in the process perfecting her manners and her charms. Word of her beauty reached the fifty-eight-year-old king, who was entranced not only by her looks but also by her sweet and undemanding personality both in and out of bed. To facilitate matters, the comte du Barry's brother was wed to her on September 1, 1768. The ceremony, performed by her own father, made her officially the comtesse du Barry; her husband returned to Languedoc and she was installed in rooms at Versailles close to those of the king.

On April 22, 1769, Madame la Comtesse du Barry, to the shock of many of the entrenched nobility, was officially presented at court. Unlike the Marquise de Pompadour, she did not mix in political affairs but contented herself with amassing a great fortune in jewels, clothes and furniture. The king gave her the small château of Louveciennes which she transformed into a

veritable jewel box of treasures. She commissioned many pieces from the porcelain factory at Sèvres, and she was also a patron of the talented dress designer Rose Bertin.

Following Louis XV's death in 1774, Madame du Barry – who had only been reluctantly tolerated by Marie Antoinette – was consigned to a convent for two years, but then returned to her beloved Louvenciennes, where she remained until the Revolution with the handsome duc de Brissac, Gouverneur of Paris until he was killed by an angry mob in 1792. In September of 1793, she was arrested and tried as a British spy, her immoral past was used against her, and she was condemned to be guillotined.

Although Madame du Barry's own favorite portrait painter had been Drouais, the duc de Brissac in 1781 chose Madame Vigée Le Brun – the most fashionable of portrait painters – to record the beauties of his mistress. The artist recalled some years later:

> [Madame du Barry] received me in the most gracious style. She seemed to have excellent manners, but I found her wit more easy than her politeness. Her glance was that of a coquette; her large eyes were never completely open and her speech had a childish quality which no longer befitted her age…Winter and Summer she wore only robes of white percale or muslin and every day no matter what the weather, she went for a walk.[1]

As Joseph Baillio has shown, the painting in the Corcoran Gallery is the second of three protraits of du Barry known to have been painted by Vigée Le Brun from life. The first, half-length, showing her facing to the left and wearing a wonderful plumed hat in the *style anglais*, is in a private collection in France. The third, also is in a private Parisian collection, was begun in 1789 and only finished in 1820; it shows her seated outdoors holding flowers. In her *Souvenirs*, Vigée Le Brun described this second painting of the courtesan: "She is dressed in white satin; in her hand she holds a *couronne* and one of her arms rests on a pedestal."[2] She goes on to relate that she had recently seen the painting and the head had been somewhat repainted. Now that the painting has recently been restored, we can again appreciate both the talent of Vigée Le Brun and the ravishing beauty of du Barry, who had been described by Colleval as having "the most beautiful blond hair, so abundant that she hardly knew what to do with it."[3] The likeness must have pleased Madame du Barry, for she had it copied, as Baillio discovered, in a miniature on a box formerly at Mentmore that bore the inscription *Souvenir d'Amitié de la Comtesse Du Barry*. In 1979 an oval bust-length copy after the painting was in the New York art market as a *Portrait of Mlle Montalivet* by Hoin.[4]

[1]Vigée Le Brun, *Souvenirs*, Paris, 1835.
[2]Ibid., pp. 167-8.
[3]Quoted in Olivier Bernier, *The Eighteenth-Century Woman*, New York, 1981, p. 81.
[4]*The Burlington Magazine*, March, 1979, p. xc.

Jacques-Louis David, 1748-1825

37. *Jacques-François Desmaisons*, 1782
 Oil on canvas, 36 x 28½ inches (91.5 x 72.4 cm.)
 Signed and dated: *J. L. David f. 1782*

Albright-Knox Art Gallery, Buffalo, New York. Purchase, 1944.

Provenance: The artist's family; Baudry (by 1880); J. Regnault; Sale, Hôtel Drouot, Paris, June 22, 1905, no. 1; D. David-Weill, Neuilly-sur-Seine (until 1937); Wildenstein and Co., New York.

Exhibitions: Salon of 1783, Paris, no. 163; *Paris-New York, A Continuing Romance*, Wildenstein, New York, November 3 – December 17, 1977, no. 33.

Bibliography: Steven A. Nash, *Albright-Knox Art Gallery, Painting and Sculpture from Antiquity to 1942*, Buffalo, 1979, pp. 186-187; Anita Brookner, *Jacques-Louis David*, New York, 1980, pp. 65 and 66; Antoine Schnapper, *David*, Paris, 1980, pp. 66, 68, ill. 28.

Although David was a key figure in the development of French art in the later eighteenth century, his talent matured slowly. He began studying with Vien in 1768 but did not win the coveted Prix de Rome until 1774. When he returned from Italy, he exhibited at the 1781 Salon his first masterpiece, *Belisarius* (Lille), which marked the emergence of a large-scale neo-classical "Davidian" style that brought him great renown. He continued to pursue this with a series of remarkable works derived from classical subjects: *Hector and Andromaque* (1783, Louvre), *Oath of the Horatii* (1785, Louvre), *Death of Socrates* (1787, Metropolitan Museum) and *Brutus* (1789, Louvre).

These dramatic pictures reflect republican sympathies which gave David an important role in both the art and politics of the Revolution. Full of grudges against the Académie, he helped abolish it in 1793. A member of the Committee for Public Safety, he voted for the death of the king, and as a supporter of Robespierre was imprisoned briefly after the latter's fall. David, an early admirer and propagandizer for Napoleon, ended his days as an exile in Brussels.

David was a master of portraiture. Perhaps influenced by the style of Duplessis and Greuze, the portraits he painted in the early 1780s, which were primarily of family members and friends, display an energetic directness of style, but there is little flattery in his penetrating likenesses. The subject of this painting is Jacques-François Desmaisons, a distinguished architect who was David's uncle on his mother's side. David had lodged with him in 1767 and been encouraged by him to pursue a career as an artist. David shows his uncle seated proudly at a desk with the tools of his profession, including a volume of Palladio's *Architettura*.

This portrait was one of several exhibited by David in the Salon of 1783, where his *Hector and Andromaque* received the most attention. One writer remarked that one would never guess that the *Hector*

92

and this portrait were by the same hand; he praised the portrait for "the pose and movement of the body which have a great deal of truth and the head which is probably very true to life."[1]

[1]*La Véridique du Salon*, Paris, 1783, p. 22.

Adélaïde Labille-Guiard, 1749-1803

38. *Comtesse de Selve,* 1787
 Oil on canvas, 35½ x 28⅜ inches (90.2 x 72 cm.)
 Signed and dated center left: *Labille Guiard 1787*

Private Collection, New York.

Provenance: Mme. de Poles, Paris; Sale, Galerie Georges Petit, Paris, June 22-24, 1927, no. 18; F. J. E. Horstmann, Amsterdam; Sale, Frederick Muller & Cie., Amsterdam, November 19-22, 1929, no. 27.

Exhibitions: Salon of 1787, Paris, no. 117 (as "*Madame de *** faisant de la musique*"); *France in the Eighteenth Century*, Royal Academy of Arts, London, January 6-March 3, 1968, no. 357.

Bibliography: A.-M. Passez, *Adélaïde Labille-Guiard: Biographie et catalogue raisonné de son oeuvre*, Paris, 1973, pp. 29, 202, no. 91, ill. p. 203, pl. LXXIII.

Claude-Edmé Labille, the artist's father, was the proprietor of a fashionable haberdashery shop in Paris and also the subject of a bust by Pajou. Adélaïde Labille received her first formal artistic instruction from the miniaturist Françoise-Elie Vincent. In 1769, she wed Louis-Nicolas Guiard, a clerk in the Department of Finance. They were legally separated ten years later, but she continued to sign her name *Labille Fme. Guiard* for the rest of her life.

Between 1769 and 1774, she studied the technique of pastels with the great master of the medium, Maurice Quentin de la Tour, and in 1774 she exhibited a pastel at the Salon of the Académie de Saint-Luc, where she had been *agréée*. When François-André Vincent, the son of her first teacher, returned to Paris from Italy in 1775, she began to study painting with him. (They eventually married in 1800.) She first exhibited at the Salon de la Correspondance in 1781. The following year, she showed portraits of herself and Vincent along with six other works which were very well received. Having undertaken a series of pastel portraits of such well-known *académiciens* as Vien, she was *reçu* by the Académie Royale on May 31, 1783 – the very same day as her rival, the younger painter Elisabeth Louise Vigée Le Brun. The same year, she established herself as a teacher, a role in which she depicted herself in the great self-portrait seen at the Salon of 1785 (The Metropolitan Museum of Art), in which she is shown at her easel accompanied by her students Marie-Gabrielle Capet and Mlle. Carreaux de Rosemond.

Labille-Guiard was a frequent exhibitor at the Salons, and received many commissions. Royal recognition came when she was made *peintre de Mesdames* for her portraits of Louis XVI's aunts and sister – Mesdames Adélaïde, Elisabeth, and Victoire (now at Versailles). Unlike Vigée Le Brun, who was a thoroughgoing royalist, Labille-Guiard supported the Revolution. She remained in Paris throughout the period, even exhibiting a pastel portrait of Robespierre at the Salon of 1791.

At the Salon of 1787, Labille-Guiard showed a work identified in the *livret* as *Mme de*** faisant de la musique*. Portalis has identified this painting as the portrait of Madame de Selve, of whom the painter had exhibited a pastel two years earlier. Labille-Guiard's sitters have a more practical, down-to-earth character than those by Vigée, seeming to regard the viewer with less pretense. However, Vigée seems to have provided the prototypical view of an elegant woman seated with her music in her 1785 *Portrait of the Barone de Crussol*. The sitters in Labille-Guiard's works dress in their finest garments, even when engaged in everyday activities. In both this portrait of Madame de Selve making music, and in Labille-Guiard's self-portrait, the ladies wear elaborate plumed hats. A similar painting, a portrait of Madame la Marquise de La Valette playing the harp, was shown at the Salon of 1787.[1]

[1]See J. G. Prinz von Hohenzollern, "Das Bildnis der Marquise de La Valette...," *Pantheon*, November-December, 1968, p. 476 ff.

Antoine Vestier, 1740-1824

39. *Dr. Jean-Louis Baudelocque,* ca. 1785-90
 Oil on canvas, 32¾ x 25⅝ inches (82 x 65 cm.)

Alice and George Benston, Rochester, New York.

Provenance: Wildenstein and Co., New York

Vestier was the son of a merchant from Troyes. Moving to Paris in 1760, he studied the art of enameling with the master Antoine Révérend, whose daughter he married in 1764. Gradually he turned to oil painting, studying with J.-B. Pierre at the Académie. From the first, Vestier specialized in portrait and miniature painting and often used himself or members of his family as models. Apparently he also travelled to Holland and England about 1776.

From 1782 until 1785, when he was *agréé* by the Académie Royale, he exhibited at the Salon de la Correspondance. That same year he painted one of his most elaborate portraits, that of the king's cabinet-maker Riesener (now at Versailles). The following year, 1786, he was *reçu* with portraits of the painters Brenet and Doyen. Vestier attempted some allegorical portraits with figures such as Bacchantes or the Seasons, but these were not in keeping with his sober approach. He seems more in tune with the less frivolous period of the Revolution, when portraiture was more severe and emphasis was placed on the quality of expression. He found it difficult to adapt to the Restoration style and died nearly forgotten despite the high quality of many of his works.

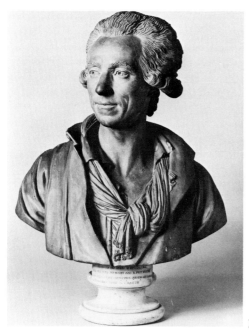

Fig. III. 10

The style of this portrait is similar to such works as the 1785 *Portrait of Foulon d'Ecotier* (Wrightsman Collection, New York) and the 1787 *Portrait of Omer Talon* (Versailles). The sitter has been convincingly identified as the celebrated surgeon Jean-Louis Baudelocque (1746-1810). This is based on the similarity of the sitter's features to those of a terra-cotta bust of Baudelocque by Philippe-Laurent Roland (fig. III.10) and an engraved portrait of the surgeon.[1] Baudelocque, a professor at the Ecole de Médecine, had developed innovative techniques for delivering babies and had written several important obstetrical texts. Shortly before his death, he was appointed chief obstetrician to the Empress Marie-Louise.

[1]See Denise Genoux, "Quelques Bustes et médaillons ré-trouvés de Philippe-Laurent Roland," *BSHAF*, 1965, pp. 194-196.

Alexandre Roslin, 1718-1793

40. *Henriette Begouen,* 1790
 Oil on canvas, 23¼ x 9½ inches (59 x 24.1 cm.)
 Signed and dated: *Le Chevl. Roslin f. 1790*

The Cummer Art Gallery, Jacksonville, Florida. Purchase with membership contributions, 1968.

Provenance: Begouen family, Le Havre; Mme. Martin Foache (née Henriette Begouen), Le Havre; Amédée Foache, Le Havre; Félix Doistau; Sale, Galerie Georges Petit, Paris, June 9-11, 1909, no. 70; Mr. Stettiner; Carl U. Palm, Stockholm, 1911; Jules Féral, Paris; Nathan Wildenstein, Paris; Private collection, New York.

Exhibitions: Salon of 1791, no. 112; *France in the Eighteenth Century*, Royal Academy of Arts, London, 1968, no. 619.

Bibliography: G. W. Lundberg *Roslin, Liv och werk,* Malmö, 1957, I, pp. 252-253, 312, III, pp. 104-105, no. 607.

Alexandre Roslin was the most successful of several Swedish-born artists who worked in France during the eighteenth century. He was born in Malmö and trained under the Swedish court painter G. E. Schröder. He spent time in Germany and lived for four years in various cities in Italy. The highly-finished portrait style which he brought to Paris in 1752 reflects a knowledge of such Italian masters as Solimena. Devoting himself to portraiture, Roslin was *agréé* by the Académie in 1753 and *reçu* later that same year with portraits of the painters Colin de Vermont and Jeaurat. He became a dedicated *académicien* and often depicted other artists such as Boucher, Vernet, and Pajou.

Roslin's style, with its detailed likenesses and attention to the textures of fabrics, was suited to the many commissions he received for formal portraits, including the daughters of Louis XV. From 1774 to 1778, on a triumphant return to Sweden, he also visited the courts of St. Petersburg, Warsaw, and Vienna and painted portraits of Catherine the Great and Empress Marie Theresa. Back in France, his works were often criticized for heaviness, and a critic observed in 1783 that the ideal portrait would have a head by Duplessis and the costume by Roslin.

He survived the Revolution, maintaining his residence in the Louvre. He exhibited for the last time with eight paintings at the open Salon ordered by the Assemblée Nationale in 1791. He must have seemed like a relic from a different era. One reviewer wrote that Roslin "reappeared with work from all periods of his life," and found that "his heads are always heavy and unartistic, his drawing barely correct, and he must rest on his old reputation as a master of fabrics."[1] Among the works shown was this painting; the style was outmoded but it is a lively and delightful rococo image. Called *Jeune fille tenant des fleurs* in the Salon *livret*, it has been identified by Lundberg as a portrait of Henriette Begouen (1780-1825), a young woman of a distinguished family from Le Havre whose parents and in-laws Roslin had earlier depicted. The work may have been an engagement portrait made for her intended husband Martin Foache. In the Dutch tradition, the young woman is depicted bearing flowers or even in the guise of the goddess Flora.

[1]*Salon de Peinture*, Paris, 1791, p. 12.

IV. Genre

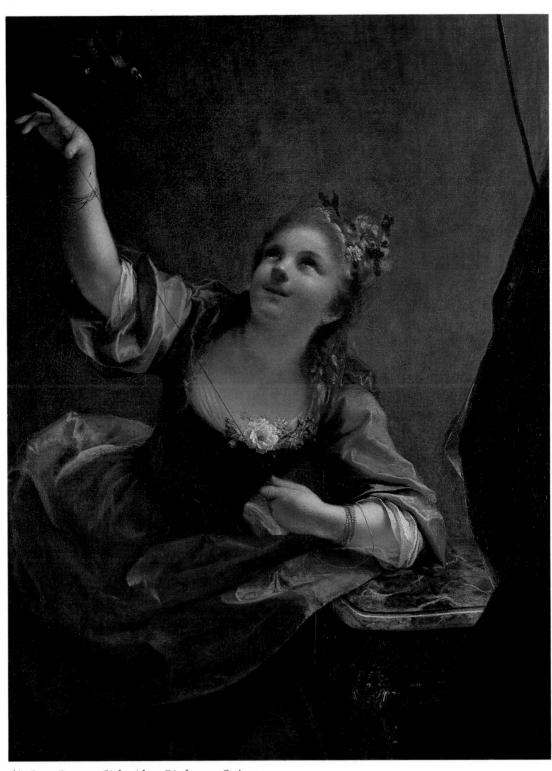

41. Jean Raoux, *Girl with a Bird on a String*

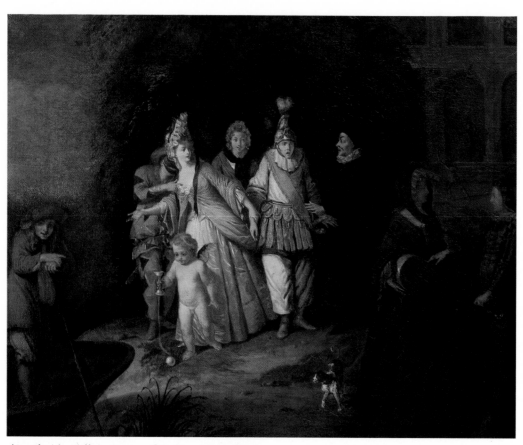

42. Claude Gillot, *Scene of Italian Comedians*

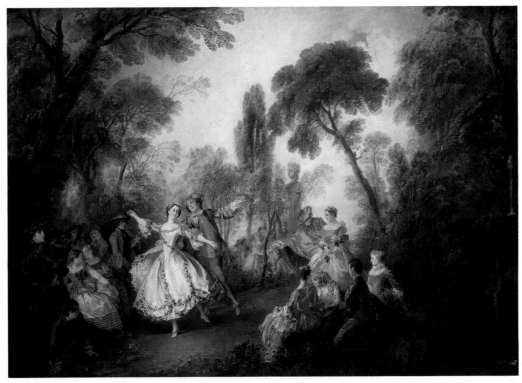

43. Nicolas Lancret, *"La Camargo" Dancing*

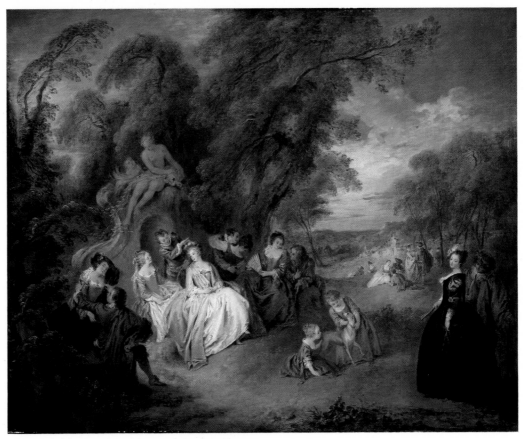

44. Jean-Baptiste-Joseph Pater, *Fête Champêtre*

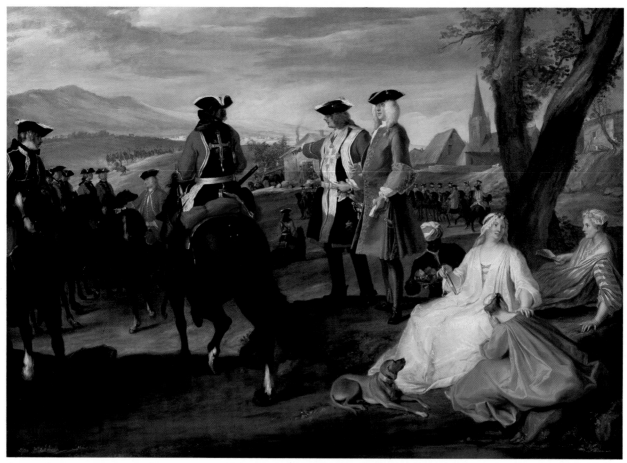

45. Paul-Ponce-Antoine Robert, *Review of the Second Company of Black Musketeers*

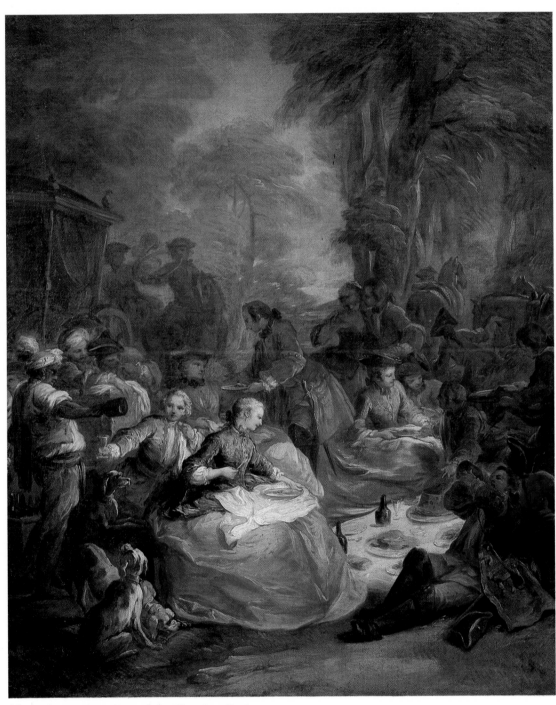

46. Carle van Loo, *Rest of the Hunting Party*

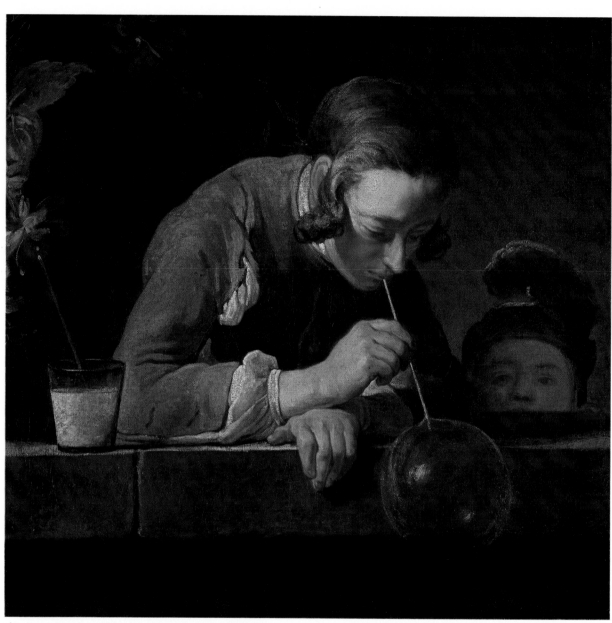

47. Jean-Siméon Chardin, *Boy Blowing Bubbles*

48. Jean-Baptiste Greuze, *Indolence*

49. Jean-Honoré Fragonard, *The Joys of Motherhood*

50. Hubert Robert, *Laundress and Child*

51. Jean-Honoré Fragonard, *The Washerwomen*

106

52. Jean-Baptiste Leprince, *The Russian Dance* and *The Seesaw*

53. Nicolas-Bernard Lépicié, *The Carpenter's Family*

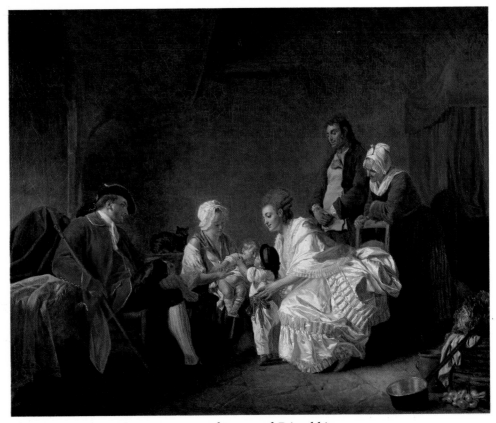

54. Etienne Aubry, *The First Lesson of Fraternal Friendship*

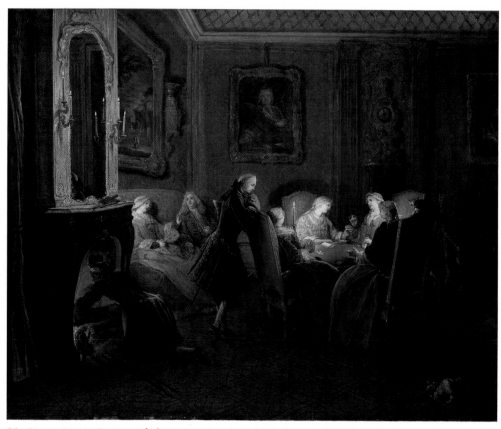

55. Pierre-Louis Dumesnil the Younger, *Interior with Card Players*

108

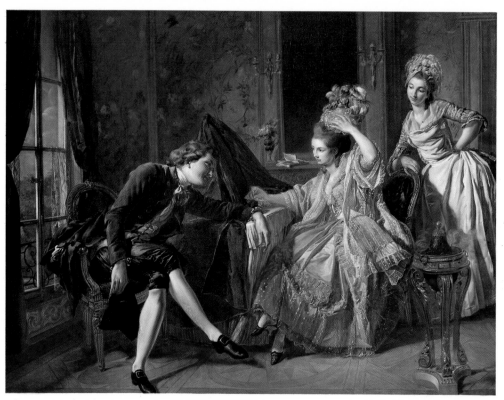

56. Louis-Roland Trinquesse, *Interior Scene*

Commentaries

Jean Raoux, 1677-1734

41. *Girl with a Bird on a String,* 1717
 Oil on canvas, 44 x 34 inches (112 x 86 cm.)
 Signed and dated at the lower right: *J. Raoux f. 1717*

 The John and Mable Ringling Museum of Art, Sarasota.

 Provenance: Comte du Barry, Paris; Sale, Paris, November 21, 1774, no. 83; Le Brun (?); George A. Kelly; John Ringling, Sarasota.

 Exhibition: *French Art,* New York City, January-February 1918, no. 106.

 Bibliography: Georges Bataille, in Dimier, 1928, II, pp. 271 and 281 (?); W. E. Suida, *Catalogue of Paintings . . . Ringling Museum of Art,* Sarasota, 1949, p. 397, no. 375.

Raoux was born in Montpellier and trained there by the young Ranc (1674-1735), who had been a student of Rigaud. Moving to Paris sometime early in the century, Raoux became a pupil of Bon Boullongne. In 1704, he won the Académie's Prix de Rome, which enabled him to spend three years in Italy. He copied frescoes by Raphael in Rome, and also travelled to Florence and Padua. The time he spent in Venice was particularly important, for he not only studied works by Titian and Veronese, but met the *Grand Prieur de Vendôme,* who was to become his most important patron. Travelling back to Paris with the *Grand Prieur's* entourage, Raoux was given lodgings in the Temple and, abandoning religious and mythological subjects, he began to produce the genre and erotic themes demanded by this rich and dissolute clientele.

Raoux for a time continued his academic progress; he was *agréé* in 1716 and *reçu* as a painter of history. His reception piece, *Pygmalion Falling in Love with his Statue* (Montpellier) was presented at the same session as Watteau's *Departure from Cythera* on August 28, 1717. An academic career, however, did not interest Raoux, who was fully occupied by commissions, including one for a portrait of the *Grand Prieur.* The chevalier d'Orléans became *Grand Prieur* in 1719 and showed the same artistic taste as his predecessor. He also commissioned a portrait from Raoux, as well as many subjects of young women in the guise of vestals or allegorical embodiments of the arts and senses. These works show the artist's debt to Veronese in their voluptuous figures and treatment of fabrics, but their high finish, use of strong contrasts of light and dark, and symbolism recall Dutch painters such as Dou, Netscher, and Schalken, who were popular in France at that time.

In 1720, Raoux spent several months in England, possibly in the company of Watteau. On his return, he continued developing his form of allegorical female portraits, depicting such well-known personages as the actresses Mlle. Prévost (as a bacchante) and Mlle. Carton (as a naïade). He also received important commissions, such as the *Telemachus Visiting Calypso* (Louvre) for the Regent's apartments in the Palais Royal, and a *Continence of Scipio* and *Alexander and Diogenes* for the Elector of the Palatinate. Although Raoux's abilities declined about the time he left the Temple in 1731, his fame had been so great that Voltaire could describe him as "an uneven artist but one who when he was at his best equalled Rembrandt."[1]

This picture of 1717, with its single figure placed in strong artificial light, is characteristic of Raoux. It is mentioned by Dézallier d'Argenville as one of Raoux's *"sujets de caprice."*[2] Based upon Saint-Aubin's sketch in the sale catalogue (fig. IV.1),[3] we can identify it as having been in the collection of the comte du Barry.

109

Fig. IV. 1

Fig. IV. 2

Claude Gillot, 1673-1722

42. *Scene of Italian Comedians*, ca. 1720
Oil on canvas, 25½ x 32 inches (64.7 x 81.3 cm.)

Private Collection, New York.

Provenance: Mr. and Mrs. Moses Taylor; Sale, Parke-Bernet, New York, October 16-17, 1959. No. 256 (as French School ca. 1700); Mr. and Mrs. J. O'Connor Lynch, New York City.

Exhibitions: *The Lynch Collection: A Selection*, University Art Gallery, State University of New York at Binghamton, April 20 - May 8, 1969, no. 52 (as attributed to Watteau).

Gillot, the son of a decorator and painter, was born at Langres. He came at an unknown date to Paris, where he studied with Jean-Baptiste Corneille (d. 1695). At first he followed a traditional path of advancement, being *agréé* by the Académie in 1710 and *reçu* in 1715 with *Christ About to be Nailed to the Cross*. He established himself as a painter of fantastic decorative subjects but found his prime subject in the theater, particularly paintings, drawings, and prints of the popular Italian comedians. He died almost unknown in humble circumstances, far eclipsed by his former student Watteau, with whom he had quarreled.

Very few authentic paintings by Gillot survive, and it is difficult to establish a chronology. While the frequently-reproduced *Cabmen's Quarrel*[1] is stiff and seems little more than a transcription of a stage performance, the painting exhibited here has a freer handling and richer atmosphere, so that one can see why this painting has sometimes been attributed to Watteau. There are certain connections between this work and others by Gillot. For example, the Pierrot figure in the center has a face nearly identical to that in Gillot's print *Ghost's Clothes*.[2]

Mary Tavener Holmes has suggested that the subject of the painting is a mock Abduction of Helen.[3] She points out that Gillot produced another painting of an incident from the story of the fall of Troy, *The Trojan Horse* (Langres Museum),[4] which, according to Populus, is based on a comedy by Fuzelier *Harlequin Aeneas or The Capture of Troy*, presented in 1711. At the Fair of Saint-Germain in 1705, another play by Fuzelier, *The Abduction of Helen; The Siege and Burning of Troy*[4] was presented and may be the inspiration for this painting, which shows an assemblage of the traditional *commedia* characters. Pierrot as Paris appears dismayed by the situation, in which Helen is the aggressor. His concern is shared by Scaramouche, to his right, while the bawdy Harlequin at the left ridicules him by pointing to Helen's bared breast. Preceding Helen is a cupid playing bilboquet, a game with explicitly sexual connotations which was depicted in other paintings of the period to suggest the lascivious character of a woman.[6] Also symbolic of female sexuality is the birdcage held by the woman

Saint-Aubin records that it sold for 360 *livres* to a Monsieur Le Brun. In the sale it had a pendant, *Young Girl Feeding a Bird*, which may be identified as the work once at The Tooth Gallery, London, and included in sales in New York in the early part of this century.[4] The theme of the caged bird, which referred to the sexual receptiveness of women, was derived from seventeenth century Dutch paintings and emblems and was elaborated by Boucher. Raoux's figure is both exuberant and refined as she prevents her bird from flying too far afield. D'Argenville records that this painting was engraved by N. G. Dupuis, whose print was used as the basis of a *trompe l'oeil* painting entitled *La Tromperie (The Deception)* by an unknown French painter (fig. IV.2, Pete and Leslie Schlumberger Collection, Houston).[5]

[1]*Oeuvre de Voltaire*, Paris, ed. 1819, p. 181.
[2]D'Argenville, 1762, p. 378.
[3]Dacier, *Saint-Aubin*, 1909, III, p. 25.
[4]Ehrlich Galleries, March 24, 1905, and the E. McMillan Sale, Plaza Hotel, January 20-23, 1913, no. 229.
[5]See the exhibition catalogue *Grey is the Color*, Rice University Museum, Houston, 1973-74, no. 61.

at the right. The cavalier with whom she speaks touches the birdcage and draws out his sword. Her little dog, straining at its leash toward the waiting boat, is perhaps a humorous inversion of a traditional representation of fidelity. The youthful boatman with a bemused expression seems to invite the viewer to observe the folly of this escapade. In the architectural backdrop are a number of tiny fighting figures reminiscent of those rapidly sketched in so many of Gillot's drawings.

[1]See Rosenberg, 1975, no. 40, pl. 20.
[2]Reproduced in B. Populus, *Claude Gillot, Catalogue de l'oeuvre gravé*, Paris, 1930, fig. 76, no. 468.
[3]In a letter of June 27, 1983.
[4]See Populus, fig. 8.
[5]*Encyclopedia dello spettacolo*, Rome, 1958, V, p. 795.
[6]See the painting by J. F. Courtin reproduced in Rosenberg, 1975, no. 18.

Fig. IV. 3

Nicolas Lancret, 1690-1743

43. *"La Camargo" Dancing*, ca. 1730
Oil on canvas, 30 x 41¾ inches (76.2 x 106 cm.)

National Gallery of Art, Washington, D.C. Andrew W. Mellon collection, 1937.

Provenance:.Prince de Carignan and Sardinia (d. 1742); Sale, Paris, July 30, 1742; Purchased by Count von Rothenburg, Prussian Ambassador to France, for Emperor Frederick the Great (d. 1786), Schloss Rheinsberg; In the possession of the Kings of Prussia, Neues Palais, Potsdam until sold by Emperor William II to Lord Duveen of Millbank; Andrew Mellon, Washington, D.C.

Exhibition: *French Painting and Sculpture of the XVIII Century*, The Metropolitan Museum of Art, New York, November 6, 1935 - January 5, 1936, no. 11.

Bibliography: Georges Wildenstein, *Lancret*, Paris, 1924, p. 110, no. 585.

Lancret's work was often inspired by the stage. About 1730, he began to produce many paintings of famous dancers, the two most important subjects being the rival prima ballerinas Mlle. Sallé and "La Camargo." Lancret's painting of Mlle. Sallé has disappeared, but of the latter there are four known examples. These include three depictions – one at the Musée des Beaux-Arts (Nantes), one at The Wallace Collection (fig. IV.3, London), and one at the Hermitage (Leningrad) – which show La Camargo dancing alone. In the present work, formerly in the collection of Frederick the Great, she is shown in a pose and costume similar to those of the other paintings, but accompanied by a partner in a *pas de deux*.

Marie-Anne Cuppi de Camargo (1710-1770) was born in Brussels. Her father was a dance master and by the age of ten the girl showed such promise that the Princess de Ligne sent her to study dance in Paris. She became a pupil of Mlle. Prévost, a great star at the Opéra, where Camargo, after performing in Brussels

and Rouen, made her debut at the age of seventeen in *Les Carectères de la Danse*. She was praised by the *Mercure de France* not only for her "effortless *cabrioles* and *entrechats*" but also for her "sensitive ear for music, her airiness, and her strength."[1] She was an immediate success with the public, and went on to dance more than eighty roles. Although not beautiful, she made a great impact through the liveliness and gaiety of her dancing. According to Baron Grimm in his *Correspondance*, she introduced the innovation of shortening the dancer's skirt, so that the charm and speed of her feet could be better observed.[2] Her fame was such that fashions were named after her; Voltaire wrote several lines praising her brilliance,[3] and she had a succession of noble lovers, including the comte de Clermont, for whom she temporarily retired in 1735 for six years. When she returned in 1741, she regained her former popularity and continued dancing, and occasionally singing, for another ten years.

In the National Gallery painting, as in the other depictions of her by Lancret, Mlle. Camargo wears a dress embroidered with flowers, suggesting she is performing one of her many pastoral roles. Her partner may be the dancer and choreographer Laval, with whom she appeared many times, especially in the second part of her career. Lancret's felicitous invention for the paintings of La Camargo is to depict her not on a stage but (perhaps inspired by Watteau) in a natural park-like setting over which a herm figure of a laurel-crowned muse casts a benign eye. The music is provided by a group of instrumentalists to the left. The graceful poses of the dancers seem mirrored in the swaying of the trees. At the extreme left, one man looks out bemusedly at the viewer. His features are close enough to those of Lancret that we may regard

it as a self-portrait. He thus appears as both host and creator of this delightful event. Mlle. Camargo has been highlighted in such a way that one recalls the eulogist's judgement: "Her physique was most favorably suited to her art. Her feet, legs, arms and height were altogether perfect."[4]

[1]Quoted in Cyril W. Beaumont, *Three French Dancers of the 18th Century*, London, 1934, pp. 10-11.
[2]See M. Montagu-Nathan, *Mlle. Camargo*, London, 1932, p. 5.
[3]See G. Letainturier-Fradin, *La Camargo*, Paris, p. 190.
[4]For the obituary notice of Camargo from *La Nécrologie des Hommes Célèbres de France*, 1771, see Emmanuel Bocher, *Catalogue Raisonné de Nicolas Lancret*, Paris, 1877, pp. 14-15, and a translation in Beaumont, p. 15.

Jean-Baptiste-Joseph Pater, 1695-1736

44. *Fête Champêtre*, ca. 1730
Oil on canvas, 29⅜ x 36½ inches (74.5 x 92.5 cm.)

National Gallery of Art, Washington, D.C. Samuel Kress Collection, 1946.

Provenance: Baronne Wilhelm Carl R. von Rothschild (d. 1924), Grüneburg, Frankfurt; Wildenstein and Co., Paris and New York; Kress Acquisition, 1946.

Bibliography: Eisler, 1977, pp. 306-307, figs. 271-274.

Pater was from Valenciennes where his father, a sculptor, was a friend of Watteau. The young Pater spent a short time in 1713 in Watteau's Paris studio. This ended due to Watteau's difficult temperament, but shortly before his death in 1721 he again offered instruction to Pater, which determined the style and content of the young artist's work. Pater produced some portraits, but primarily painted *fêtes galantes*, elegant figures in delightful parks. Even military subjects were given this theatrical treatment. His graceful compositions, with strokes touched in as if with a feather, capture a mood of suspended time. Pater was *agréé* at the Académie Royale in 1725 and *reçu* in December 1728 with the painting *Soldiers Carousing*.

As in works by Watteau, the couples in this *fête champêtre* are shown in an ideal park in which the statues symbolize the swift passage of love. Pater often repeated compositional motifs and many of the figures here are similar to those in other *fêtes galantes*. For example, the standing couple at the right appear in a painting at Kenwood and the young girl with the dog in another which was at Potsdam. Several of the costumes and poses – as well as the form of the fountain – recall two famous paintings by Rubens of *The Garden of Love* (Prado, Madrid and Waddesdon Manor) which were widely known through the woodcuts of Christoffel Jaegher. In Pater's painting the boldness of Rubens's figures has been refined for eighteenth-century taste.

Paul-Ponce-Antoine Robert, called Robert de Séry, 1686-1733

45. *Review of the Second Company of Black Musketeers under the Command of Plouy de Pincetaille*, 1729
Oil on canvas, 41¾ x 57⅞ inches (106 x 147 cm.)
Signed and dated: *Robert 1729*

Musée National du Château de Versailles.

Provenance: Seraphin-Antoine de Plouy de Pincetaille; Monsieur Devyndt, Paris, by 1941; Sold to the Musées royaux in 1841; Collection Louis Philippe; Versailles.

Bibliography: Henri Bourin, "Paul-Ponce-Antoine Robert (de Séry), "*Revue historique Ardennaise*, July 1907, pp. 140, 145-146, no. 1.

Born in the town of Séry-en-Porcien, Robert was of Ardennaise origin. He studied with the painter Jean Tisserand in Reims and then with Jouvenet and Cazes in Paris. By 1706, he was established in Rome, where he was active as both a painter and art dealer. He was acquainted with most of the important visiting Frenchmen such as Vleughels, Caylus, Crozat, and Mariette. Few works are known from his Italian period, but the informal *Portrait of a Woman* of 1722 (Lille) reveals a marked originality.

Employed by the visiting Cardinal de Rohan to paint copies of works by Correggio, Robert travelled to Parma and Venice in 1724. He then returned to Paris in the Cardinal's retinue and was given lodgings in the Cardinal's palace. In Paris, he continued his business activity, as well as painting religious subjects and preparing some of the etchings for the *Cabinet Crozat*. Despite that collector's support, Robert failed to gain admission to the Académie. Both his personality and his commercial activity seem to have offended some of the established members.

Robert's most important works in France were large religious compositions, such as the scenes of the Life of the Virgin for the chapel of Chanteloup.[1] His works at the churches of Yville (1727) and Saint-Merry in Paris (1730) show the influence of Correggio and Barocci. In the last year of his life, Robert worked for the Convent of the Capuchins of Marais. Upon his death, the *Mercure de France*, noting also the loss of Raoux, wrote: "In M. Robert de Séry we have also lost an artist who had a great deal of natural talent for painting, especially, according to the opinion of connoisseurs, for the fine depiction of figures and their expressions."[2]

Perhaps the most unusual picture by Robert is his 1729 depiction of a company of *Mousquetaires noirs* reviewed by their *commissaire* Seraphin-Antoine de Plouy de Pincetaille. The eighteenth century was a period of many wars for France and in addition to the military subjects in the works of such specialists as the Parrocels, such scenes also occur in the world of Watteau and Pater. Robert's work is unusual because the

112

soldiers are actual portraits, painted in a large format and combined with the elegant assemblage of three ladies and a servant, arranged in the style of the fashionable genre works by one of his academic antagonists, Jean-François de Troy. Robert's work lacks de Troy's high finish, and his figures have a somewhat awkward look to them, but his palette is extraordinarily vivid, almost shocking.

[1]Boris Lossky, "Identifications Recentes…," *BSHAF*, 1957, pp. 107-109.
[2]*Mercure de France*, February 1734, quoted in Bourin, p. 143.

Carle van Loo, 1705-1765

46. *Rest of the Hunting Party*, 1737
Oil on canvas, 23¼ x 19¾ inches (59 x 50 cm.)

Robert D. Brewster, New York.

Provenance: David David-Weill, 1926; Wildenstein and Co., New York, 1941.

Bibliography: Pierre Rosenberg and Marie-Catherine Sahut, *Carle van Loo*, exhibition catalogue, Nice, Clermont-Ferrand, Nancy, 1977, no. 50.

Van Loo's versatility was remarked upon during his lifetime. In the present exhibition, we see a mythological subject with erotic overtones – the *Erigone* (no. 14) – and in this painting a *sujet galante*, treated with the delicacy of a Lancret and the *brio* of a Fragonard. Painted the same year he was made a *professeur* at the Académie, this is a preliminary sketch for the *Halte de Chasse* which he was commissioned to paint for the dining room in the king's chambers at Fontainebleau, as a pendant to Charles Parrocel's *Halte de grenadiers*. For the large work, which is now in the Louvre (fig. IV.4), van Loo was paid 3000 *livres*.[1]

Fig. IV. 4

In this small oil sketch, the composition is more vertical. No pose is identical with that found in the large painting, although individual characters – such as the servant in Eastern garb, the standing man in the frock coat, and the seated woman in an expansive skirt – are similar. An additional element here is the elegant coach that has brought the ladies to join the huntsmen. Each detail and gesture of the outing is lovingly and humorously captured, from the amorous couple in the far distance, to the expression of the dogs, to the uninhibited guzzling of the gentleman at the right. The *joi de vivre* displayed here reflects that quality of eighteenth century life which is best described as "Mozartian."

[1]Engerand, 1901, p. 475.

Jean-Siméon Chardin, 1699-1779

47. *Boy Blowing Bubbles*, ca. 1733
Oil on canvas, 24 x 24⅞ inches (61 x 63.2 cm.)
Signed on the stone at left: *J. Chardin*

The Metropolitan Museum of Art, New York City. Purchase, Catherine D. Wentworth Fund, 1949.

Provenance: Louis-François Trouard, Paris; Sale, Paris, February 22, 1779, no. 44; Jacques Doucet, Paris, from 1899; Sale, Galerie Georges Petit, Paris, June 6, 1912, no. 136; D. David-Weill, Paris, from 1926; Fritz Mannheimer, Amsterdam; Confiscated by the German Occupation Forces and sent to the Führer Museum, Linz; Mannheimer heirs; Wildenstein and Co., New York.

Exhibition: *Chardin, 1699-1779*, Grand Palais, Paris, The Cleveland Museum of Art, and Museum of Fine Arts, Boston, January-November, 1979, no. 61.

In 1739 Chardin exhibited at the Salon a small painting representing "the frivolous play of a young man blowing soap bubbles." This was probably not his first treatment of this subject. Mariette, in his 1749 biography of Chardin, wrote that this very subject played a part in Chardin's "conversion" around 1733 by his friend the portrait painter Aved from still life painting to figure subjects:

> He had the opportunity to paint the head of a young man blowing soap bubbles, which exists as a print; he had painted him carefully from life and had tried hard to give him an ingenuous air; he showed it around; people said nice things to him about it. The masters of the art praised the effort he had made to get that far, and the public by displaying great interest in this new subject, caused him to embrace it.[1]

The only known print of this subject, entitled *Les Bouteilles de Savon*, is by Pierre Filloeul and appeared shortly before December 1739. It presents a vertical composition but whether it is of the Salon painting is not certain. A vertical painting of the subject is now in the National Gallery, Washington (fig. IV.5), which corresponds to the engraving except for the lack of a bas-relief below the window ledge and the vines to the left

113

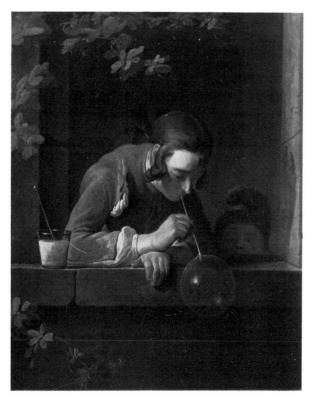

Fig. IV. 5

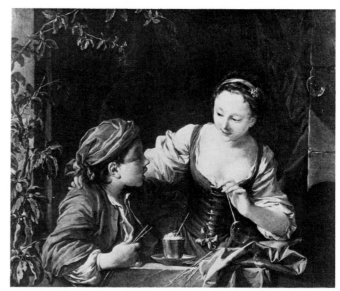

Fig. IV. 6

114 and upper edge. If Mariette is correct, then the vertical representation of the subject came first and the horizontal treatment seen in this painting from the Metropolitan Museum came later. Pierre Rosenberg dates it about 1733-34, which would mean this is probably not the Salon painting. In Chardin's estate inventory (December 18, 1779) there is also listed a "boy making soap bubbles, valued at 24 *livres*." Based on their supposed provenances, this can be neither the Washington nor the New York painting. There are several other known versions of the horizontal composition. Two sales record it with a pendant of a *Girl Showing a Child How to Read*. The version sold in both the Trouard and Doucet sales, which is believed to be the Metropolitan's, had a pendant of a young boy building a house of cards. That work (now in the Reinhart collection, Winterthur) is not of the same quality as the Metropolitan's painting, so we must assume they were not originally painted as companion pieces.

Chardin's interest in this subject was probably inspired by seventeenth century Dutch paintings, extremely popular in France at this time. Among the artists in whose works he may have seen the subject were Frans van Mieres, Casper Netscher, Pieter de Hooch, and Nicolaes Maes. Other eighteenth century French painters, such as Boucher, Raoux, and C.-A. van Loo, also treated the theme. Traditionally, the motif of bubble-blowing was a *vanitas* symbol, an emblem of the impermanence and futility of human life. There is certainly a melancholy air about the young man in Chardin's picture. The engraving published by Filloeul bore the following inscription: "Consider well, young man; These little globes of soap/ Their movement so variable/ their luster so fragile/ will prompt you to say with reason/ that many an Iris in this is very like them." This may be the engraver's invention rather than Chardin's and would be more appropriate to Boucher's 1734 depiction of the subject (fig. IV.6, Ananoff 96, in the Patino collection, Paris). More to the point, as Pierre Rosenberg has observed, with this theme Chardin undertook for the first time the representation of childhood or early adolescence. The games and pastimes of children, treated with gravity and tenderness, were to constitute a major portion of Chardin's oeuvre.

[1]Rosenberg, 1979, p. 206.

Jean-Baptiste Greuze, 1725-1805

48. *Indolence*, 1756
Oil on canvas, 25½ x 19¼ inches (64.8 x 48.8 cm.)

Wadsworth Atheneum, Hartford, Connecticut. The Ella Gallup Sumner and Mary Catlin Sumner Collection, 1934.

Provenance: Jean-Baptiste-Laurent Boyer de Fonscolombe, Aix-en-Provence, 1757; Sale, Paris, January 18, 1790, no. 101; Prince Radziwill Branicki, Rome, Paris and Warsaw, before 1874; Wildenstein and Co., New York.

Exhibitions: Salon of 1757, Paris, no. 114; *Jean-Baptiste Greuze, 1725-1805*, Wadsworth Atheneum, Hartford, California Palace of the Legion of Honor, San Francisco, and Musée des Beaux-Arts, Dijon, December 1976-July 1977, no. 10.

During his stay in Rome, Greuze executed a series of four moralizing paintings of figures in Italian costume which were then exhibited in the Salon of 1757. This painting, which was entitled *La Paresseuse italienne (The Lazy Italian Girl)* had as its pendant *A Fowler, Returning From the Hunt, Plays his Guitar* (fig. IV.7, Narodowe Muzeum, Warsaw). Both works belonged to Greuze's early patron, J.-B.-L. Boyer de Fonscolombe, to whose brother P.-E. Moitte dedicated the engravings of these subjects.

As Edgar Munhall has pointed out, Greuze has here provided a memorable illustration of indolence as it was defined in Diderot's *Encyclopédié*: "a lack of concern that prevents man from working and from fulfilling his duties." In the painting, it is not a man but a slovenly woman whose irresponsibility is manifest not only in her appearance, but in such details as the broken chair, fallen crockery, and the discarded wine bottles. The imagery is derived from Dutch prototypes – for example, Nicolaes Maes's *The Idle Servant* – and Italian genre paintings such as Giuseppe Maria Crespi's *The Flea*. The pose of the woman also recalls the Magdalene in Caravaggio's painting in the Palazzo Doria, Rome.

Greuze was not only a master of incisive allegory but also of still life details, much in the manner of Chardin. This relationship was perceived at the time. Renou, the secretary of the Académie, relates that at the Salon of 1757, "the works of Chardin were placed in the same row as those of Greuze...[Greuze] proves to us that the least noble style has nobility all the same, but he does not always have the ingenuity of Chardin."[1]

[1]M. Renou, *Observations sur la physique et les arts*, Paris, 1757, pp. 15-16.

Jean-Honoré Fragonard, 1732-1806

49. *The Joys of Motherhood*, ca. 1752
Oil on canvas, 57 x 38½ inches (144.8 x 97.8 cm.)

Indianapolis Museum of Art. Gift of Mr. Herman C. Krannert, 1973.

Provenance: Comte de Malleray, Versailles; Jules Bache, New York; Baron de Rothschild, Paris; Wildenstein and Co., New York; J. K. Lilly, Indianapolis; Mr. and Mrs. Herman C. Krannert, Indianapolis.

Bibliography: Anthony F. Janson, *100 Masterpieces of Painting, Indianapolis Museum of Art*, 1980, p. 134, ill. p. 135.

This large painting dates from the period when Fragonard was still working with Boucher and was very much influenced by the older master. This is evident in both the pastoral subject and the decorative style with its free brushwork and brilliant colors. Such scenes of happy motherhood were popular in eighteenth century France and reflect the idealization of pastoral life found, for example, in the writings of Rousseau. Here the exuberant treatment of all elements – children, mother, plants, and sky – conveys a sense of health and well-being.

Another version of the composition, known as *The Shepherdess* (Wildenstein, no. 32), in which the mother does not carry flowers on her back, is in the Chicago Art Institute and has a companion piece of a woman with two children bearing grapes. A composition quite similar to the Indianapolis painting, *The Gardener*, is known in two versions (Wildenstein nos. 35 and 39) in which the child is not in a wheelbarrow but carried on the mother's back along with the flowers. In the Indianapolis painting, the vibrant young girl places her bare foot daintily forward and looks fetchingly out at the viewer. Surely she is not a shepherdess, but rather a gardener or, more properly, a rustic Flora, an idyllic representation of fecundity.

115

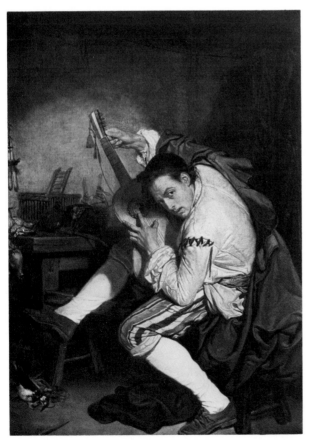

Fig. IV. 7

Hubert Robert, 1733-1808

50. *Laundress and Child*, 1761
Oil on canvas, 13¾ x 12½ inches (35.1 x 31.6 cm.)
Signed and dated: *H. Roberti Rom/1761*

Sterling and Francine Clark Art Institute, Williamstown, Massachusetts.

Provenance: Adrien Fauchier-Magnin, Neuilly-sur-Seine; M. Knoedler and Co.; Robert Sterling Clark.

Exhibition: *Romance and Reality, Aspects of Landscape Painting*, Wildenstein, New York, October 18 - November 22, 1978, no. 56.

Bibliography: *List of Paintings in the Sterling and Francine Clark Art Institute*, Williamstown, 1972, p. 94.

According to Mariette, the young Hubert Robert studied drawing with the sculptor Michel-Ange Slodtz. His interest in landscape painting may have been stimulated by a brief contact with Joseph Vernet in 1753. Because he had not studied at the Ecole Royale des Elèves Protégés, it took the special intercession of the comte de Stainville, for whom his father was *valet de chambre*, to obtain Robert's admission to the Académie de France in Rome. He arrived there by November 9, 1754. He was particularly influenced by the professor of perspective, the Italian painter Giovanni Paolo Panini, whose paintings of ruins provided a continual source of inspiration. Robert progressed rapidly and in 1759 the Marquis de Marigny commissioned a small picture by him, and later that year designated him a *pensionnaire* at the Académie. In 1760 Robert went to Naples with the amateur engraver the abbé de Saint-Non. Although Robert's residency ended in October 1763, he was able to extend his Italian period to eleven years by working in Italy for Bailli de Breteuil. He finally returned to France in July of 1765.

Already a heralded artist at the time of his return, Robert was both *agréé* and *reçu* on July 26, 1766 for a *Port of Rome*, shown at the Salon the following year. His many paintings of ruins (both invented and based on antiquities in Italy and France), as well as charming pastoral subjects, brought him great renown. In the 1770s and '80s Robert devoted much time to garden design, and in 1778, he was appointed *dessinateur des jardins du roi* and given lodging in the Louvre. Under Louis XVI he was also appointed a curator for the proposed national museum. Although imprisoned briefly during the revolutionary period, he was able to resume his museum post. Many of his later paintings are depictions of the Grande Galerie of the Louvre that he helped arrange.

Laundresses and cooks, painted in a frothy, spontaneous manner, were frequent subjects for both Robert and Fragonard during their years in Italy. A drawing by Robert inscribed with the date 1764 is in the Baltimore Museum of Art,[1] but recollections of such Italian scenes also occur later, as in the red chalk drawing *Souvenir d'Italie*, at the Musée des Beaux-Arts, Valence, which is inscribed and dated 1775.[2] In this small painting of 1761, we are reminded of an 1808 commentary: "Robert's paintings delight the eye by the elegance of his composition and the delicacy and lightness of his touch."[3]

[1] See Victor Carlson, *Hubert Robert Drawings and Watercolors*, exhibition catalogue, National Gallery of Art, Washington, D.C., 1978, no. 23.
[2] Marguerite Beau, *La Collection des dessins d'Hubert Robert au Musée de Valence*, Lyon, 1968, no. 50a.
[3] Charles Lecarpentier, *Notice sur Hubert Robert peintre... Mai, 1808*, Rouen, 1808, quoted in Carlson, op. cit., p. 24.

Jean-Honoré Fragonard, 1732-1806

51. *The Washerwomen*, ca. 1762
Oil on canvas, 24⅛ x 28¾ inches (61.5 x 73 cm.)

The St. Louis Art Museum. Purchase, 1937.

Provenance: Private collection, Moscow; Cathabard Collection, Lyons; Arnold Seligmann; Rey & Co. Gallery, New York.

Exhibition: *Fragonard*, The National Museum of Western Art, Tokyo, 1980, no. 55.

Bibliography: Thelma R. Stockho, "French Paintings of the Seventeenth and Eighteenth Centuries," *Bulletin of the St. Louis Art Museum*, Summer, 1981, p. 22, ill. p. 23.

This is one of a number of paintings by Fragonard treating the subject of laundresses or washerwomen, probably based on scenes which both he and Hubert Robert (no. 50) witnessed in their years in Italy. Other examples by Fragonard include a painting in Rouen (fig. IV.8) which may actually be a pendant to the St. Louis painting, and one in The Metropolitan Museum of Art called *The Italian Family*. A drawing of washerwomen, formerly at the Cailleux Gallery in Paris, is also

Fig. IV. 8

quite similar in composition to the St. Louis painting.[1] Not only the subject matter but also its treatment seems inspired by the works of such Venetian masters as Piazzetta and Liss, and it seems plausible to follow Charles Sterling's dating of these works to shortly after Fragonard's visit to Venice in 1761.[2] But one would not mistake this for the work of an Italian painter. The figures, despite their mundane work, have a graceful charm, and playful details such as the child teasing the dog are characteristic of Fragonard. The effect of smoke and steam within vast columned spaces seen in these washerwomen subjects was incorporated by Fragonard into his immense reception piece *Corésus et Callirhoé*, shown at the Salon of 1765.

[1]Ananoff, 1961-1970, I, no. 95. See Eunice Williams, *Drawings by Fragonard in North American Collections*, exhibition catalogue, National Gallery of Art, Washington, D.C., 1979, no. 26.
[2]Sterling, 1955, p. 132.

Jean-Baptiste Leprince, 1734-1781

52a. *The Seesaw*, 1768
 Oil on canvas, 16⅞ x 14 inches (42 x 35.5 cm.)
 Signed and dated at left: *Le Prince 1768*

52b. *The Russian Dance*, 1768
 Oil on canvas, 16⅞ x 14 inches (42 x 35.5 cm.)

 Mrs. Frederick M. Stafford, New York.

 Provenance: Comte du Barry by 1774; Sale, Paris, November 21, 1774, no. 99; Duchesse de Raguse; Sale, Hôtel Drouot, Paris, December 14-15, 1857, nos. 35 and 36; Gustave Rothen; Sale, Galerie Georges Petit, Paris, May 29-30, 1890, nos. 168 and 169; Private collection, Paris; Heim Gallery, Paris.

 Exhibition: Salon of 1769, Paris, nos. 77 and 78.

 Bibliography: Jules Hedou, *Jean Le Prince et son oeuvre*, Paris, 1879, pp. 46 and 318.

Leprince was born at Metz into a family of artisans. Desiring to pursue a career as a painter, he presented himself to the city's Governor, the Maréchal de Belle-Isle, who took him to Paris. There the young man entered the atelier of Boucher, whose decorative technique and subject matter he adopted. Two years spent in Italy do not seem to have affected him. Far more decisive was the 1758 trip he made via Holland to visit his brothers who were musicians working in St. Petersburg. Leprince travelled widely in Russia, not only to major cities but to remote sections of Livonia and Siberia. He was presented to Peter III in 1762 and received some commissions from the Empress Elizabeth for the decoration of the Imperial Palace. The sketches, costumes, and experiences that Leprince gathered on his travels were to provide subjects for innumerable painted and etched *russeries* after his return to France in 1763.

According to Mariette, Leprince had departed a mediocre artist and returned a masterly one.[1] By February of 1764 he was agréé by the Académie and in August 1765 *reçu* with the presentation of *The Russian Baptism* (Louvre). It was shown in the Salon of that year with many other paintings of Russian subject matter, including a *View of St. Petersburg, Cossacks and Tartars Returning from a Raid, The Departure of a Horde of Calmoucks, A Winter Voyage*, and *A Mill in Livonia*. Diderot, like the other critics, was struck by the novelty of the subjects, but wrote, "I will not answer for the imitations of Russia. Let those who are familiar with the locale and mores of that country pronounce on that; but I find them for the most part weak like the health of the artist, melancholy and sweet like his character."[2]

As the novelty of the subjects waned, Diderot in subsequent reviews criticized the monotony of Leprince's paintings and what he considered their poor technique. He wrote of this pair, exhibited in the Salon of 1769: *"tout est ebauche et faible."*[3] As in many other cases, it is difficult for us to agree with Diderot. These paintings have a remarkable charm, Leprince's touch is extraordinarily delicate, and his palette vivid, so that these works are like jewels. Their distinguished provenance is witness to the spell they have cast over knowledgeable *connoisseurs*.

An earlier pair of paintings, signed 1764 and 1765, treats similar subjects with slight differences.[4] In still another pair, sold at Christie's (November 26, 1971), the subject of the seesaw is treated in an identical fashion but paired with a scene of fortune-telling. Finally, an oval pen and wash drawing of the Russian dance was with Gallerie Cailleux in 1975.[5] The theme of music-making Russians was also employed by Leprince in 1768 for the series of six tapestry cartoons he designed for the Beauvais factory on the theme of *"Jeux Russiens."*

[1]Mariette, *Abécédario*, III, pp. 192-93.
[2]Seznec and Adhémar, 1960, II, pp. 171-180.
[3]Ibid, III, p. 97.
[4]Sale, Galerie George Petit, Paris, May 29-31, 1890, nos. 168 and 169.
[5]See the exhibition catalogue *Eloge de l'Ovale*, Gallerie Cailleux, Paris, 1975, p. 35, no. 17.

Nicolas-Bernard Lépicié, 1755-1784

53. *The Carpenter's Family,* ca. 1775
Oil on canvas, 19¼ x 24⅜ inches (49 x 62 cm.)
Signed lower right: *Lépicié*

Private Collection, New York.

Provenance: Nicolas-Bernard Lépicié; Bequeathed at his death to his niece; Sold ca. 1850 to Monsieur Boittelle, Paris; bought in at his sale, Hôtel Drouot, Paris, April 24-25, 1866, no. 77; Purchased at a later date by Baronne d'Erlanger; Private collection, New York.

Exhibition: *La Douceur de Vivre: Art Style and Decoration in XVIIIth Century France,* Wildenstein, London, June 1-July 30, 1983.

Bibliography: F. Ingersoll-Smouse, "Nicolas-Bernard Lépicié," *Revue de l'Art Ancien et Moderne,* December 1926, p. 294, ill. p. 295.

Nicolas-Bernard's father was François-Bernard Lépicié, a *graveur du roi* and secretary of the Académie who was known for his prints, especially those after paintings by Chardin. He and his wife, who was also an artist, resided in the Louvre from 1748, and provided the first training for their son, who then went on to study with Carle van Loo. Nicolas-Bernard won several prizes at the Académie, including the second Grand Prix in the *Concours* of 1759. He was *agréé* for his *William the Conqueror* in 1764, which was then exhibited at the Salon of 1765, and *reçu* as a history painter in 1769. In the early part of his career, he was primarily a painter of history and religious subjects. Works such as the small *Quos Ego (Neptune Unleashing the Winds,* fig. 13) shown at the Salon of 1771 (and now in a private collection, Los Angeles) gained him recognition.

In the early 1770's Lépicié also began painting and exhibiting small genre scenes inspired by seventeenth century Dutch paintings and the much-acclaimed works of Greuze. Contemporary critics such as Bachaumont, writing in 1773, noted Lépicié's deficiencies as a history painter but found these genre subjects captivating. Acknowledging the debt to the tradition of Teniers, Bachaumont praised their "truthfulness."[1]

At the Salon of 1775, Lépicié showed an *Education of the Virgin,* a *Portrait of the Duc de Valois,* and several genre subjects, including one entitled *The Carpenter's Shop.* Later, as was his custom with well-received subjects such as *Le Lever de Fanchon,* he painted a smaller replica, possibly to assist the engraver Jacques-Philippe Le Bas in making the print after his work.

Towards the end of his life, Lépicié underwent a spiritual crisis and sought to eliminate what he felt were licentious elements from his work. In his will, made sometime before April 1783, he lamented having painted and engraved mythological works such as the *Quos Ego.* Fearing that "it might give rise to evil thoughts," he also specified the Le Bas plate and the prints after his two paintings of *The Carpenter's Shop*

(which he had repainted) be destroyed. Fortunately, one impression survived, and it shows that in his original conception the carpenter paused in the midst of his work to glance down the bosom of the young woman and perhaps whisper a lewd proposal to her. Another painting by Lépicié, *La Demande Acceptée,* was regarded as its pendant. The Salon painting, which was sold from the artist's estate after his death, has disappeared, but in this reduced replica we can see that Lépicié changed the painting to become a celebration of familial bliss – the carpenter, now a virtuous father, and his wife look on approvingly as the grandmother teaches their daughter to read. There is also a small painting of the grandmother and daughter in the Wallace Collection, London. An ink drawing of the entire revised composition is in the Musée d'Orléans.

Despite its altered state, one can still appreciate the precision of touch "with the heads perfectly characterized and the naturalism of their poses,"[2] that typify the genre paintings of Lépicié and made him, along with Aubry, one of the chief representatives of the cult of *sentimentalité.*

[1] P. Gaston-Dreyfus, "Une dernière volonté de N.-B. Lépicié," *BSHAF,* 1910, pp. 18 and 20, and idem, *Catalogue raisonné…* Paris, 1923, p. 205, no. 179.
[2] Review of the *Courtes Réflexions* quoted in Seznec and Adhémar, p. 244.

Etienne Aubry, 1745-1781

54. *The First Lesson of Fraternal Friendship,* 1776
Oil on canvas, 30 x 37½ inches (76.2 x 95.3 cm.)
Signed at lower right: *E. Aubry 1776*

The Nelson-Atkins Museum of Art, Kansas City.
Nelson Fund, 1932.

Provenance: Baron Jacques Augustin de Silvestre; Sale, Paris, Feb. 28 - March 25, 1811; Boittelle; Sale, Paris, April 24-25, 1866; G. Wildenstein, Paris, by 1925; L. Paraf; D. A. Hoogendijk and Company, Amsterdam, by 1929.

Exhibition: Salon of 1777, Paris, no. 125.

Bibliography: Florence Ingersoll-Smouse, "Quelques Tableaux de Genre inédits par Etienne Aubry (1745-1781)," *GBA,* 1925, p. 82, ill. op. p. 84.

Aubry, who was born at Versailles, was a student of J. A. Silvestre and Joseph Vien. As a portrait painter, he was *agréé* in 1771 and *reçu* in 1775, but from then on he was best known as a painter of moralizing genre scenes which often recall the work of Greuze. Having gone to Rome in 1777, Aubry was tempted to try his hand at history paintings, and in the year of his death, he sent to the Salon a *Coriolanus Bidding Farewell to his Wife.*

At the Salon of 1777, Aubry exhibited several works which were to become his most famous genre scenes. Each has a different subject, but they are related in their general concern for family relationships. The

Salon *livret* described the present painting: "The parents go to see one of their children, who is with a nurse, and have the nursing child embraced by his older brother." The title, *La Premiere Leçon d'Amitie fraternelle*, is from the Nicholas Delaunay print that was made after the painting. The subject of wet nurses, with whom children were left for long periods, was a popular one in both art and literature in the eighteenth century.[1] Greuze had depicted both a *Departure for the Nursery* and *Return from the Nursery*. Among Aubry's other entries in the Salon of 1777 was *Farewell to the Nurse*. Known in versions at both the Pushkin Museum (Moscow) and the Sterling and Francine Clark Art Institute (fig. IV.9),[2] it depicts several of the same characters in an outdoors setting.

Aubry brings to his sentimental subject a marvelous technique. As the author of the *Lettres pittoresques* (1777) observed, this work is "a painting in which the vigor, the effect, and the expression are equally to be admired." The painting contrasts the clothes and manner of the two families – the elegantly dressed aristocratic mother and father and the gnarled surrogate parents in their humble surroundings. All are united in the warmth of this charming moment of the first filial embrace, which serves as a metaphor for the idea of universal brotherhood which flourished in this period.

[1]Louis Hautecoeur, "Le Sentimentalisme dans la peinture Française," *GBA*, 1909, pointed out, in addition to Aubry, such examples as Saint-Lambert's *Sarah* works by Moreau le jeune and Fragonard.
[2]See *La Peinture Française au Musée Pouchkine*, Moscow, 1980, no. 57 and *List of Paintings in the Sterling and Francine Clark Art Institute*, Williamstown, 1972, p. 101, no.636.

Pierre-Louis Dumesnil the Younger, 1698-1781

55. *Interior with Card Players*, ca. 1752
Oil on canvas, 31⅛ x 38¾ inches (79 x 98 cm.)

The Metropolitan Museum of Art, New York. Bequest of Harry G. Sperling, 1971.

Provenance: C. Duits, London; F. Kleinberger and Co., Inc.; Harry G. Sperling.

Bibliography: Paul M. Ettesvold, *The Eighteenth Century Woman*, New York Metropolitan Museum of Art, 1981, p. 51.

Pierre-Louis Dumesnil the Younger came from a family of painters. Although he resided for a time in Bordeaux, he made his career in Paris. There he was a distinguished member of the Académie de Saint-Luc, achieving the status first of *professeur* and then *recteur*. He exhibited at the Académie's Salons from 1751 to 1774, and his subject matter ranged from religion and mythology to portraits and genre scenes.[1]

The present painting, although at one time attributed to Jean-François de Troy, is clearly by Dumesnil. The figures have an attenuated, slightly naive quality characteristic of his work. The theatrical lighting effect, in this case the reflected glow of the fire and candles, is also typical of Dumesnil. The humor and charm of the comfortable bourgeoise interior is similar to his painting *Le Traitant* at the Musée des Beaux-Arts, Bordeaux.

[1]See the *Livrets des expositions de L'Académie de Saint-Luc à Paris, 1751-1774*, Paris, 1872.

119

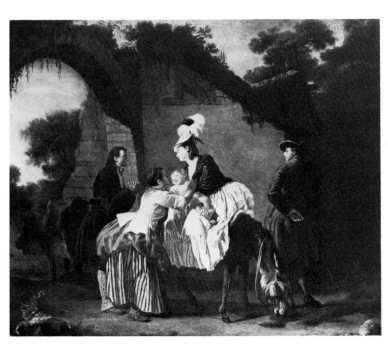

Fig. IV. 9

Louis-Roland Trinquesse, ca. 1746-ca. 1800

56. *Interior Scene with Two Women and a Gentle-
man,* 1776
Oil on canvas, 38 x 48 inches (96.5 x 121.9 cm.)
Signed and dated at lower left: *Trinquesse 1776*

Maurice Segoura Gallery, New York.

Although a remarkable painter, Trinquesse seems an
outsider in the world of late-eighteenth century paint-
ing. Probably of Burgundian origin, he came to Paris
and won medals at the school of the Académie in 1770
but did not continue as an *académicien*. Instead he
exhibited his works from 1779 to 1787 at the Salons de
la Correspondance organized by Pahin de Blancherie.
His paintings were not only the genre scenes for
which he is best known, but also portraits – including
one of George Washington for General Lafayette,
which was based on a likeness by Charles Wilson
Peale.[1] Following the Revolution, Trinquesse exhi-
bited in the open Salons of 1791 and 1793.

Trinquesse's chief subject was the pursuit of love
and pleasure in either the intimate confines of the
boudoir or the shaded recesses of gardens. His figures
wear the elegant dress of the early years of Louis XVI's
era. Both these subjects and their treatment, inspired
in part by Dutch seventeenth century painters Metsu
and Terborch, are often reminiscent of his contem-
poraries Boilly and Marguerite Gérard. This painting
of 1776 shows that on occasion he could produce a
surprisingly large-scale work in a vigorous manner.
The relationships between the three figures, looking
rather like characters from a Beaumarchais play, is
keenly portrayed. Trinquesse had certain models
whom he used repeatedly and the young woman who
here takes the role of a slatternly maid is the subject of
several drawings.[2]

[1]See Jacques Wilhelm, "Les portraits masculins dans l'oeuvre
de L.-R. Trinquesse," *Revue de l'Art,* 1974, fig. 10.
[2]See Jean Cailleux, "The Drawings of Trinquesse," *The Bur-
lington Magazine* supplement, February 1974, fig. 27.

V. Still Life & Landscape

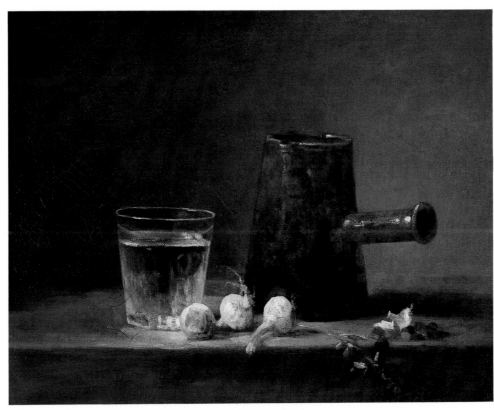

57. Jean-Siméon Chardin, *Glass of Water and Coffeepot*

58. Alexandre-François Desportes, *Still Life*

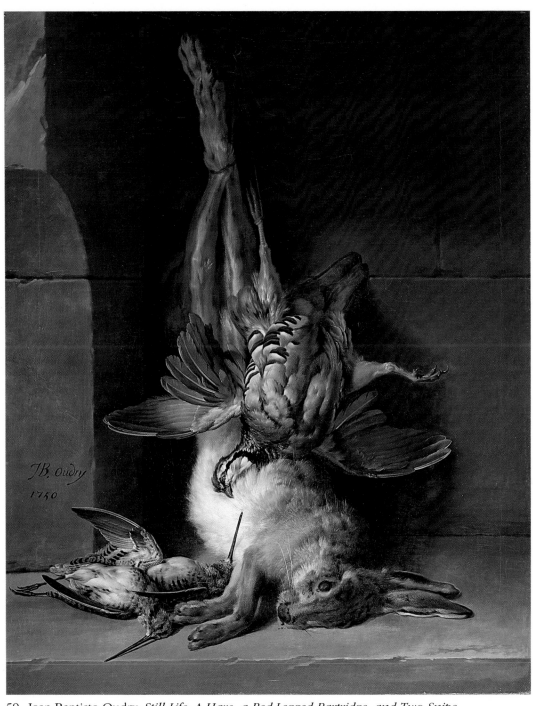

59. Jean-Baptiste Oudry, *Still Life: A Hare, a Red-Legged Partridge, and Two Snipe*

60. Roland Delaporte, *Lapis Lazuli Vase, Globe and other Objects*

61. Anne Vallayer-Coster, *Still Life with Lobster*

62. Jacques de Lajoue, *The Fountain of Bacchus*

63. Claude-Joseph Vernet, *The Calm (Sunrise)*

64. Claude-Joseph Vernet, *The Storm*

65. François Boucher, *Idyllic Landscape with a Woman Fishing*

66. Jean-Honoré Fragonard, *Landscape with Passing Shower*

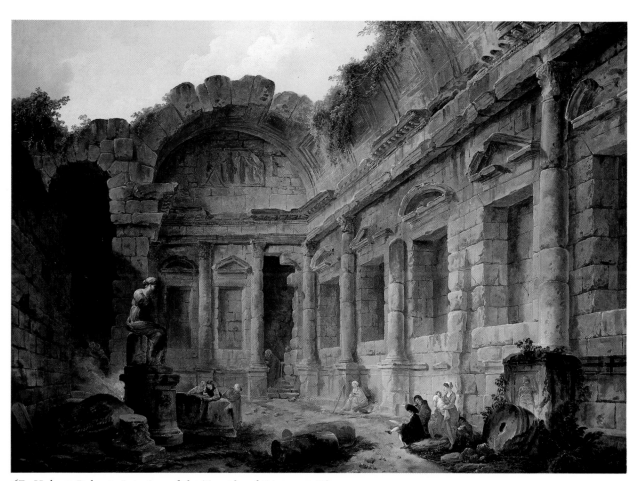

67. Hubert Robert, *Interior of the Temple of Diana at Nîmes*

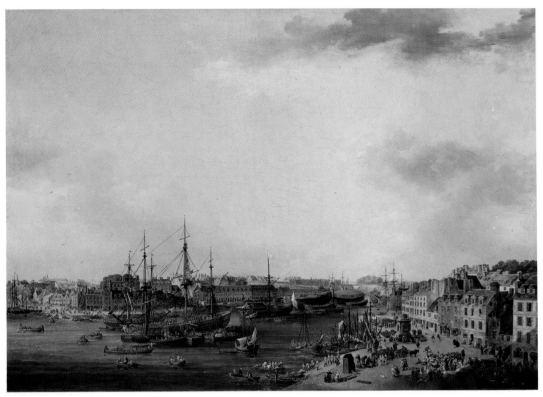

68. Louis-Nicolas van Blarenberghe, *The Outer Harbor of Brest*

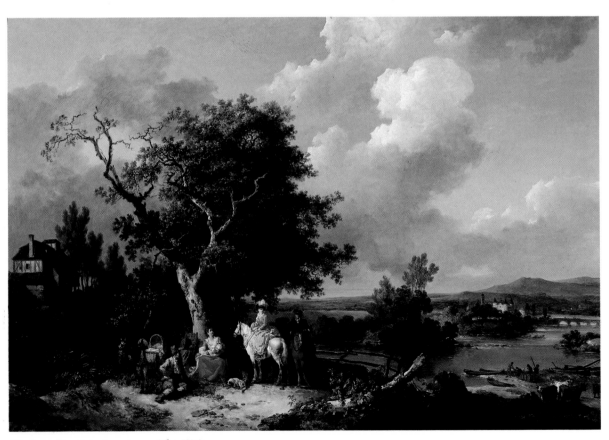

69. Jean-Baptiste Leprince, *The Visit*

Commentaries

Jean-Siméon Chardin, 1699-1779

57. *Glass of Water and Coffeepot,* ca. 1761
Oil on canvas, 12¾ x 16⅛ inches (32.5 x 41 cm.)
Signed at the lower left (scarcely legible): *Chardin*

Museum of Art, Carnegie Institute, Pittsburgh. Gift of Howard A. Noble, 1966.

Provenance: Philippe Burty (d. 1890) from ca. 1874; Sale, March 2-3, 1891, no. 30; Charles Haviland; Sale, December 14-15, 1922, no. 42; George Haviland; Sale, June 2-3, 1932, no. 105; A. M. Schwenk.

Exhibition: *Chardin 1699-1779*, Grand Palais, Paris, The Cleveland Museum of Art, and Museum of Fine Arts, Boston, 1979, no. 116.

In his *Essai sur la vie de M. Chardin*, written the year after the artist's death, C.-N. Cochin summed up the eighteenth century view of Chardin: "His paintings possess yet another rare quality: they show truth and simplicity in attitudes and in composition. Nothing seems deliberately introduced for the sake of effect. Quite apart from the truth and strength of the coloring, his paintings beguiled everybody by their natural simplicity."[1] By the late 1750s, Chardin had achieved this masterful simplicity and had begun to experiment with unusual compositions. One of the difficult motifs he dealt with was the representation of water in a clear glass. A painting of a glass of water and bucket of plums at the Musée des Beaux-Arts, Rennes, is probably identical to one shown in the Salon of 1759. A contemporary reviewer praised Chardin's glass "half filled with water which creates two kinds of transparencies perfectly rendered."[2] Another painting of a glass of water – this time with a basket of wild strawberries (private collection, Paris), was shown at the 1761 Salon. Pierre Rosenberg has dated the Carnegie Institute painting to the same year, rather than to the much earlier date given by Wildenstein. This seems entirely convincing.

It was this type of painting which led to the reassessment of Chardin in the late nineteenth century. The Goncourts, for example, wrote:

Fruits, flowers, accessories, utensils, who has painted such things better than Chardin? Who has expressed, as he has expressed, the life of inanimate objects? Who has given our eyes such a sensation of the actual presence of things?...Look at another picture, quite as simple and quite as full of light and harmony: it shows a glass of water standing between two chestnuts and three walnuts; look at it for a long time, then move back a few paces; the contour of the glass solidifies, it is real glass, real water, it has a nameless colour produced by the double transparency of vessel and the liquid. The tenderest colour range, the subtlest variations of blue turning to green, the infinite modulation of a certain sea-green grey, crystalline and vitreous...that is what you see when you stand close.[3]

The *Glass of Water and Coffeepot* belonged to Philippe Burty (1830-1890), a friend of the Goncourts and one of the critics instrumental in the revival of interest in Chardin. The Goncourts described his painting as follows:

Three little white onions, a branch of fennel, a brown clay pitcher, a glass three-quarters full. A marvel, this little picture, in which the insignificance of the composition sets off to best advantage the artistic wisdom of the best still-life painters of all the schools.[4]

[1] Charles-Nicholas Cochin, *Essai sur la vie de M. Chardin*, 1780, published by Ch. de Beaurepaire in 1875-76, pp. 426-428, translated in Rosenberg, 1979, p. 83.
[2] Translated in Rosenberg, 1979, p. 314.
[3] Translated in *Edmond and Jules de Goncourt, French Eighteenth Century Painting*, by Robin Ironside, 1980, pp. 114-116.
[4] Translated in Rosenberg, 1979, p. 326.

Alexandre-François Desportes, 1661-1743

58. *Still Life,* ca. 1739
Oil on canvas, 18½ x 22 inches (49.9 x 55.8 cm.)

Mead Art Museum, Amherst College. Purchase, 1978.

Provenance: Neville Orgel Ltd., London.

One of the most important still life painters of the first half of the eighteenth century, Desportes received his training in the Flemish tradition from the painter Nicasius Bernaert. Following that master's death, he worked with Audran on various decorative projects in which he painted the animals. For a period of two years in the mid-1690s, the artist was called to Warsaw to work for King Sobieski as a portraitist, recording the king and queen and members of the Polish court.

Shortly after his return to Paris, Desportes was *reçu* by the Académie in 1699 as a painter of animals with his *Self-Portrait as a Hunter Accompanied by his Dogs* (Louvre). This work became well known and was the basis for a number of commissioned portraits, but it was as a painter of still lifes, animals, and the hunt that Desportes gained his greatest fame. His first royal commission for such subjects came in 1700; he painted scenes of hunting for the Ménagerie at Versailles. Recognizing his skill, Louis XIV gave Desportes a *pension* and a residence in the Louvre. The painter produced many additional hunting scenes as well as portraits of the king's favorite dogs.

In 1712 Desportes was allowed to go to England in the retinue of the French ambassador, the duc d'Aumont, subject to immediate recall by the king. He remained six months, executing many works for the

English nobility. Returning to France, he painted additional hunt and still life decorations at both Versailles and Marly. During the Regency, he worked for the duc d'Orléans at the Palais Royale, and decorated many other châteaux. He became a favorite of Louis XV, whom he accompanied on the hunt and whose dogs he also painted. In 1735 Desportes was commissioned to do a series of large tapestry cartoons for the Gobelins factory on Indian subjects.

As prolific as he was popular, Desportes exhibited regularly at the Salons throughout his life. The biographer d'Argenville noted, "There was hardly a house of any significance which did not possess one of his works – be it a portrait, animals, hunting scene, overdoor, or buffet."[1] D'Argenville also called attention to the remarkable oil sketches on paper that Desportes did as preparatory studies. These works, recently unearthed at the library of Sèvres, attest to his impassioned observation of all of nature's phenomena – clouds, plants, and animals.[2]

This small still life, which clearly shows the artist's mastery of varied textures, is one of a number of related works that date form the mid- and late 1730s.[3] A nearly identical work, signed and dated 1739, was sold at the Palais Galliera, Paris, March 28, 1968; it differs only in the addition of some flowers to the basket of figs and in the absence of the carved relief on the lower edge of the table. This classicizing relief, like others that appear in works by Desportes, may be based on a work by the Roman-trained Flemish sculptor François du Quesnoy.[4]

[1]A. J. Dézallier d'Argenville, IV, p. 336.
[2]*L'atelier de Desportes*, Musée du Louvre, Paris, 1982-83.
[3]See, for example, those reproduced in M. Faré, *La Nature Morte en France*, Paris, 1962, II, pls. 312 (signed and dated 1736) and 313, and a pair of paintings also featuring dead birds at Heim, Paris, in June 1975.
[4]See Jean Cailleux, "Themes and Survivals in Connection with Two Still Life Paintings by François Desportes," *The Burlington Magazine* supplement, November 1969.

Jean-Baptiste Oudry, 1686-1755

59. *Still Life: A Hare, a Red-Legged Partridge, and Two Snipe*, 1750
Oil on canvas, 32⅜ x 26 inches (82.2 x 66 cm.)

Signed at lower left: *J B Oudry / 1750.*

Worcester Art Museum. Theodore T. and Mary G. Ellis Collection, 1960.

Provenance: Sale, Berlin, March 15, 1933, no. 76.

Bibliography: Hal N. Opperman, *Jean-Baptiste Oudry*, New York, 1977, I, p. 557, no. P520, II, p. 946, fig. 345; Idem, *J.-B. Oudry, 1686-1755*, exhibition catalogue, Paris, Fort Worth, Kansas City, 1983, English ed., p. 212, fig. 115.

Jean-Baptiste Oudry was the son of a non-academic painter and art dealer. He studied first under his father, then briefly with Michael Serre, and became a pupil at the Académie de Saint-Luc in 1706. He began a five-year apprenticeship with Largillierre in 1707 and mastered both portrait and still life painting. He was *agréé* by the Académie Royale in 1717 with an *Adoration of the Magi*, and was *reçu* two years later as a history painter for his *Abundance with her Attributes.*

The two major influences on Oudry were his teacher Largillierre and the contemporary Parisian still life painter Desportes. Opperman has divided Oudry's life into four periods, characterized as follows: "The Portraitist," through his early years in the Académie; "The Animal Painter," throughout the decade of the 'twenties; "The Tapestry Designer," during the 'thirties, when he was appointed financial and artistic director at Beauvais in 1734 and then at Gobelins in 1736; and "The Academician," from 1739 until his death, Oudry having been appointed to a professorship in 1743.

He was a regular and enthusiastic contributor to the Salons, reliable for his enormous output (he entered twenty-nine paintings, drawings, and engravings at his final Salon exhibition in 1753). He never lacked commissions, enjoyed international patronage from the Courts of Sweden, Denmark, and Mecklenburg, and had his most important commissions from Louis XV, including trophy pictures of the royal hunts.

Oudry went far beyond Chardin in seeking virtuosic illusions in his still lifes. His paintings, especially of dead game, are not Chardin's humble assemblages of found objects, but proud and gleaming trophies of the hunt. Oudry sought novelty in his arrangements, coloration, and in the contrast of his paintings. Dézallier d'Argenville wrote of Oudry's "particular talent for representing things with the colors which were entirely appropriate to them."[1] The artist's own concern was made manifest in his *conférence* of 1749:

Suppose that you would like to paint a silver vase all by itself on a canvas. The general idea that one has concerning the color of silver is that it is white, but to render this metal in its true tone, one has to determine the white which is particularly appropriate to it. Question: How do we determine this? Here's how: It is in placing next to the silver vase other objects of different whites, such as linen, paper, satin, and porcelain. These different whites make it possible for you to evaluate the precise tone of white which you will need to render your silver vase...[2]

This concern with the quality of whiteness found expression the following year in one of a pair of paintings he exhibited at the Salon of 1750. This was the *Still Life of Sea Gulls on a White Background* (fig. V.1). The location of this work is not known. The pendant, however, was this exquisite still life of dead game in which the variety of colors set against a dark background is as remarkable for its warmth as the *Sea Gulls* is for its cool reserve. Oudry repeated his investigation of color harmony on an even grander scale in 1753, when he exhibited his famous *White Duck* (private collection, London) and its pendant *Still Life with*

134

a Hare, Pheasant, and Red-legged Partridge (Louvre). In both instances, it was the white-on-white work which drew the most attention. The critic in 1750 was not amiss when he wrote: "M. Oudry is a magician in paint."[3]

[1]Dézallier d'Argenville, 1762, IV, p. 412.
[2]Oudry, "Réflexions...," 1749, printed in *Cabinet de l'Amateur et de l'Antiquaire*, ed. by E. Piot, III, 1844, p. 39, and quoted in Opperman, 1983, p. 211.
[3]*Lettres sur la peinture à un Amateur*, Geneva, 1750, p. 28.

Roland Delaporte, 1724-1793

60. *Vase, Globe and Musical Instruments*, 1763
 Oil on canvas, 43⅛ x 31⅞ inches (110 x 81 cm.)

 Musée du Louvre, Paris.

 Provenance: Collections of the Academy of Painting from 1763-1816.

 Exhibition: *French Paintings from French Museums XVII-XVIII Centuries*, Fine Arts Gallery of San Diego, California Palace of the Legion of Honor, E. B. Crocker Art Gallery, New Orleans Museum of Art, San Antonio Museum, 1967-1968.

 Bibliography: M. and F. Faré, *La vie silencieuse en France*, Paris, 1976, ill. p. 277; Elisabeth Walter, "A propos de la *Petite collation* de Roland Delaporte," *La Revue du Louvre*, June 1980, p. 159.

Delaporte was born in Paris and may have studied for a time with Oudry. Although he was to paint some portraits, he became a specialist in still lifes and was *agréé* by the Académie on May 30, 1761, as a "painter in the genre of animals and fruits." He began exhibiting at

the Salon that same year, and on March 26, 1763, was *reçu*. The picture exhibited here was his *morceau de reception* and was described in the Académie's records as a "grouping of a vase with several musical instruments."[1] The large lapis lazuli vase with its bronze fittings, the elaborate bagpipe, the globe, and the musical score, all placed before a rich curtain, form a grandiose arrangement that is not typical of the artist's work. But it was undoubtedly appropriate for a reception piece, and also probably led to the painting's being copied in a tapestry now at the Musée des Arts décoratifs in Lyon. For the most part, Delaporte's still lifes are of humbler objects and foods – in his review of the Salon of 1763, Diderot characterized Delaporte as "another victim of Chardin."[2] As has increasingly been recognized, however, Delaporte's work displays a virtuosity and a color sensibility that is quite distinct from Chardin's. Like Chardin, Oudry, and Jeaurat de Berty, Delaporte often included musical instruments and scores in his compositions, as can be seen in his paintings now in the museums of Cambrai and Bordeaux. In this noble composition from the Louvre, the combination of the rustic bagpipe, the Chinese-style vase, and the globe may be intended to emblemize the universality of music.

[1]A. de Montaiglon, *Proces-Verbaux de l'Académie Royale*, 1884, VII, p. 235.
[2]Seznec and Adhémar, *Diderot Salons*, I, 1957, p. 231.

Anne Vallayer-Coster, 1744-1818

61. *Still Life With Lobster*, 1781
 Oil on canvas, 27¾ x 35¼ inches (70.5 x 89 cm.)
 Signed and dated lower left: *Mme Vallayer-Coster/1781*

 The Toledo Museum of Art. Gift of Edward Drummond Libbey, 1968.

 Provenance: Marquis Giaradot de Marigny, Paris, 1783; Achille Fould, Paris; Sale, Hôtel Drouot, Paris, May 22, 1967, no. 20; Galerie Cailleux, Paris.

 Exhibition: Salon de la Correspondance, Paris, 1783.

 Bibliography: M. R. Michel, *Anne Vallayer-Coster, 1744-1818*, Paris, 1970, pp. 168, 196, no. 226.

Anne Vallayer was the daughter of a goldsmith at the Gobelins tapestry factory. When she was ten, her father opened his own shop in Paris which after his death was run by her mother. Anne's training in painting is unknown. Her first recorded work was a portrait in 1762, but she became a specialist in still life painting. In 1770, she was simultaneously *agréé* and *reçu* by the Académie for her impressive still lifes *Allegory of the Visual Arts* (Louvre) and *Allegory of Music* (Louvre). The works she showed at the Salons received warm, if somewhat patronizing, praise. Diderot wrote of her *Instruments of Military Music* in the Salon of 1771: "Absolutely no one of the French School can rival the force of her color nor her finish.

What a success at her age! That her great talent is so much criticized as a result of her age and gender is our own failing. She is certainly made to inspire in us a more forgiving spirit."[1] Writing in 1777, a female Salon reviewer "glories in the fact that a member of her sex distinguishes herself in such an outstanding way."[2]

It was probably through either the Director of the Académie Pierre or the *directeur des bâtiments* d'Angiviller, that the painter came to the attention of Marie Antoinette. In 1780, the queen arranged for Vallayer to have an apartment in the Louvre and the following year appointed the artist as her *professeur de peinture*. Although she painted a portrait of the queen (as well as of other notable women, such as the soprano Mme. de Saint-Huberty as Dido), she was not well received as a portraitist. Bachaumont, among others, advised her to concentrate on still life and leave portraiture to Vigée Le Brun and Labille-Guillard, the other two of the "*immortelles*," as the three leading women painters were called. As a painter of flower pictures, Vallayer was favorably compared to the Dutch-born specialist Gerard van Spaendonck. Her still life painting sometimes recalls Chardin and at other times Delaporte. Perhaps influenced by her father's profession, she often included extravagant silver objects.

In 1781 Vallayer married the wealthy lawyer and member of Parlement Jean-Pierre-Silvestre Coster. On this painting of a *Still Life With Lobster*, she amended her signature from "*Mlle. Vallayer*" to what became her standard form, "*Mme. Vallayer-Coster*." This work and its pendant *Still Life with Game* (fig. V.2) are among the grandest produced by the artist and were in the collection of the Marquis Giaradot de Marigny, who also owned two works by the painter in the 1779 Salon. Both Toledo paintings are in frames marked by the noted framemaker Etienne-Louis Infroit (1720-1794).

Following in the tradition of Oudry, Vallayer-Coster varies the coloration and composition of the two paintings. The *Still Life with Game* includes a gun and is placed in an outdoor setting while the one with the lobster is indoors and includes household objects. The silver pieces may be examples of her father's work. In the large tureen, one sees a reflection of the artist's studio. This, along with the illusionistic device of the knife placed over the edge in the foreground, and the general splendor of the composition, suggest that Vallayer-Coster may have been inspired by such seventeenth century Dutch masters as van Beyern and de Heem.

[1]Seznec and Adhémar, III, p. 201.
[2]*Judgement d'une demoiselle de quatorze ans au Salon*, Paris, 1777, p. 19.

Jacques de Lajoue, 1687-1761

62. *The Fountain of Bacchus*, ca. 1760
Oil on canvas, 28⅛ x 35⅞ inches (71.5 x 91 cm.)

Vassar Art Gallery, Vassar College, Poughkeepsie. Gift of Mr. and Mrs. E. Powis Jones.

Provenance: Dolgorouki collection; B. Narischkine; Sale, Paris, May 4, 1868, no. 48; Dépinay collection, Senlis; Galerie Cailleux, Paris; Mr. and Mrs. E. Powis Jones, New York City, 1971.

Exhibition: *Promised Gifts '77*, Vassar Art Gallery, Poughkeepsie, 1977, no. 3.

Lajoue is one of the artists whose works define the fantastic and decorative aspects of rococo art. The son of an architect, he was greatly influenced by the premier architect of the Regent, Gilles-Marie Oppenord, who in turn had been inspired in Italy by the complex and innovative structures of Borromini. Lajoue had a successful career from the time of his admission to the Académie in 1721. He collaborated with Watteau and Boucher, rendering the architectural elements in their paintings, and followed them in the creation of *chinoiserie* designs. His independent work included not only stage sets, but designs for trophies, fountains, imaginary structures and gardens. Lajoue worked for the royal family and for many noble patrons, designing vast sets of ornaments. He exhibited in most of the Salons of his era, appearing for the last time in 1753 with an *Allegory of the Glory of the King* which was purchased by Madame de Pompadour.

The *Fountain of Bacchus* is an excellent example of the *genre pittoresque* that Lajoue helped invent. All the elements — the ruins of classical statues, the Silenus fountain, the tasteful garden, and the elegant tiny figures — combine to create an enchanted environment. Marianne Roland Michel has pointed out the similarity of the fountain here to that in a drawing dated 1759 in the Destailleur sale (Paris, May 19, 1896, no. 417) and to a similar motif appearing in Lajoue's second *Book of Architecture*, which leads her to propose a date of 1755-60 for the painting.

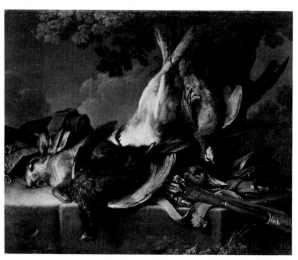

Fig. V. 2

Claude Joseph Vernet, 1714-1789

63. *The Calm (Sunrise)*, 1759
 Oil on canvas, 38½ x 53 inches (97.8 x 134.6 cm.)
 Signed at lower left: *J. Vernet 1759*

 Elvehjem Museum of Art, University of Wisconsin, Madison. Robert Gale Doyon Fund and Endowment Fund Purchase.

64. *The Storm*, 1759
 Oil on canvas, 38½ x 53 inches (97.8 x 134.6 cm.)
 Signed: *J. Vernet f. 1759*

 The Currier Gallery of Art, Manchester, New Hampshire.

 Provenance: Francis Egerton, Sixth Earl and Third Duke of Bridgewater, 1759-1803; to his nephew Second Marquis of Stafford, 1803-1833, Cleveland House, London; to his son the Earl of Ellesmere and by descent in the family, Bridgeport House; Thomas Agnew and Sons, Ltd., London, 1976.

 Bibliography: F. Ingersoll-Smouse, *Joseph Vernet*, 1926, I, p. 91, nos. 714 and 716; Philip Conisbee, "*The Storm* by Claude-Joseph Vernet," *The Currier Gallery of Art Bulletin*, 1977, pp. 14-26.

Vernet, one of the greatest international artists of the eighteenth century, was born in Avignon, the son of a minor decorative artist. He studied with local painters at Aix-en-Provence and was patronized by members of the nobility who made it possible for him to journey to Italy in 1734. Vernet worked with Benedetto Fergioni and the Lyon-born painter Adrien Manglard, who specialized in adapting the subjects of Claude Lorrain to contemporary taste. In addition to observing the Italian coast, especially around Naples, Vernet also studied paintings by such earlier landscape specialists as Salvatore Rosa, Gaspard Dughet, and Pietro Tempesta. By 1740 he was already renowned as a painter of landscape and marine subjects – both real and imaginary. He was *agréé* by the Académie in 1746, the first year his views of Naples and Italy were exhibited at the Salon. He was *reçu* following his return to France in 1752.

Having met the marquis de Marigny in Italy in 1750-51, Vernet was employed in 1754 to paint a series of views of the ports of France for Louis XV. Over the next eleven years, the artist travelled about the country to fulfill this commission. He produced fifteen large views that brought him tremendous fame. He then settled in Paris and was granted a residence in the Louvre.

In 1745, while in Rome, Vernet had married an Englishwoman, Virginia Parker, whose father was a captain in the Papal navy. Through this family connection, Vernet received many commissions from English collectors, who were then making the Grand Tour to Italy in increasing numbers. Just as they were eager to have a souvenir portrait by Batoni, so they desired one (or, even better, a set) of Vernet's proto-romantic landscapes or seascapes. Francis Egerton, the future Duke

of Bridgewater, arrived in Rome just after the painter had returned to France. In 1756 he sent Vernet a commission for a set of four paintings. Vernet recorded payment for the completed works early in 1759. Their subjects were described as a stormy landscape, a storm at sea, a sunrise, and a sunset. By the time of the earliest published catalogues of Bridgewater House, only the two paintings reunited here were known.

Following his custom, Vernet sought to emphasize the contrasts within this set of paintings. As Conisbee has observed, these two works could be used to illustrate Edmund Burke's influential definitions of the Sublime and the Beautiful. An element of the Sublime was the sensation of terror evoked by the awesome power of natural forces such as the storm and ocean, and the Beautiful is easily identified with the serene idyl of *The Calm*. Likewise, these two paintings perfectly reflect the two primary sources of Vernet's inspiration – Claude Lorrain in *Sunrise* and Salvatore Rosa in *The Storm*. Contemporary viewers like Diderot found the activities of the figures highly significant. Diderot wrote in 1765, "the seascapes of Vernet which present a variety of incidents and scenes are as much history paintings as the *Seven Sacraments* of Poussin."[1]

[1]*Diderot: Oeuvres esthétiques,* ed. by P. Vernière, Paris, 1959, p. 726.

François Boucher, 1703-1770

65. *Idyllic Landscape with a Woman Fishing*, 1761
 Oil on canvas, 19½ x 26 inches (49 x 66 cm.)
 Signed and dated lower right center: *F Boucher 1761*

 Indianapolis Museum of Art. Gift of Mr. and Mrs. Herman C. Krannert, 1960.

 Provenance: Duc de Deux-Ponts; Sale, April 6, 1778, no. 79; Sale, Galerie Georges Petit, Paris, June 22-24, 1927, no. 14; Lennie Davis; Rosenberg and Stiebel, New York; Mr. and Mrs. Herman C. Krannert, New Augusta.

 Exhibitions: *Three Masters of Landscape: Fragonard, Robert and Boucher*, Virginia Museum, Richmond, Virginia, 1981, no. 39.

 Bibliography: Ananoff, 1976, II, pp. 211-213, no. 546, fig. 1504; Anthony F. Janson, *100 Masterpieces of Painting, Indianapolis Museum of Art*, 1980, p. 132; Ananoff, 1980, no. 575.

Boucher had begun painting landscapes as early as the mid-1730s, perhaps in his search for new motifs of rural backgrounds for tapestry designs. Boucher travelled through the countryside and made studies of sites such as the mill at Charenton on the juncture of the Seine and Marne rivers, which later appeared in enhanced form in both paintings and tapestry compositions. The importance Boucher placed on the painting of landscapes is suggested in a letter of May, 1749, written by his student Jacques-Nicolas Julliar to Lenourment de Tournehem, *directeur des bâtiments*, stating his reasons for wishing to be sent to study in

137

Fig. V. 3

Rome: "After having trained in the study of history, it is necessary to develop a more specialized study – the talent for landscape; this is being pursued on the express advice of M. Boucher, who pointed out what was lacking in the landscape painters of France, above all in works for the King, be they tapestries, decorations, or other forms."[1]

Boucher, from the very beginning, usually conceived his landscape paintings in pairs. Such is the case with this idyllic view of 1761, which had as a pendant a *Landscape with a Mill* (Ananoff, no. 547, fig. V.3, last at the Hallsborough Gallery, London). The mill serves as contrast to the ruined building in this work. The cheerful depiction of pastoral activities – the herding of sheep and fishing – in this bucolic setting is typical of eighteenth century sentimental pastoralism, which found expression not only in paintings but also in plays such as those by Jean-Jacques Rousseau. The lush vegetation and radiant sky of Boucher's painting, with its artificial arrangement of natural forms, may in fact be the outgrowth of his own set designs for the theater and opera.

The rich exuberance of Boucher's brushwork and the refinement of his colors is very compelling in this work. In 1761, Boucher exhibited several landscapes at the Salon. These brought from Diderot a commentary which, in its praise of the artist's painterly qualities and denigration of his naturalism, could be applied to this painting:

> "What colors! What variety! What richness of objects and ideas! This man has everything except truth. There is not one portion of his compositions which separated from the others isn't pleasing; even the ensemble is seductive. One asks oneself however: But where has one seen shepherds dressed with such elegance and luxury?…One senses every absurdity. *Yet* one does not know how to leave the picture. It binds itself to you. One comes back to it. This is such an agreeable vice; an extravagance so inimitable and rare. There is so much imagination, effect, magic and facility.[2]

[1]Quoted in Janet Phyrn Black, *Theater and Landscape in the Art of François Boucher*, thesis, Ohio State University, 1978, p. 19.
[2]Seznec and Adhémar, I, 1975, p. 112.

138

Jean-Honoré Fragonard, 1732-1806

66. *Landscape with Passing Shower*, ca. 1765
Oil on canvas, 15 x 18 inches (37 x 44 cm.)

Detroit Institute of Art. Gift of Mr. and Mrs. Edgar B. Whitcomb, 1948.

Provenance: Huot-Fragonard; Sale, May 19-20, 1876, no. 55; de Beurnonville; Sale, January 30-31, 1887, no. 13; David David-Weill; Wildenstein, New York.

Exhibition: *Three Masters of Landscape, Fragonard, Robert and Boucher*, Virginia Museum of Fine Arts, Richmond, November 10-December 27, 1981, no. 22.

Bibliography: G. Wildenstein, 1960, p. 236, no. 176, fig. 94; D. Wildenstein and R. Mandel, 1972, p. 94, no. 189.

Fragonard's landscapes, more than other eighteenth century French works, reveal the influence of Dutch seventeenth century painting. It is probable that Fragonard visited Holland, and various dates have been proposed for such a journey.[1] It is also possible that he studied the works of the famous Dutch painters in Parisian collections. It is from Jacob van Ruisdael in particular that he takes such elements as the gnarled tree silhouetted against the sky that appears in this painting and in the larger and more famous *Return of the Drover* (Worcester). The present painting is one of the several landscapes nearly identical in size, including a *Landscape with Washerwomen* (Richmond), that show scenes of rural life disrupted by the sudden appearance of a thunderstorm. Again a Dutch source can be found, such as Nicholas Berchem's *Ploughing* (The National Gallery, London), but Fragonard intensifies the effect of dark clouds on sunlit sky that the Dutch masters had developed and creates exquisite little panoramas of an idyllic world.

[1]See A. Ananoff, "La Realité du Voyage de Fragonard aux Pays-Bas," *BSHAF*, 1959, pp. 5-22.

Hubert Robert, 1733-1808

67. *Interior of the Temple of Diana at Nîmes*, 1771
Oil on canvas, 29 x 40½ inches (73.7 x 101.9 cm.)
Signed and dated at left: *H. Robert 1771*

The Phillips Family Collection.

Provenance: Durand-Ruel, Paris; Mr. and Mrs. William H. Crocker, Hillsborough, California; Wildenstein and Co., New York.

Exhibition: *Three Masters of Landscape, Fragonard, Boucher and Robert*, Virginia Museum of Fine Arts, Richmond, 1981, no. 34.

During his years in Rome, Hubert Robert, under the influence of the leading Italian painter Giovanni Paolo Panini and the printmaker Piranesi, developed an interest in painting the fashionable subject of ruins. On his return trip to France in 1765, he may have stopped at Nîmes, the site of several important classical ruins, including the Temple of Diana. This possibility has been suggested by Marianne Roland Michel, based

upon a drawing of the site by Robert in the Louvre (RF 30623) from a notebook of Robert sketches in which another sheet is dated 1765.[1] It could well have been that initial visit which provided the material for this 1771 painting. It had been previously believed that Robert visited Provence for the first time only in 1783. The result of the 1783 trip was a series of paintings including an *Interior of the Temple of Diana*, 1783 (now Carroll collection, Munich).[2] It had as a pendant a painting of *The Maison Carée*. This 1771 view, on the other hand, has as its apparent pendant a painting of a site identified by Michel as the steps of the Palazzo Durazzo in Genoa (fig. V.4). Robert repeated the subject of the ruined Temple of Diana in a painting shown at the Salon of 1785 and also in a set of four large views of the antiquities of Provence, painted for the king's dining room at Fontainebleau, which were shown at the Salon of 1787 and are now in the Louvre (fig. V.5).

The Phillips family painting is thus not only an important document for establishing the chronology of Robert's career but also a record of his presence in the forefront of the movement to discover and appreciate the classical monuments of France. It was, for example, in the early 1770s that Charles-Louis Clerriseau was commissioned to record these monuments for Catherine the Great of Russia. His volume *Les Antiquities de Nismes* appeared in 1778, and in 1780 the Marquis de Laborde commenced his monumental *Voyages pittoresques de la France*, which contained the following description of the site of the Temple of Diana:

> Placed in the interior of the temple are a large quantity of fragments from different epochs belonging to ancient baths and other ruins. The large number of tombs, altars, bas reliefs, cornices and inscriptions all in marble combines to make this monument a local museum which is perhaps unique in the world. The vegetation itself seems to lend to and embellish the picturesque quality of this enchanting place.[3]

Fig. V. 4

Fig. V. 5

De Laborde's characterization of the interior of the Temple as a haphazard repository of architectural and sculptural fragments could partly explain the differences we observe between the appearance of the site in Robert's painting of 1771 and those following his visit of 1783. The most significant differences are the presence in the earlier painting and the Louvre drawing of a bas relief on the top of the rear wall and a ruined but still impressive statue of a seated female figure. Also, we note that in the 1771 painting the figures, including the artist himself shown sketching the ruins, are all in contemporary dress, while in the later ones some are shown in classical togas.

After Robert's showing of several paintings of ruins at the Salon of 1767, Diderot wrote in praise of the ease and harmony of his painting but took him to task for not sufficiently capturing the poetic quality of the subject:

> Since you have devoted yourself to the painting of ruins, know that this genre has its poetry which you ignore. Look for it. You have the technique but you lack the ideal. M. Robert, you do not yet know why ruins cause so much pleasure, independently of the variety of accidents which they illustrate.

This painting of 1771 shows the advancement Robert had made in investing scenes of ruins with a suitable melancholic atmosphere.

[1]In correspondence of July 8, 1983.
[2]See Marianne Roland Michel, "A Taste for Classical Antiquity in Town Planning Projects: Two Aspects of the Art of Hubert Robert, "*The Burlington Magazine*, supplement, November 1972, p. ii, fig. 1.
[3]Quoted in Michel, p. iii, and also in John Bandiera, *The Pictorial Treatment of Architecture in French Art, 1731 to 1804*, Ph.D. diss., Institute of Fine Arts, New York City, 1982.
[4]Quoted in Seznec and Adhémar, III, pp. 228-29.

139

Fig. V. 6

Louis-Nicolas van Blarenberghe, 1716-1794

68. *The Outer Harbor of Brest*, 1773
Oil on canvas, 29¼ x 42⅛ inches (74.3 x 107 cm.)
Signed and dated lower left: *van Blarenberghe f. 1773*

The Metropolitan Museum of Art, New York City. Gift of Mrs. Vincent Astor, 1978

Provenance: Purchased in Brest by Mr. Vincent Astor in the 1920s; Vincent Astor, New York, ca. 1920-1959; Mrs. Vincent Astor, New York, 1959-1978.

Bibliography: Katherine Baetjer, *European Paintings in The Metropolitan Museum of Art*, New York, 1980, I, p. 12, III, ill. p. 510.

The van Blarenberghe family of artists, originally from Leyden, settled in Lille, where Louis-Nicolas, known as "le grand van Blarenberghe," was born and began his career. He married in 1739 and, following the death of his wife in 1751, he moved to Paris. There he established his fame primarily as a miniature painter. Among his patrons were Madame de Pompadour, for whom he decorated a snuff box with miniatures of the unveiling of the statue of Louis XV, and the duc de Choiseul, for whom he painted snuff box miniatures of the duc's château and Parisian residence. He also painted a series of overdoors for the Hôtel des Affaires Etrangères at Versailles (now the Municipal Library.)

In 1769, through the duc de Choiseul's influence, van Blarenberghe was appointed *Peintre du Département de la Guerre* and 1773 received the more important post of official painter at the *Ministère de la Marine*. From 1780 to 1790, he worked on the series of gouache paintings of Royal Victories commissioned by Louis XVI, now in the Musée du Versailles. Louis-Nicolas's son Henri-Joseph, who had a very similar style, was from 1774 to 1792 the drawing master of the king's children.

Although he had spent time in Brest in 1760, it was after his appointment to the post at the *Ministère de la Marine* that Louis-Nicolas made the port of Brest an important subject, painting a series of large watercolors now in the Louvre.[1] One of these (fig. V.6) is especially close to the Metropolitan Museum's painting and may have been a preliminary study for it.[2] The watercolor is a bird's-eye-view made from the rigging of a ship and is inscribed with a key which identifies the principal features of the locale. The boulevard at the right is the Quai Marchand de Brest; in the watercolor it is shown nearly deserted but in the painting it

has been peopled with a multitude of tiny figures – soliders, tradesmen, and strolling citizens – all engaged in their daily activities.

In all of his depictions of the port and the preparations of the ships for the French fleet, van Blarenberghe was undoubtedly influenced by the popular port scenes of Joseph Vernet. In the minute precision of his painting and in the luminosity of his rendering of the vast expanse of sky, he also reveals his own Dutch heritage.

[1]See *French Landscape Drawings and Sketches of the Eighteenth Century, a loan exhibition from the Louvre and other French museums at the British Museum*, London, 1977, no. 47.
[2]Similar to the painting is a gouache by van Blarenberghe, signed and dated 1776, that was in the Roseberg collection at Mentmore and was sold by Sotheby's May 25, 1977, no. 2607.

Jean-Baptiste Leprince, 1734-1781

69. *The Visit*, 1779
Oil on canvas, 34¼ x 51¼ inches (87 x 131 cm.)
Signed and dated lower left: *Le Prince / 1779*

Memorial Art Gallery of the University of Rochester. Marion Stratton Gould Fund, by exchange, 1977.

Provenance: Comte de Seuilhade de Chavin; Newhouse Galleries, New York.

Exhibition: *Romance and Reality: Aspects of Landscape Painting*, Wildenstein Galleries, New York, October 18-November 22, 1978, no. 41.

Bibliography: Remy G. Saisselin, "A Leprince Landscape," *Porticus*, 1979, pp. 26-33, figs. 1, 7-9.

It was illness which forced the painter Leprince to leave Paris in the last decade of his life. He bought a house near Lagny at Saint-Denis du Port. Just as he had made use of his trip to Russia, so now he began a careful study of the natural surroundings. In 1773, the first year he exhibited landscape paintings at the Salon, he read a treatise to the Académie on this subject. He advocated a process of careful observation beginning with the study of leaves and progressing then to the study of the whole tree. At a distance, only the "spirit" of the tree can be adequately rendered, and he points out that for an old tree complete suppression of detail and emphasis on mass and touch is required.

The artist effectively applied his theory to the painting of the powerful tree that dominates the composition of *The Visit*. It is the focal point around which are grouped the figures and animals and from which seems to radiate the distant view.

Landscapes came to dominate Leprince's late output; he exhibited eight in the Salon of 1777. In works such as *The Visit*, there is a successful blending of traditions – the grandiose treatment of sky and trees recalls the Dutch seventeenth century manner of painters such as Ruisdael, while the careful treatment of the figures, both peasants and artistocrats, is characteristic of other popular French painters of these same years such as Aubry and Lépicié.

140

VI. Drawings

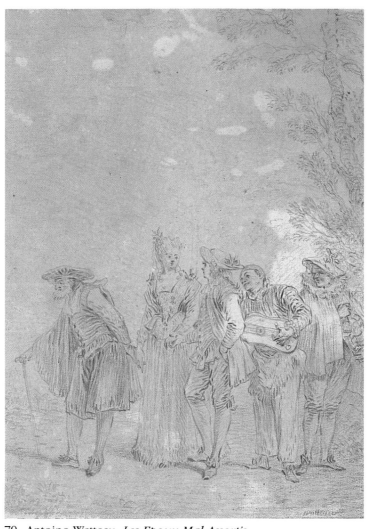

70. Antoine Watteau, *Les Epoux Mal Assortis*

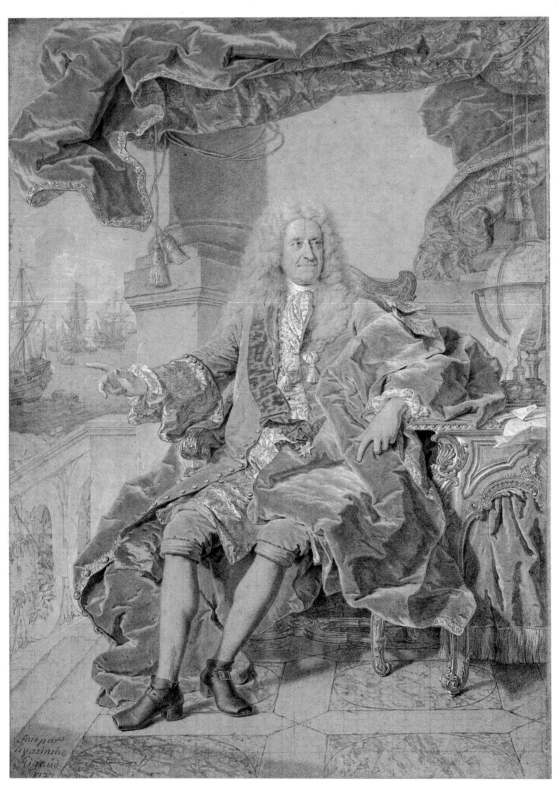

71. Hyacinthe Rigaud, *Samuel Bernard*

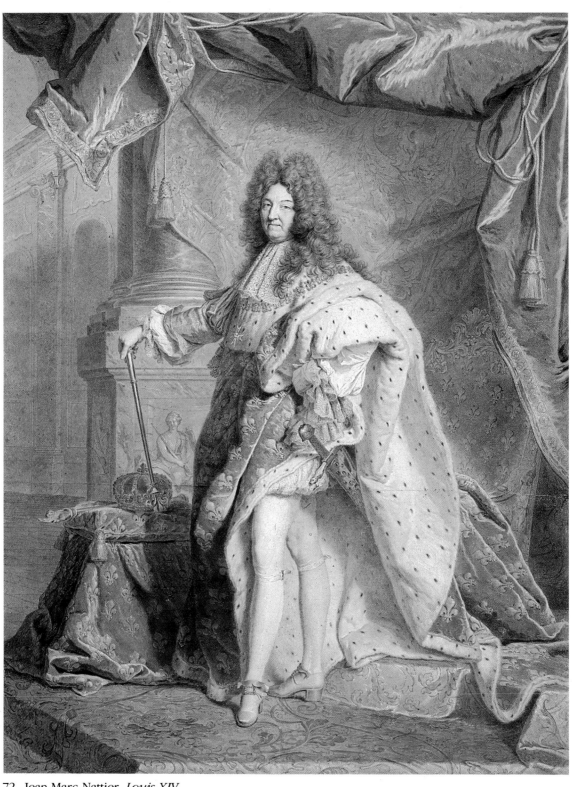

72. Jean-Marc Nattier, *Louis XIV*

73. Jacques de Lajoue,
 Cartouche in the Form of a Boat

146

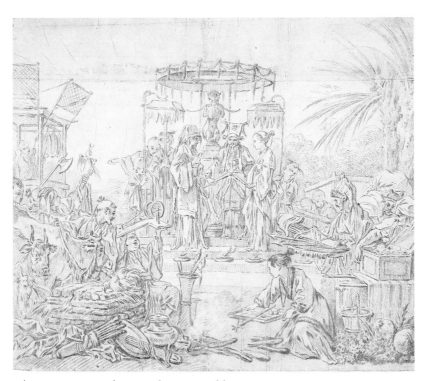

74. François Boucher, *A Chinese Wedding*

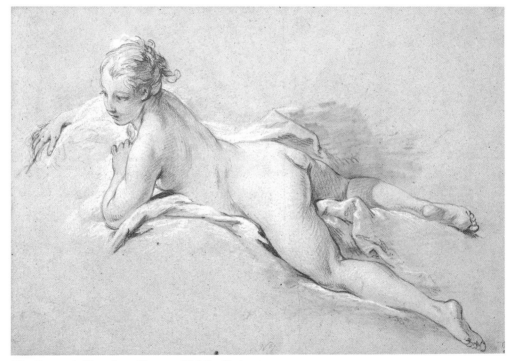

75. François Boucher, *Young Girl Reclining*

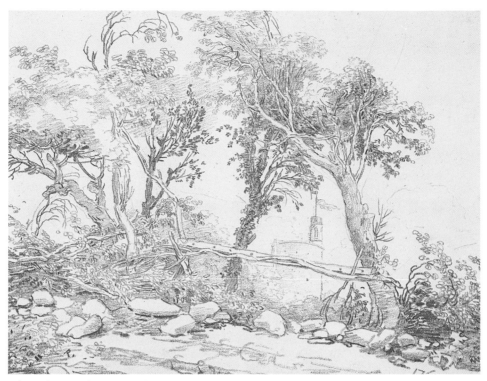

148 76. Hubert Robert, *Landscape*

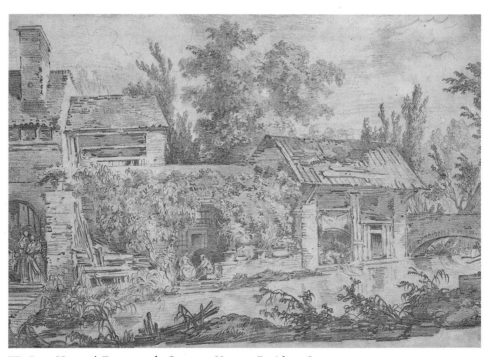

77. Jean-Honoré Fragonard, *Country Houses Beside a Stream*

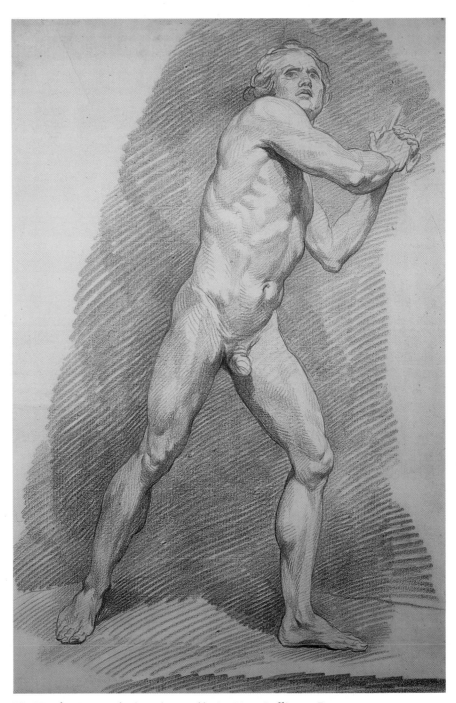

78. Nicolas-Bernard Lépicié, *Académie: Man Pulling a Rope*

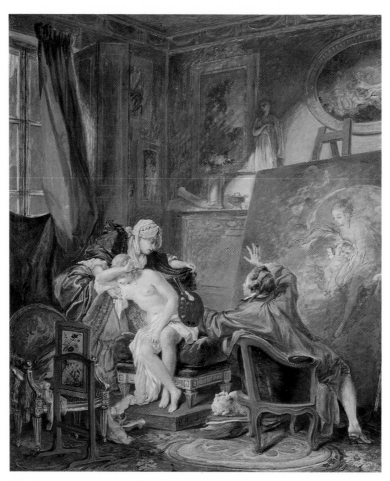

79. Pierre-Antoine Baudouin, *Le Modèle honnête*

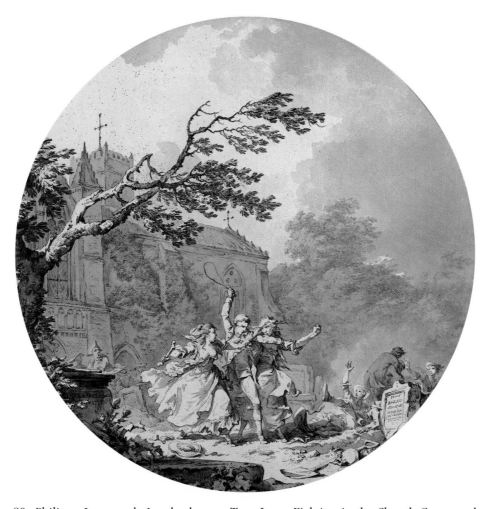

80. Philippe-Jacques de Loutherbourg, *Tom Jones Fighting in the Church Graveyard*

152

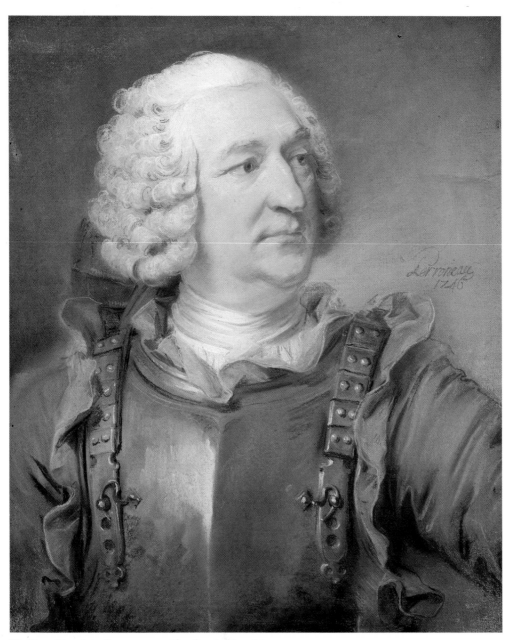

81. Jean-Baptiste Perroneau, *Charles de Baschi*

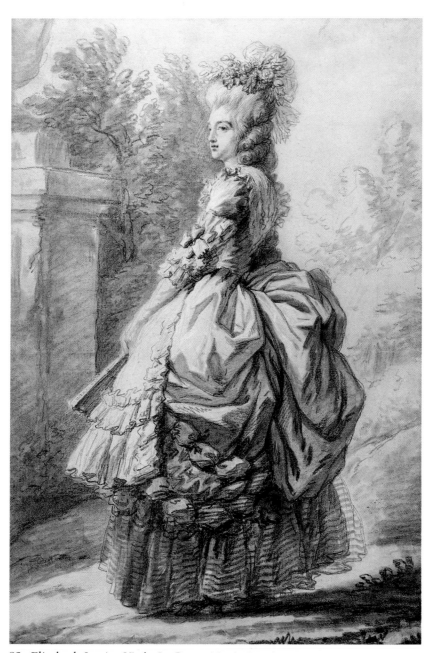

82. Elisabeth Louise Vigée Le Brun, *Marie Antoinette*

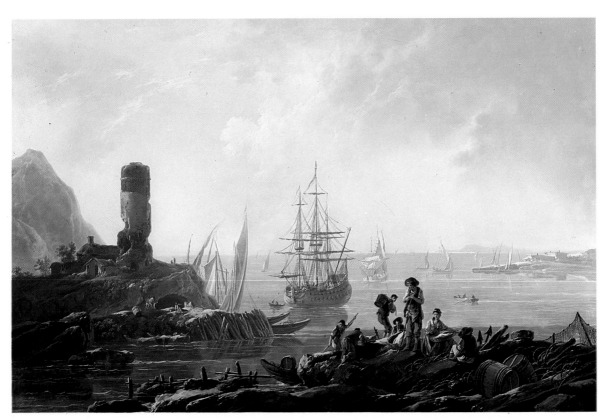

83. Jean Pillement, *Shipping on the Tagus*

Commentaries

Antoine Watteau, 1684-1721

70. *Les Epoux Mal Assortis,* ca. 1700
Sanguine on paper turned tan in color, 8⅞ x 6¾ inches
(22.5 x 17.2 cm.)
Inscribed at the lower right: *Watteau*

Private Collection, Atlanta.

Provenance: Emile Galichon, Paris; Sale, Paris, May 10-14, 1875, no. 173; Louis Galichon, Paris; Sale, Paris, March 4-9, 1895, no. 169; Leboeuf de Mongermont (or Lehmann), Paris; Sale, Galerie Georges Petit, Paris, June 16-19, 1919, no. 292; Gentile de Giuseppe; Sale, Sotheby's, London, June 8, 1955, no. 70; Curtis Baer, New Rochelle.

Exhibition: *Drawings from the Collection of Curtis Baer,* The Fogg Art Museum, Cambridge, January 11-February 25, 1958, no. 40.

Bibliography: K. T. Parker and J. Mathey, *Antoine Watteau, Catalogue complet de son oeuvre dessiné,* Paris, 1957, I, p. 20, pl. 141.

This drawing is from Watteau's early career when, as evidenced by the slightly attenuated figures and subject matter taken from the *commedia dell'arte,* he was still under the influence of Gillot. However, the boldness with which he used the red chalk, the individual personality with which he endows each character, and the complexity of the relationships already reveal the quixotic genius of Watteau.

The title traditionally associated with the drawing suggested to Professor Herbert Breckmann, according to Agnes Mongan, that it depicts a scene from the two-act comedy *Les Mal Assortis,* presented by the Italian Comedians for the first time on May 20, 1683. Represented are *Le Procureur,* the bearded and bent older man in elegant costume, leading his wife *La Coquette,* who gives an infatuated gaze and her left hand to *Le Jeune Homme.* Pierrot playing a guitar and another costumed musician follow them. Watteau establishes a tension between the figures not only by the glances among the figures, but also by their careful placement within the outdoor set – the separation between the old man and his wife, the closeness of Pierrot's head to the young man's, as if whispering mocking insinuations. The whole has a rhythm which is distinctly musical.

The drawing was engraved by J. Audran in the *Figures de Different Caractères* (no. 302) and also by the comte de Caylus.[1] A copy of the drawing was in the A. Beaurdeley Sale at Galerie Georges Petit June 9-10, 1920, no. 345.

[1]Comte de Caylus, *Oeuvres de Caylus,* Paris, Cabinet des Estampes, Bibliothèque Nationale, T.I, fol. 105, no. 32.

Hyacinthe Rigaud, 1659-1743

71. *Samuel Bernard,* 1727
Black chalk heightened with white on blue paper, 22 x 12¼ inches (55.9 x 31.2 cm.)
Signed and dated at lower left: *fait par/ hyacinthe / Rigaud/ 1727*

The Nelson-Atkins Museum of Art, Kansas City. Purchase, 1966.

Provenance: Johann von und zu Liechtenstein in Feldsberg; Rothschild family; Rosenberg and Stiebel, New York.

Exhibition: *French Master Drawings of the 17th and 18th Centuries,* Art Gallery of Ontario, Toronto, 1972, no. 122.

Rigaud is best known for his majestic portraits of Louis XIV (see no. 72), but he lived well into the eighteenth century and was able to adapt his style to the more decorative rococo taste of the 1730s. Rigaud was born into a family of artists at Perpignan, where his realistic style was probably formed before he came to Paris in 1681. Supported by Le Brun, Rigaud was *reçu* in 1700 as a history painter. Although he won the Grand Prix in 1685, he never made the trip to Italy. Instead, he developed his own impressive formal style which owes something to the example of van Dyck. Rigaud established his reputation not only with portraits of the French and Spanish monarchs, but also those of notable churchmen, courtiers, and nobles. He was enobled in 1727 and became *directeur* of the Académie in 1733.

Samuel Bernard (1651-1739), the son of a Protestant painter, became wealthy as one of the chief financiers of the military campaigns in the last years of Louis XIV's reign. He was also a patron of the arts, commissioning paintings by Jean-François de Troy for his Paris residence. In 1726, he commissioned from Rigaud a great portrait (now at Versailles) for which the painter's *Livre de Raison* records that he was paid the tremendous price of 7200 *livres.* The *Livre* also records that a drawing after the painting was sold for the also considerable sum of 200 *livres.* This is surely the highly finished drawing which is now in the Nelson-Atkins Museum. The work shows Rigaud's ability at capturing the personality of his subjects – in this case a shrewd, hard-nosed character – and creating a grandiose setting to enhance it.

Dézallier d'Argenville made mention of Rigaud's drawings on blue paper with white heightening and noted their "precision and truth which enchants us,

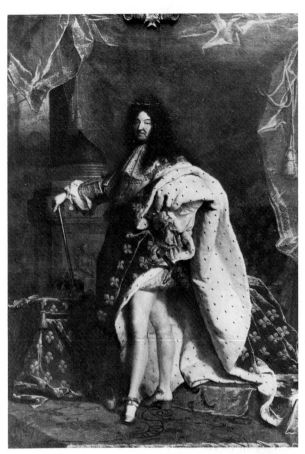

Fig. VI. 1

especially in the treatment of the hair, feathers, curtains, and laces…," and aptly observed that "the fine finish could not be improved upon, combined as it is with his remarkable perception of light and the harmony of the architectural backgrounds and landscapes with which he completes his pictures."[1]

[1]D'Argenville, 1762, IV, p. 325.

Jean-Marc Nattier, 1685-1766

72. *Louis XIV,* ca. 1710
Pencil, pen and ink, heightened with white on paper, 25 x 19¼ inches (63.5 x 48.9 cm.)

Phoenix Art Museum. Gift of Mr. and Mrs. John C. Pritzlaff, 1965.

Provenance: Private Collection; Wildenstein and Co., New York; Mr. and Mrs. John C. Pritzlaff.

Bibliography: Rosenberg, 1975, p. 59.

Hyacinthe Rigaud was commissioned by Philip V to paint a portrait of his grandfather Louis XIV. Upon its completion in 1701, the king was so pleased that he had the original hung in the throne room at Versailles and ordered several copies, including one at the Louvre (fig. VI.1), as well as an engraving by Pierre

Drevet which is dated 1712. The young Jean-Marc Nattier, known to the king for his drawings for engravings after Rubens's *Marie de Médicis* cycle, was employed to make a drawing of Rigaud's painting. For this he was paid in 1713 the handsome sum of 500 *livres*.[1] According to the biography of Nattier written by his eldest daughter, when the drawing was shown to Louis XIV, he said: "Pursue your work, Nattier, and you will become a great man."[2]

Nattier's drawing is an exact copy of the Rigaud painting. The only slight changes are in the angle of the table bearing the crown and sceptre and the extension of the background at the right. The drawing, however with its mixture of ink and chalk, has a distinctive quality of its own. The high finish and uniform tonality suggest that the young artist may have received guidance from Rigaud himself.

[1]Engerand, 1901, p. 322.
[2]P. de Nolhac, *Nattier*, Paris, 1925, p. 29.

Jacques de Lajoue, 1687-1761

73. *Cartouche in the form of a Boat,* ca. 1740
Pencil, ink and wash on paper, 8⅛ x 6⅝ inches (20.5 x 16.9 cm.)
Signed at lower right: *Lajoue*

The Cooper-Hewitt Museum, the Smithsonian Institution's National Museum of Design, New York.

Provenance: The Hewitt family, New York, 1914.

Bibliography: Richard Wunder, *Extravagant Drawings of the Eighteenth Century from the Collection of The Cooper Union Museum*, New York, 1962, p. 103, no. 75.

The rococo style of florid decoration was derived from *rocaille*, the ornamental rocks applied to artificial grottoes. These encrusted and fantastic forms were gradually adapted for architectural and theatrical designs. In the 1730s they were inventively integrated into the work of Jacques de Lajoue. A painter of architecture, illusionistic ceilings, and imaginary gardens (see no. 62), he also produced countless drawings and engravings.

In this cartouche design, one of a series, Lajoue has made the sail of the gallant sailing ship the area for an inscription. The bizarre beasts that ornament the precious vessel convey the sense of whimsical humor that underlies so much rococo art. As in the similar drawings of the Seasons,[1] even the artist's signature is conveyed with a great flourish.

[1]See Per Bjurström, *French Drawings, Eighteenth Century in Swedish Public Collections*, Stockholm, 1982, nos. 989-992.

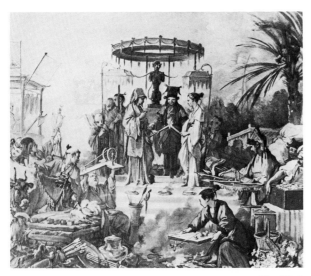

Fig. VI. 2

François Boucher, 1703-1770

74. *A Chinese Marriage,* ca. 1743

Red chalk on paper, 15½ x 18½ inches (39.4 x 47 cm.)

Private collection, New York.

Provenance: L. G. Duke, London; Steven Spector, New York.

Exhibitions: *François Boucher, 1703-1770,* Wildenstein, New York, 1980, no. 49.

Bibliography: Ananoff, 1976, I, p. 347, no. 231/1, fig. 697.

An interest in things Chinese developed in France in the seventeenth century, stimulated in part by the 1665 French edition of John Nieuhof's account of the Dutch embassy to China in 1656. At the same time, Chinese lacquer and porcelain began to be imported, and the end of Louis XIV's reign witnessed the birth of *chinoiserie.* As Peter Hughes has pointed out, *chinoiserie* "is not a contemporary late-17th-or-18th century term, but rather a word coined in the 19th century, presumably by analogy with *singerie.* Its meaning should be restricted to European works made with the intention of appearing Chinese."[1]

Antoine Watteau, in the early part of the eighteenth century, was entrusted with the *chinoiserie* decoration of the *cabinet du roi* in the château de la Muette. This work – now lost, but known from engravings – did a great deal to establish the character of French *chinoiserie.* Twelve of these subjects were engraved by the young Boucher, who thus absorbed a type of decorative subject matter that he was to make his own. Boucher's most important *chinoiserie* project was the series of nine oil sketches probably inspired by drawings by the Jesuit priest Attiret, painter to the Emperor Ch'ien Lung. Boucher's paintings of *scènes de la vie Chinoise,* which were exhibited at the Salon of 1742, passed through the collection of the financier Bergeret de Grancourt and the architect P. A. Paris, who bequeathed them to the city of Besançon where

they remain to this day. The paintings were transferred into cartoons for the tapestry series *Tenture Chinoise* by J.-J. Dumons, and were retouched by Boucher himself before being woven at the Beauvais Manufactory from 1743 to 1775. One set was purchased by Madame de Pompadour, another was sent by Louis XV as a gift to the Chinese Emperor K'ang Hsi. Other sets can now be found in The Metropolitan Museum of Art, Cincinnati Art Museum, and Minneapolis Museum of Art.

Six of the subjects were also engraved by Huquier *pere* and *fils,* and it was probably for this purpose that Boucher executed red chalk drawings such as this one after his sketches. *Un Mariage Chinois* (as this subject was originally titled at the Salon of 1742, rather than it's more recent title, *Wedding of the Mandarin*) shows the young couple in the midst of the marriage ceremony presided over by a priest. Distributed in the foreground are the requisite presents and doweries. This was one of the subjects not engraved, but obviously this is a drawing by Boucher, for it retains all of the vitality and exoticism of the Besançon oil sketch (fig. VI.2).

[1]Peter Hughes, *Eighteenth Century France and the East,* Wallace Collection Monographs, 4, London, 1981, p. 10.

François Boucher, 1703-1770

75. *Young Girl Reclining,* ca. 1751

Red, black, and white chalks on paper, 12½ x 18¼ inches (31.6 x 46.2 cm.)

Kimbell Art Museum, Fort Worth.

Provenance: Greville; Earl of Warwick; Michel-Lévy; Sale, Galerie Georges Petit, Paris, May 12-13, 1919, no. 45; A. Mayer.

Bibliography: Ananoff, 1966, I, pp. 140-141, no. 502, fig. 94; Idem, 1976, p. 380, no. 264/2, fig. 791; *Kimbell Art Museum, Handbook of the Collection,* Fort Worth, 1981, p. 90.

157

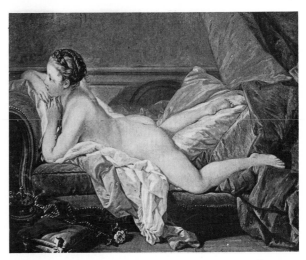

Fig. VI. 3

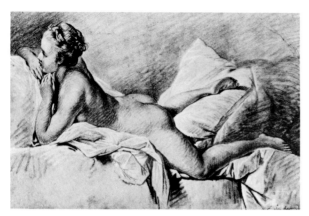

Fig. VI. 4

Ananoff related this drawing to Boucher's 1743 painting *L'Odalisque* (Reims), but it appears more closely related to the several paintings of a *Nude on a Sofa*. One at Cologne (Ananoff 379) is signed and dated 1751, one at Munich 1752 (fig. VI.3, Ananoff 411), and another – perhaps the prime example – was in the Charpentier collection. There is in fact another drawing in three chalks, which was also in the Michel-Lévy collection, of the same model lying on pillows (fig. VI.4, private collection, Paris)[1] which is signed and dated 1751. The model in these drawings is thought to be Louise O'Murphy, an Irish girl who for a time became the mistress of the Louis XV.[2]

The "*trois crayon*" or three-chalk technique that Boucher perfected was ideal for rendering the shimmering quality of light playing upon bare flesh.

[1]See the exhibition catalogue, *François Boucher*, Galerie Cailleux, Paris, 1964, no. 55.
[2]See Paul Frankl, "Boucher's Girl on the Couch," in *De Artibus Opuscula XL, Essays in Honor of Erwin Panofsky*, New York, 1961, I, pp. 138-152.

Hubert Robert, 1733-1808

76. *Landscape*, ca. 1763
Red chalk on paper, 13 x 17½ inches (33 x 44.5 cm.)
Possible monogram at left and dated at the lower right corner: *176?*

Private Collection, Atlanta.

Provenance: Sale, Galerie Charpentier, Paris, June 22, 1933, no. 23.

This is a fine example of Hubert Robert's red chalk landscape drawings. Victor Carlson has written of these works, "passages of foliage tend to spread across and remain on the paper's surface, lacking deep recession into space unless there is a natural or architectural feature to create linear perspective."[1] In this case the tower in the distance provides the contrasting depth.

Robert's focus here on the pattern of tall overlapping trees – rendered in what Carlson has described as "a combination of oval loops and saw-tooth lines" – relates it to a group of red chalk landscape drawings of

the early 1760s, three of which are at Valence[2] and one at Boston.[3] Two of the Valence sheets are dated 1763, which is most likely the date of this work as well. These drawings show the verdant countryside around Rome where the artist was in residence until his return to France in 1765.

[1]Victor Carlson, *Hubert Robert, Drawings and Watercolors,* exhibition catalogue, National Gallery of Art, Washington, D.C., 1978, p. 54.
[2]Ibid., nos. 14a and 14b, and Marguerite Beau, *La Collection des desseins d'Hubert Robert au Musée de Valence*, Lyon, 1968, no. 54a.
[3]Eunice Williams, *Drawings by Fragonard in North American Collections*, exhibition catalogue, National Gallery of Art, Washington, D.C., 1978, no. 70.

Jean-Honoré Fragonard, 1732-1806

77. *Country Houses Beside a Stream,* ca. 1761
Red chalk on paper, 12 x 17⅝ inches (30.5 x 45.2 cm.)

Collection of Arthur Ross, New York.

Provenance: Marquis de M...., Reims; Private collection, Switzerland; William H. Schab Gallery, Inc., New York.

Bibliography: Ananoff, 1970, IV, p. 86, no. 2128.

When Fragonard was in Italy, the Director of the French Academy in Rome, Charles Natoire, encouraged his students to make landscape drawings *en plein air*. Fragonard followed this method and through his association with Hubert Robert also perfected his red chalk technique. He spent the summer of 1760 at the Villa d'Este in Tivoli, capturing in bold hatching and expressive patterns the picturesque quality of sunfilled landscapes. The rustic scene exhibited here may have been made shortly after, perhaps on the painter's return trip to France in the fall of 1761. Red chalk drawings from this stay at Tivoli were exhibited at the Salon of 1765 and the great connoisseur of drawings Mariette noted "their spiritual execution and great intelligence."[2]

[1]P.-J. Mariette, *Abécédario*, Paris, 1857-58, p. 263.

Nicolas-Bernard Lépicié, 1735-1784

78. *Académie: Man Pulling a Rope,*
Red chalk on paper, 21⅞ x 14¼ inches (55.5 x 36.5 cm.)

Bill Blass, New York.

Provenance: The artist's estate sale, Paris, 1785 (?); Girodet-Trioson collection, Paris: William H. Schab Gallery, Inc., New York.

One of the essential pedagogical methods of the Académie, from the time of its foundation, was life drawing. A depiction of such a class can be seen in a drawing by Natoire (fig. 3). So much a part of the Académie's process of instruction was this rigorous training that the drawings done from the nude male model came to be called *académies*.[1]

There were various techniques of drawing, but the one most frequently employed for *académies* was red chalk (sanguine) on white paper. The texture of the paper was often used to enhance the modeling. Life drawing served not only as an exercise for students, but also as a means for established masters to study certain attitudes they might wish to incorporate into a composition.

Lépicié, although best known for his genre scenes (see no. 53), was also a painter of mythological and religious subjects. Like all other *académiciens*, he learned and practiced this drawing method. His sanguine *académies*, as seen in this example and one in the Abbé Thuélin collection (sold Paris, 1927), reveal an especially forceful treatment in the application of the strokes. Lépicié's method was indebted to that of his teacher Carle van Loo and also perhaps to Greuze, but his *académies* have a boldness and breadth of conception that sets them apart.

[1]See the exhibition catalogue *Eighteenth-Century French Life-Drawing*, The Art Museum, Princeton, 1977.

Pierre-Antoine Baudouin, 1723-1769

79. *Le Modèle honnête,* 1769
Gouache, 15¾ x 13⅝ inches (40 x 34.5 cm.)
Signed in the side of the platform at lower left:
P. Baudouin

Ian Woodner Collection, New York.

Provenance: Mlle. Testart Sale, Paris, January 22, 1776, no. 30 (?); Prault Collection Sale, Paris, November 27, 1780, no. 41 (?); George Blumenthal; Baroness Wrangell; Sale, Sotheby's, London, November 26, 1970, no. 93; William H. Schab Gallery Inc., New York.

Exhibitions: Salon of 1769, Paris, no. 68; *Woodner Collection II, Old Master Drawings from the XV to the XVIII Century*, William H. Schab Gallery, New York, The Los Angeles County Museum, and Indianapolis Museum of Art, 1973-74, no. 106.

Baudouin was a pupil of Boucher and married his younger daughter. It was through his father-in-law's protection that he was admitted to the Académie. He worked primarily in gouache, and although he prepared illustrations for some religious texts, he achieved renown for his erotic subjects, which were frequently engraved. The writer of the *Sentiments sur les tableaux* of 1769 noted that Baudouin reveals in these pleasing subjects "his agreeable genius and facility" and found the idea of *Le Modèle honnête (The Modest Model)*, exhibited that year, one of his "most ingenious."

This small gouache drew crowds at the Salon as its subject proved to be a topic of great debate. The artist at his easel painting a very Boucher-like Venus and Cupid is apparently startled by the appearance of an older woman coming to the assistance of his charming nude model. According to several contemporary reports, the work's original frame was inscribed at the top with the phrase *Qui non Cogit Egestas?* which was rendered into French as *Que ne fait pas faire le manque d'argent* (See what poverty makes one do). Bachaumont wrote that there were three questions in particular provoked by this work: 1) How does one reconcile the model's seeming resistance with the already fully worked-out composition on the easel, which represents many hours of posing; 2) What is the role of the old woman? Is she the model's mother who is trying to conceal her indecency, or is she an evil woman who has forced the girl into this infamous profession; and 3) What is the relevance of the inscription; does it relate to the mother or the young girl?[1] It was the second question upon which most ink was spilt. There were those who compared the old woman to Mrs. Jervis and Mrs. Jewkes in Samuel Richardson's popular novel *Pamela*. Others, however, argued that she was indeed the girl's mother and claimed to see a tear in her left eye.

Diderot, who did not fancy such a subject, first berates the artist for being too dependent on his father-in-law, and a weak colorist, and goes on to say that "the manner in which the subject is treated is obscure. This woman cannot be a mother. She is an ignoble creature who engages in some vile business." Diderot, who had actually suggested in print this very subject to Greuze, concludes by saying that Baudouin should

> leave this sort of subject to Greuze, who claims Baudouin has stolen the subject that he invented and proposed to paint; but in appropriating the subject, he should have at the same time stolen the manner and the genius with which to treat it. Baudouin, as libertine with his brush as he is in his morals, does not possess in his soul the least iota necessary for the execution of a painting of such honesty.[2]

159

It is difficult to agree with Diderot's severity, for Baudouin's handling of the gouache and the richness of details is masterly. Contemporary artists responded positively. Saint-Aubin sketched the composition of *Le Modèle honnête* in his copy of the Salon *livret* and the work was engraved by J.-M. Moreau le Jeune and J.-B. Simonet with a dedicatory inscription to the comte de Strogonoff. This or the original inspired similar compositions by other artists such as *Le Modèle disposé*, painted by both Schall and Derosier, and most notably *Le Début du Modèle* by Fragonard, which is in the Musée Jacquemart-André in Paris. A preparatory study in gouache and black chalk by Baudouin is at Wildenstein.[3] It is not possible to be sure whether it was this work or the one in the Woodner Collection which passed through the eighteenth century collections noted in the provenance.

[1]Bachaumont, "Salon de 1769," (published 1780), p. 57.
[2]Seznec and Adhémar, IV, 1967, pp. 94-95.
[3]See the exhibition catalogue *La Douceur de Vivre*, London, June-July, 1983, p. 55 and ill. p. 32.

Philippe-Jacques de Loutherbourg, 1740-1812

80. *Tom Jones in the Church Graveyard,* 1775
Pencil, brown ink and wash on tan paper, 12¾ x 12¾
inches (32.4 x 32.4 cm.)
Signed and dated: *P.I. de Loutherbourg 1775*

Private Collection, New York.

Provenance: Christian Humann, New York; Sale Sotheby
Parke-Bernet, April 30, 1982, no. 60.

Loutherbourg was born in 1740 in Strasbourg, where
he received lessons in drawing from Tischbein and in
engraving from his father, a successful miniaturist. He
came to Paris in 1755 and studied with Carle van Loo
and the Venetian-born François-Joseph Casanova,
brother of the famous lover, who was a successful
painter of battle scenes. Loutherbourg copied old mas-
ters while working with the engraver Jean-Georges
Wille, and studied the Dutch painters, especially the
work of Wouwermans and Berchem. Among his con-
temporaries, Joseph Vernet's dramatic landscapes and
seascapes most strongly influenced him.

Loutherbourg's success in Paris was swift. He was
agréé at the Academie Royale and *reçu* in 1767; he be-
came famous for being the youngest painter ever to
attain those positions. After 1763 he exhibited fre-
quently at the Salons, where his landscapes, seascapes,
and battle scenes were well received by the critics
(especially Diderot) and the public. At the Salon of
1771, Loutherbourg was the most prolific exhibitor
(Diderot reported that he worked at "inconceivable
speed"), but within three months of its opening he left
Paris permanently for London. There he began an
even more successful career, first as David Garrick's
set designer at Drury Lane, and then as an astonish-
ingly versatile painter, illustrator, Royal Academician,
and inventor.

The drawing exhibited here is one of a series by
Loutherbourg which were engraved in 1782-83 (fig.
VI.5) for Henry Fielding's 1749 novel *Tom Jones.* The
book was immensely popular in both France and Eng-
land, as the inscriptions on these engravings attest.[1]
Tom Jones in the Church Graveyard illustrates an inci-
dent from Book IV, Chapter Eight. Molly Seagrim,
pregnant by Jones, has incited the jeers and taunts of
the local parishoners when she attends church ser-
vices dressed in the aristocratic garments of Sophia
Western. As Molly tries to leave the Church, the disrup-
tion turns into a full-scale fight and spills into the
graveyard, where a freshly dug grave had been pre-
pared for a funeral service that evening. After dispatch-
ing most of her assailants with thigh-bones, skulls, and
her fists, Molly is challenged by the promiscuous and
combative Goody Brown. The ladies fight, claw, and
bite to a bloody stalemate when Jones, riding by,
comes to the rescue, and then "flying at the mob, who
were all accused by Molly, he dealt his blows so pro-
fusely on all sides, that…it would be impossible for
me to recount the Horsewhipping of that Day."[2]

160

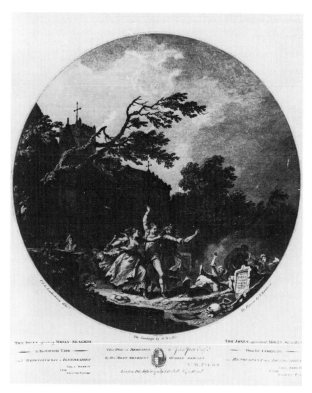

Fig. VI. 5

At the time Loutherbourg executed this drawing, he
was being paid handsomely by Garrick for stage de-
signs at Drury Lane; the composition of this and many
of his works from this period reflect the theatrical ar-
rangement of scenic elements. In his treatment of de-
tail, Loutherbourg reveals his earlier Dutch influences,
while his crisp and fluid lines retain a French rococo
flavor. Yet, as both Rüdiger Joppien and Ellis
Waterhouse have observed, it was during this part of
Loutherbourg's career that he sought to adapt himself
totally to the English style.[3] In 1774-75, Loutherbourg
created a series of six specifically English caricature
drawings which presuppose a knowledge of Hogarth;
and vivid descriptions of English country folk in this
1775 work, as well as the satirical tone of the drawing,
evoke further comparison with Rowlandson. Such
concerns were to result in his best known English
masterpiece, *A Midsummer Afternoon with a Method-
ist Preacher* (1777, Ottawa).

[1]This taste for English things also was part of the general
movement of *sentimentalisme.* See Louis Hautecoeur, "Le
Sentimentalisme dans la Peinture Française," *GBA,* 1909,
p. 275.
[2]Henry Fielding, *The History of Tom Jones, A Foundling,*
Fredson Bowers, ed., Oxford, 1975, I, p. 183.
[3]Ellis Waterhouse, *Painting in Britain 1530-1790,* London,
1953, p. 234; and Rüdiger Joppien, *Die Szenenbilder Philippe
Jacques de Loutherbourgs,* dissertation, Cologne, 1972, p. 6.

Jean-Baptiste Perroneau, 1715-1783

81. *Charles de Baschi, marquis d'Aubais,* 1746
Pastel on paper, 23¼ x 19 inches (59 x 48.2 cm.)
Signed and dated at right center: *Perroneau 1746*

E. V. Thaw and Co., Inc., New York.

Provenance: Laperlier; Sale, Paris, 1867; Marquis de Beurnonville; Emile Lévy; Sale, Paris, March 26, 1925, no. 22; Marius Paulme, Paris; Sale, Galerie Georges Petit, Paris, May 13, 1929, no. 195; Germain Seligman (d. 1978) New York.

Exhibition: Salon of 1746, Paris, no. 146.

Bibliography: John Richardson, ed., *The Collection of Germain Seligman*, New York, 1979, no. 60.

Perroneau was a master portraitist who worked in both pastel and oils. He studied with Natoire and the engraver Laurent Cars. *Agréé* at the Académie in 1746, he exhibited at the Salon for the first time in that year. Included among his works was this pastel. Perroneau's work was inevitably compared to that of Maurice Quentin de La Tour, who had created the vogue for pastel portraits,[1] and whose virtual monopoly of the field led Perroneau to seek out patrons abroad. He visited Italy, Holland, and Russia, and died in Amsterdam.

While his portraits may be less original than those of La Tour, Perroneau's pastels nevertheless display a complete control of the medium and have a freshness which captures the personality of his sitters. He is particularly deft at conveying the textures of surfaces, such as the filmy shirt sleeve or a metal cuirasse in this case.

The sitter, Charles de Baschi, marquis d'Aubais (1686-1777), also baron de Caila and Seigneur de Junas, had served briefly with the First Company of Musketeers. He then retired to his château at Aubais, where he devoted himself to study, writing a history of geography and accumulating much of the material for Ménard's *Recueil de pièces fugitives pour servir à l'histoire de France*.

This pastel was the basis for an engraving by J. Daulle in 1778. For this, either he or Perroneau prepared a wash drawing (fig. VI.6) which gives a less flattering impression of the subject. In this pastel, the artist has succeeded in capturing both the nobility and keen intellect of the marquis.

[1]In the Salon review *Réflexions sur quelques causes de l'état present de la peinture en France*, The Hague, 1746, pp. 281, 118, and 121, the author notes the tremendous number of pastels shown and hopes that the facility with which they are done will not lead to the displacement of the slow and thoughtful process of oil painting. He credits this profusion to La Tour, but states that he approves of the pastels of Drouais and Perroneau.

161

Elisabeth Louise Vigée Le Brun, 1755-1842

82. *Marie Antoinette,* 1780
Black chalk, estompe, heightened with white on gray-blue paper, 32½ x 16 inches (59.7 x 40.6 cm.)

Private Collection, New York.

Provenance: Jean-Pierre Norblin de La Gourdaine (?); Baronne de Connantré; Baronne Ruble; Mme de Witte; Marquise de Bryas; Paul Cailleux, Paris; William Schab Gallery, New York; Christian Humann, New York; Sale, Sotheby Parke-Bernet, New York, April 30, 1982, no. 35.

Bibliography: J. Baillio, "Propos sur un dessin de Mme. Vigée Le Brun," *L'Oeil*, June-July, 1983, pp. 30-35, figs. 2 and 4.

Having already made copies in 1776 and 1777 of portraits of Marie Antoinette (1755-1793) by other artists, Vigée Le Brun was called to Versailles to paint her first portrait of the queen from life in 1778. This was a grandiose full-length portrait that was sent to the Austrian Court and is now in the Kunsthistorisches Museum in Vienna. The queen, pleased with the result, commissioned many additional portraits from the artist, whose career she greatly advanced. Joseph Baillio has convincingly identified this splendid drawing, which retains some of the same character as the portrait of 1778, as having been done in 1780. He has drawn attention to Vigée Le Brun's reminiscences, recorded by Charles-Edouard de Crespy, of the queen

Fig. VI. 6

requesting to be drawn in the magnificent costume which she wore for a presentation in September of that year for the opéra-comique *Rose et Colas* by Sedaine and Monsigny at the Théâtre du Petit Trianon.

As Baillio has written apropos of another portrait of Marie Antoinette, Vigée Le Brun, "operating like a plastic surgeon," has modified the queen's unattractive features, "her high bulging forehead, pale blue myopic eyes, aquiline nose, and the thick Hapsburg lower lip."[1] In this drawing the queen has a magnificent haughty bearing which can only be called regal. Vigée Le Brun evoked this very quality when she later described the queen in her *Souvenirs*: "She was grand, admirably proportioned, heavy enough without being too heavy. Her arms were superb, her hands small and perfect in form and her feet charming. Of all the women in France her carriage was the best, her head held high with a majesty that made her easily recognizable as the sovereign amidst all her court."[2]

Vigée Le Brun's elaborate drawing technqiue, combining black chalk, stump work, and white heightening, is known from only a few other drawings, such as a *Girl Dressed as a Vestal* in the Louvre. It is a style which is vigorous yet sensitive.

[1] *Elisabeth Louise Vigée Le Brun*, exhibition catalogue, Kimbell Art Museum, Fort Worth, 1982, p. 63.
[2] Elisabeth Louise Vigée Le Brun, *Souvenirs*, 1835, I, pp. 63-64.

162

Jean-Baptiste Pillement, 1727-1808

83. *Shipping on the Tagus,* 1782
Pastel on paper, 23 x 32 inches (58.5 x 81.3 cm.)

Hirschl and Adler Galleries, New York.

Bibliography: Peter Mitchell, "Jean Pillement Revalued," *Apollo*, January, 1983, p. 49, fig. 1.

Pillement, who came from a family of painters in Lyon, was one of the most widely-travelled artists of the eighteenth century. His specialty was romantic landscapes, reminiscent of Vernet, rendered in oil, gouache, or pastel. He was also a master of ornamental design, often in the Chinese style.

At Lyon, his first training was with the local painter Sarrabat. He came to Paris at age sixteen, spent a short time as a draughtsman at the Gobelins tapestry factory and the following year, 1745, went to Spain. As a sought-after decorative painter and designer, he was also to visit Italy, Austria, and Poland. He was especially popular in England, where he remained from 1750-1760, exhibiting at the Society of Artists, and patronized by the actor-collector David Garrick. A large sale of his work was held in London in 1774. In 1778, after carrying out some decorative work in the Petit Trianon for Marie Antoinette, he was appointed her court painter. The Revolution, however, ended the vogue for his style of decoration, and he died in poverty in Lyon.

The landscapes Pillement produced during his trip to Portugal in the 1780s are generally considered among his finest. This pastel and other views of the Tagus[1] display a remarkable high finish and brilliant tone. The compositions are reminiscent of both Hubert Robert and Francesco Guardi.

[1] See for example a 1783 work from the collection of Louis Speelman, illustrated in *France in the Eighteenth Century*, Royal Academy, London, 1968, no. 565, fig. 208.

Bibliographical Abbreviations

Ananoff, 1961-70

A. Ananoff, *L'oeuvre dessiné de Jean-Honoré Fragonard (1732-1806), Catalogue Raisonné,* 4 vols., Paris, 1961-70.

Ananoff, 1976

A. Ananoff, *François Boucher,* 2 vols., Lausanne, 1976.

Ananoff, 1980

A. Ananoff, *L'Opera Completa di Boucher,* Milan, 1980.

D'Argenville

A.-J. Dézallier d'Argenville, *Abrégé de la vie des plus fameux Peintres,* 4 vols., Paris, 1762.

Bachaumont, 1780

M. de Bachaumont, *Lettres sur les Peintres,* London, 1780.

BSHAF

Bulletin de la Société des Beaux-Arts de l'Historie de l'Art Français, Paris.

Dacier, *Saint-Aubin*

E. Dacier, *Catalogues des Ventes et livrets de Salons illustrés par Gabriel de Saint-Aubin,* 7 vols., Paris, 1909-1919.

Dimier

Louis Dimier, *Les Peintres français du XVIIIe siècle,* 2 vols., Paris, 1928-1930.

Eisler, 1977

Colin Eisler, *Paintings from the Samuel H. Kress Collection, European Schools Excluding Italian,* Oxford, 1977.

Engerand

F. Engerand, *Inventaire des Tableaux Commendés et Achetés par la Direction des Bâtiments du Roi, (1709-1792),* Paris, 1901.

GBA

Gazette des Beaux-Arts, Paris

Goncourts

E. and J. de Goncourt, *L'Art du XVIIIème siècle,* 3 vols., Paris, 1909 ed.

Mariette, 1851-60

P. J. Mariette, *Abécédario de P. J. Mariette et autres notes,* 6 vols., Paris, 1831-1860.

Rosenberg, 1975-76

Pierre Rosenberg, *The Age of Louis XV,* exhibition catalogue, Toledo, 1975-76.

Rosenberg, 1979

Pierre Rosenberg, *Chardin 1699-1779,* exhibition catalogue, Paris and Cleveland, 1979.

Seznec and Adhémar

J. Seznec and J. Adhémar, *Diderot Salons,* 4 vols., Oxford, 1957-67.

Sterling, 1955

Charles Sterling, *A. Catalogue of French Paintings XV-XVIII Centuries, The Metropolitan Museum of Art,* New York, 1955.

D. Wildenstein and Mandel, 1972

Daniel Wildenstein and G. Mandel, *L'Opera completa di Fragonard,* Milan, 1972.

Wildenstein, 1963

Georges Wildenstein, *Chardin,* Zurich, 1963.

Wildenstein, 1960

Georges Wildenstein, *The Paintings of Fragonard,* New York, 1960.

163

Index of Artists

Photographic Credits

With the exception of the works listed below, color transparencies were supplied by the lenders. Numbers 10, 31, 47, 55, 68 are copyrighted by The Metropolitan Museum of Art, New York.

Eric Pollitzer, New York, nos. 5, 20, 42, 46, 52a, and 52b.
Frederick Charles, New York, no. 8.
Bruce C. Jones, New York, no. 7.
David Stansbury, Springfield, Massachusetts, nos. 17, 21, and 58.
Mike McKelvey, Atlanta, nos. 35, 70, and 76.

The black and white figures are from the following sources:

Photo Bulloz, Paris, figs. 2, 5, 9, and 10.
H. Roger Viollet, Paris, fig. 1.
Photographie Giraudon, Paris, figs. 4 and 6.
Documentation Photographique de la Réunion des Musées. Nationaux, Paris, figs. I.3, V.6 and VI.1.
Witt Library, London, figs. 3 and VI.5.
National Gallery, London, fig. 12.
The Wallace Collection, London, fig. IV.3.
Fitzwilliam Museum, Cambridge, fig. III.1.
Rice Museum, Rice University, fig. IV.2.
Sterling and Francine Clark Art Institute, fig. IV.9.
Musée des Beaux-Arts, Strasbourg, fig. I.4.
Eugene V. Thaw, New York, figs. III.6 and VI.6.
National Gallery of Art, Washington, D.C., fig. IV.5.